SEASON 1 & 2 SHIP SCALES

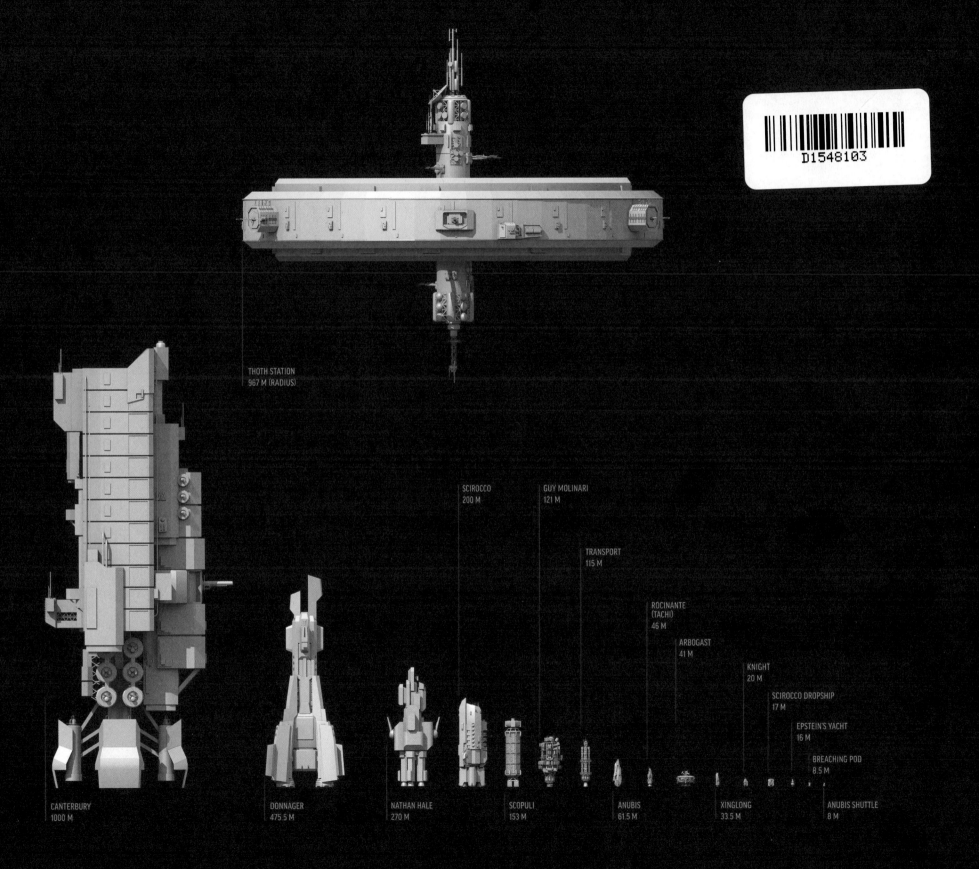

D1548103

THOTH STATION
967 M (RADIUS)

SCIROCCO
200 M

GUY MOLINARI
121 M

TRANSPORT
115 M

ROCINANTE
(TACHI)
46 M

ARBOGAST
41 M

KNIGHT
20 M

SCIROCCO DROPSHIP
17 M

EPSTEIN'S YACHT
16 M

BREACHING POD
8.5 M

CANTERBURY
1000 M

DONNAGER
475.5 M

NATHAN HALE
270 M

SCOPULI
153 M

ANUBIS
61.5 M

XINGLONG
33.5 M

ANUBIS SHUTTLE
8 M

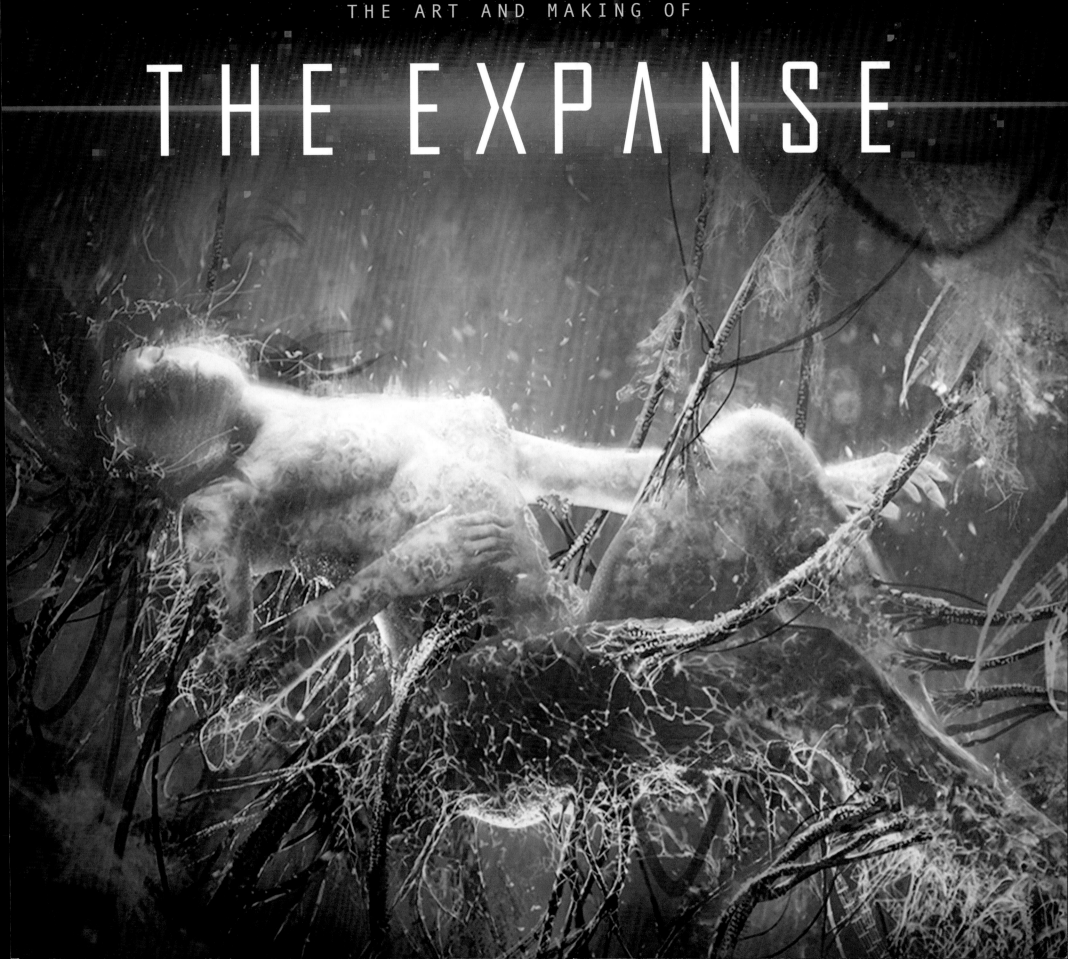

THE ART AND MAKING OF

THE EXPANSE

THE ART AND MAKING OF THE EXPANSE

ISBN: 9781789092530

Published by Titan Books (in partnership with Alcon Publishing)
A division of Titan Publishing Group Ltd.
144 Southwark St.
London
SE1 0UP

First edition: November 2019
10 9 8 7 6 5 4 3 2 1

© 2019 Expanding Universe Productions, LLC.

To receive advance information, news, competitions, and
exclusive offers online, please sign up for the Titan newsletter
on our website: **www.titanbooks.com**

Did you enjoy this book? We love to hear from our readers.
Please e-mail us at: **readerfeedback@titanemail.com** or write
to Reader Feedback at the above address.

No part of this publication may be reproduced, stored in a retrieval
system, or transmitted, in any form or by any means without
the prior written permission of the publisher, nor be otherwise
circulated in any form of binding or cover other than that in which
it is published and without a similar condition being imposed on the
subsequent purchaser.

A CIP catalogue record for this title is available from the British
Library.

Project editors:
Andy Jones (Titan Books); Jeff Conner (Alcon Publishing)

Printed and bound in Canada.

ALCON PUBLISHING, LLC
ALCON TELEVISION GROUP, LLC

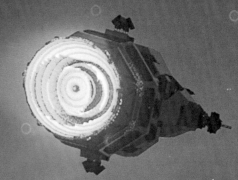

THE ART AND MAKING OF

THE EXPANSE

TITAN BOOKS

ALCON
PUBLISHING®

"Our intention all along was to see Ty and Daniel's complex and compelling world brought to life. Watching this happen—from the first concept drawings, the building of the sets, finding the incredible cast, on to the special effects—was immensely gratifying. Magical in every way."

Andrew Kosove, executive producer ↘

"The success of this series is rooted in quality storytelling and compelling, complex characters. The source material laid the foundation for us, and it is our goal to continue to preserve and expand upon it."

Broderick Johnson, executive producer ↘

CONTENTS

THE EVOLUTION OF *THE EXPANSE*

There's an oft-repeated and convincing story that writing is solitary—even lonesome—work. The effort of a single, isolated mind creating more or less in a vacuum. There may be times when that's true, but there are also undeniably times when it isn't. From its first incarnation a decade and a half ago, the project that became *The Expanse* was the second kind. The kind that relies on the power of collaboration.

Back in the ancient days when *World of Warcraft* ruled the earth, Ty was approached by a friend to help think about how to design a new massively multiplayer online game. Feeling that fantasy settings were well-covered ground, Ty envisioned a game more like the science fiction of Alfred Bester, Arthur C. Clarke, Robert Heinlein, and Larry Niven. Something kind of like *Eve Online*, but where players could leave their ships and explore, and have adventures on the many bodies of our real solar system: Earth and Mars, and the Jovian moons.

The truth of any creative business is that most things fail. When the financial and programming obstacles made it clear that the game pitch wasn't going to go anyplace, Ty held on to the ideas he'd had, not because he saw any particular business model to go forward with them, but because he liked them and thought there was more there to play with. And he found new collaborators. For years, he ran tabletop and play-by-post role-playing games that explored the universe. Going under the name *2350*, he had crews of ships trying to eke out a living in the great stations of the system, and teams of detectives dealing with crime and politics in the port of Ceres Station. At one point, a player had to drop out of the game and let Ty engineer a dramatic exit for him. His character was named Shed Garvey, and that shocking death has now appeared in every iteration of *The Expanse* so far.

Among the people who played in Ty's games were a fair number of writers: Walter Jon Williams, Ian Tregellis, Melinda Snodgrass, and (yes) George R.R. Martin—all had adventures in Ty's universe even before Daniel came along.

When he started playing the tabletop game, Daniel had published seven novels and about a dozen short stories, to some critical acclaim and commercial success. The world-building and thought that Ty had put into the games impressed him, and the events and setting in the game captured his attention to the point that after just a few sessions, he was staying up late at night and writing long emails to Ty about things like how to build a Belter-specific currency based on accumulated and unresolvable debt to Earth banks. And the collaboration found its next incarnation there, when Daniel suggested that they write up the overarching campaign story in novel form. Ty brought the characters and story universe, Daniel the knowledge of how to write a book.

That first novel was written largely on Wednesdays, and while we are no longer restricted to writing one day a week, the process we used would remain largely the same as we wrote another eight novels together in nine years. We made a rough outline of the whole novel, then detailed outlines of the first two chapters. Ty would write the first draft of one chapter, and Daniel wrote the other. Then each would edit the other's chapter, and put the edited chapters together in a master document. Chapter by chapter over a year's time, the novel grew into *Leviathan Wakes*.

Writing aside, the process of selling and publishing a novel is almost never a solitary job. The book was sold by our agent, Danny Baror, to the team at Orbit Books. That by itself isn't a small thing, but he also contracted for the next two novels that wound up being *Caliban's War* and *Abaddon's Gate*. Then the process of publishing began. Our editors gave us notes on the books, and copy editors tracked down typos and grammatical gaffes. We went through galley proofs that the printers made for us. The amazingly talented Daniel Dociu gave us the iconic art that became the cover. And so even before the first copy of the book hit the shelf, dozens of people had become involved.

While we were writing the second book, *Caliban's War*, we had a conversation with Tim Holman, our publisher, during the Worldcon in Reno. We had three books under contract, but knew that the story could extend much longer. However, if the publisher wasn't interested in more than three books, that of course would change how we approached writing the third. Tim gave us the green light to plan for as long as it took

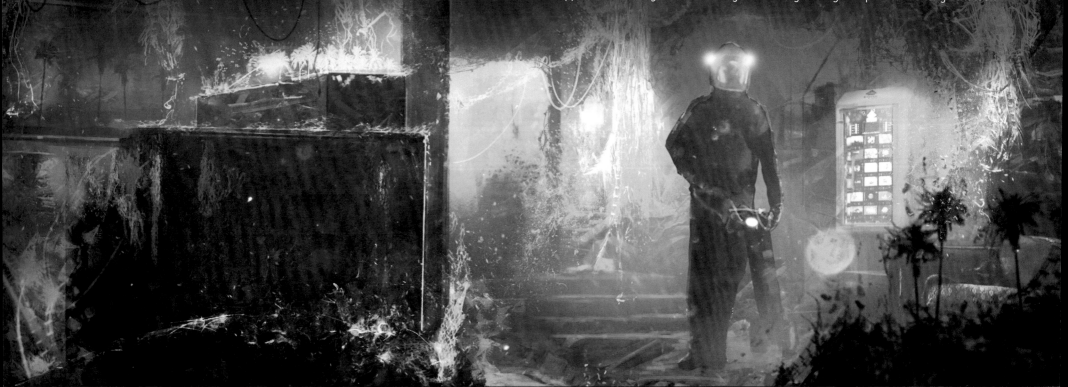

to tell the whole story, and tell it well, so we put the writing on hold long enough to build an outline of the whole series, including the ending of the last book. We understood then that we were looking at a nine-book series, with a handful of stories that filled in and fleshed out the universe. It was an insanely ambitious plan, and even that wasn't the last incarnation of the project.

It's not unusual for successful books to be optioned for film, and after *Leviathan Wakes* was nominated for the Hugo award (losing to the immensely talented Jo Walton, of whom we are both fans), we had several offers. The usual pattern is for the author to sell the rights, after which they might have a little consultation in the process. But, as Ty says, the last time most authors have any real power in an adaptation is when they decide whether or not to take the money. It takes a rare set of people for that collaborative spirit to keep the original authors deeply involved. When we were approached by the Sean Daniel Company, we fell in with that rare set of people. Mark Fergus and Hawk Ostby, the writers of *Iron Man* and *Children of Men*, were interested in doing a pilot script, and with their openness and willingness to keep us involved, we became part of the team.

With that group assembled, we started going to development companies, looking for someone who would love the project as much as we did. In meeting after meeting, Mark pitched the story we had written, what drew him to it, and what he saw it could be. And through that, we found Alcon Television. And Alcon Television found us a home for the show: Syfy.

If the process of writing a novel is quietly a collaboration between author, editor, publisher, and production staff, the collaborative effort of making a television show is several orders of magnitude more expansive. Alcon brought on experienced showrunner Naren Shankar, who is both a deeply creative storyteller in his own right and one of the best managers we have worked with in any industry. It became his job to put together all the people we needed as we took the story Ty had started more than a decade earlier and prepared it for its next incarnation.

And the process of translating a prose work into a visual medium is not a trivial problem. The toolboxes of writing books and scripts overlap, but they also diverge wildly; it's not always clear at first which techniques that work well in one, will fail in the other. For a novelist coming blind into the screenwriting process, the writers' room is either a classroom or a catastrophe. With a lot of work, and the support of the other writers working on the show, it became a classroom. The same way we'd taken the role-playing campaigns apart and put them together again as books, we took the books apart and put them back together as scripts. Only this time "we" weren't Ty and Daniel. "We" were Ty and Daniel and Naren and Robin and Georgia and Jason and Hawk and Mark.

Only, of course, that wasn't all of us. With every week, more people were folded into the process as the financial and bureaucratic structures that run a project this monumental came together. The search began for cast, for sound stages, for costumers and directors and concept artists—all of the hundreds of jobs that need to be filled for a show to work. At Syfy, distribution and marketing teams started finding ways to make *The Expanse* visible in an age of peak television. And the team got bigger.

In this book, you will get to see a tiny fraction of the work that the team put into the show. It often begins with amazing concept art by Ryan Denning and Tim Warnock. It becomes production design by Tony Ianni and his team, sets by Rob Valeriote and the construction crew, costumes by Joanne Hansen and her department, props by Jim Murray, visual effects by Bret Culp. Making *The Expanse* a reality has gone from a collaboration between two people to a cast and crew of hundreds.

Naren has a saying that is both ominous and true: For a show to work, a thousand things have to go right. For it to fail, three things have to go wrong. For three seasons in a row, a thousand things went right. In the middle of airing the third season, the third thing must have gone wrong. On May 10th of 2018, Chris McCumber, the President of Entertainment Networks for NBCUniversal, broke the news. *The Expanse* was cancelled.

Most stories would end here. The number of projects of this size and complexity that have survived a hit like this you can count on your fingers. But for us—unexpectedly— what happened was this: The team got bigger.

While Alcon, who still owned the show, looked for another partner to take Syfy's place, a network of fans sprang into action. A plane with a banner saying SAVE THE EXPANSE flew over Amazon headquarters. A model of the *Rocinante* was launched into space. Petitions rolled out. The writers and producers were making condolence calls to each other, hoping to work together again somewhere down the road, and organizing one last big watching party for the finale. But the fans of the show were out there, shovels in hand, digging us out of the grave. And behind the scenes, it started seeming like it might work. Many of the cast and crew, who would normally have been out looking for new jobs, held off, waiting to see whether, against all odds, *The Expanse* might be saved.

On May 25th, Jeff Bezos was attending the National Space Society's International Space Development Conference. He broke from the expected content of his talk to make an announcement: Amazon was part of the team now too. *The Expanse* was picked up for a fourth season, this time on Amazon's global streaming service.

We're writing this as that fourth season is in post-production, getting edited and mixed, ready to roll out sometime later this year, and the collaboration is still going on. Ty and Daniel are working on the manuscript for the ninth and final novel in the series. Naren and the writers' room are looking toward what the fifth and sixth seasons will look like. The fans have adopted their own name—Screaming Firehawks—and are forming communities and groups, cosplaying characters at media conventions, and playing their own tabletop role-playing campaigns in the world of *The Expanse*.

The book you're holding now is, for us, something like a high school yearbook. It's a collection of memories and artifacts that can't ever encompass the full scope and depth and breadth of the collaborative project that we've been lucky enough to take part in over these last five years. Or these last ten. Or more. This is a reminder of the astounding talent and energy that hundreds of people have put into *The Expanse*, and the expertise and creativity and passion that got the work here, and that even now drives it forward.

We hope you enjoy sitting with the art and world of *The Expanse* as much as we do. We can never sufficiently express our gratitude to the whole team who made and continue to make this massive, complex, improbable act of storytelling possible.

Including you.

Ty Franck & Daniel Abraham

THE ROCINANTE

Showrunner Naren Shankar: "To the extent possible within the restrictions of a television series, we strive to create a realistic depiction of life and work in space. In *The Expanse*, spaceships are everywhere—and a critical part of our look. The orientation of the decks and the distribution of mass relative to the direction of thrust, these and many other factors dictate the form of our ships, which often end up resembling big, chunky buildings (which we love). The *Rocinante* is our crew's home, but it is also a Martian Navy corvette, a fast, tough gunship. It had to look *badass*."

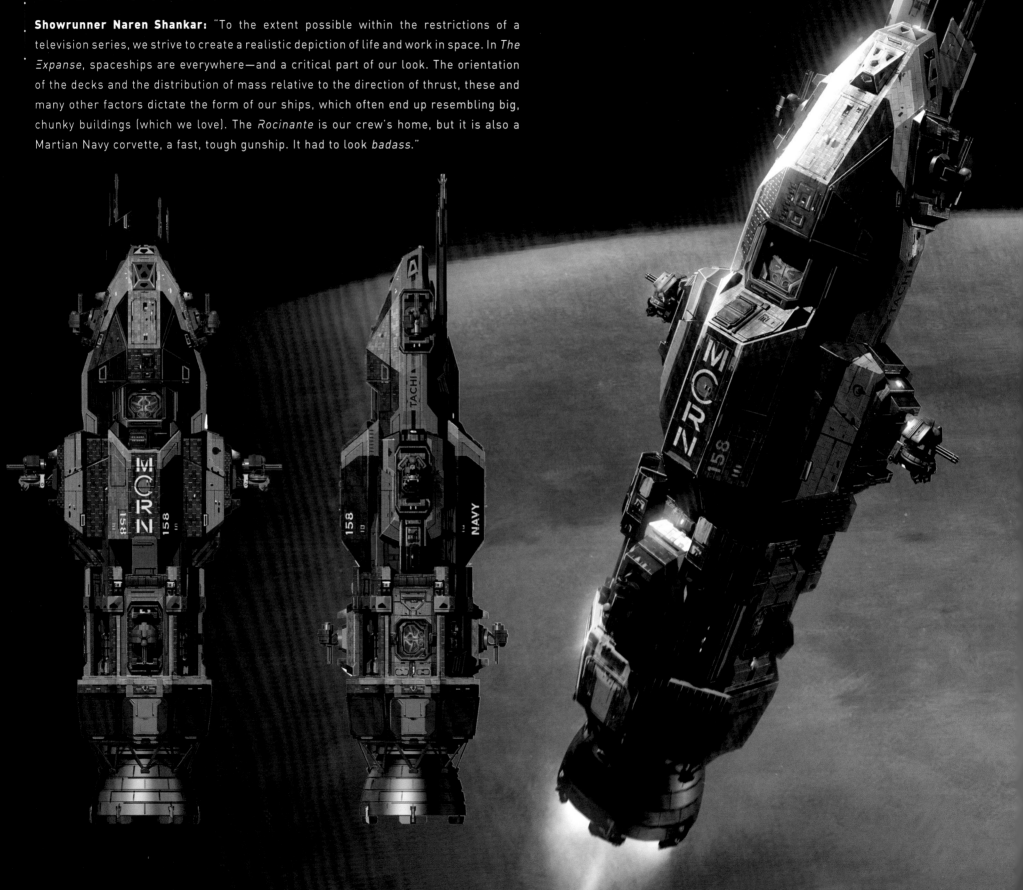

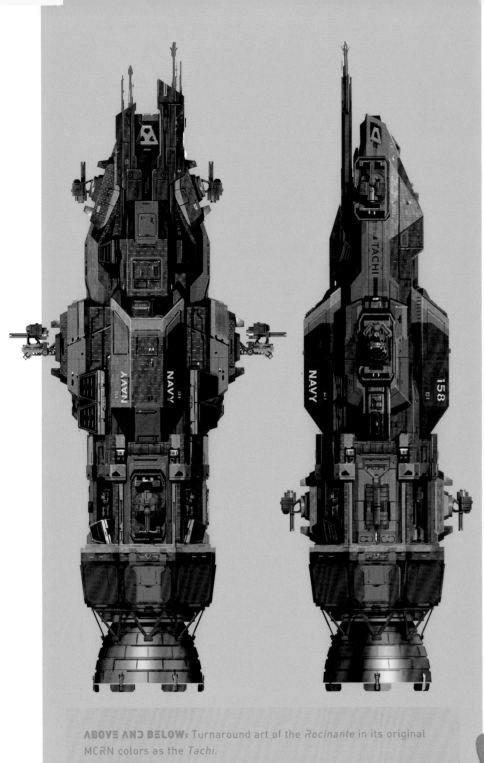

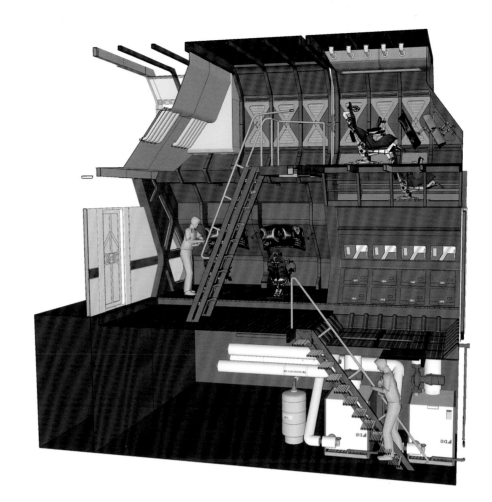

ABOVE: Computer model of the *Roci*'s interior, showing its 'skyscraper' configuration.
BELOW: One of the *Roci*'s seats, complete with tubes ready to inject the infamous 'juice.'

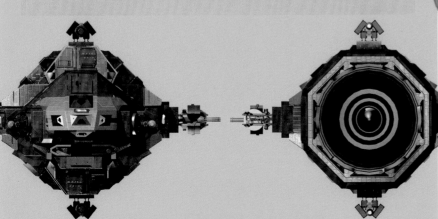

ABOVE AND BELOW: Turnaround art of the *Rocinante* in its original MCRN colors as the *Tachi*.

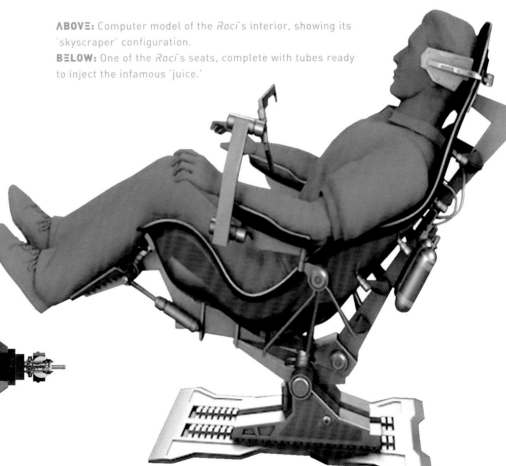

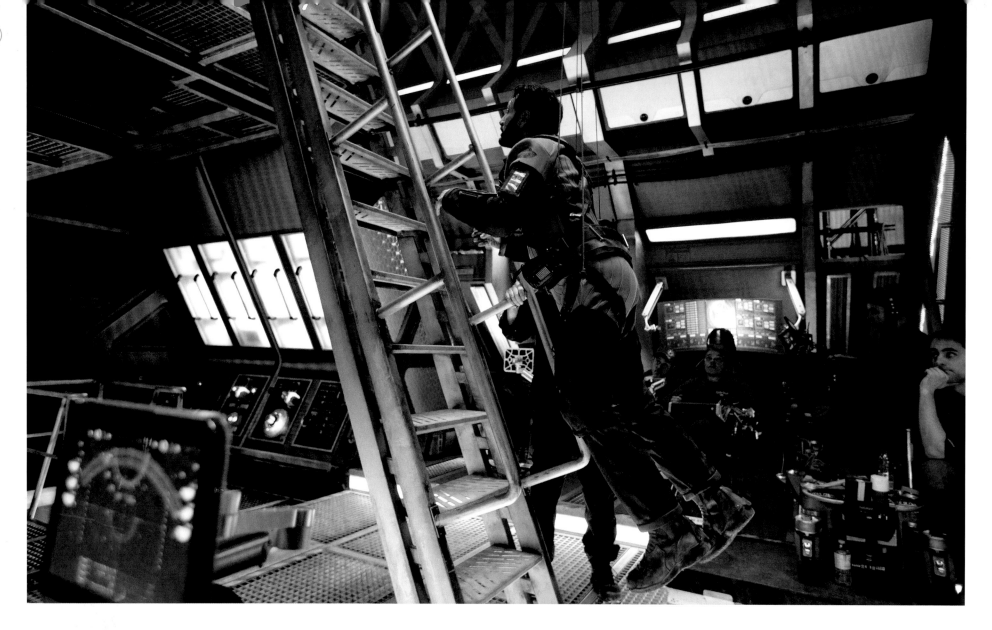

ABOVE AND BELOW: Filming on the *Rocinante* sets. Wire work was used extensively for the many zero-g scenes when the ship was not creating 'artificial' gravity via constant forward thrust.

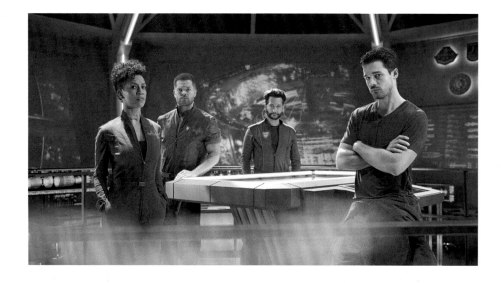

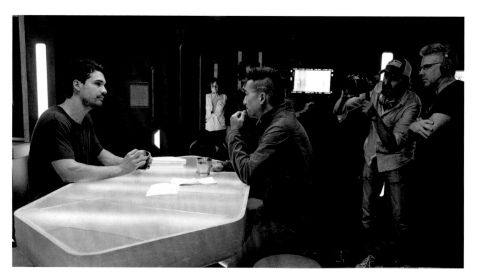

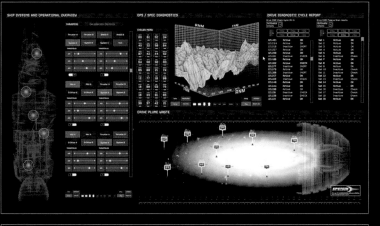

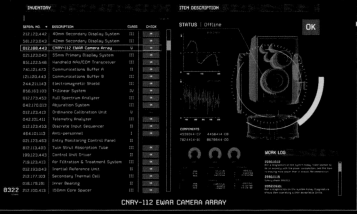

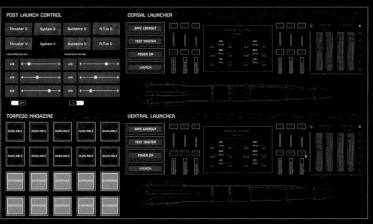

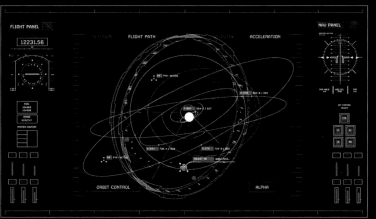

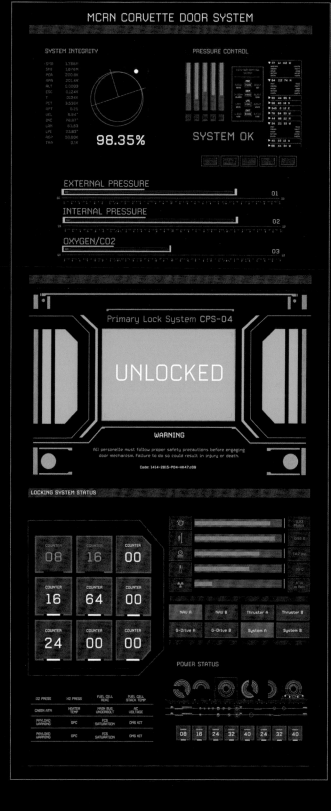

ABOVE: Some of the screen displays created for the *Rocinante*, including drive plume waste, equipment status, torpedo controls and door systems.

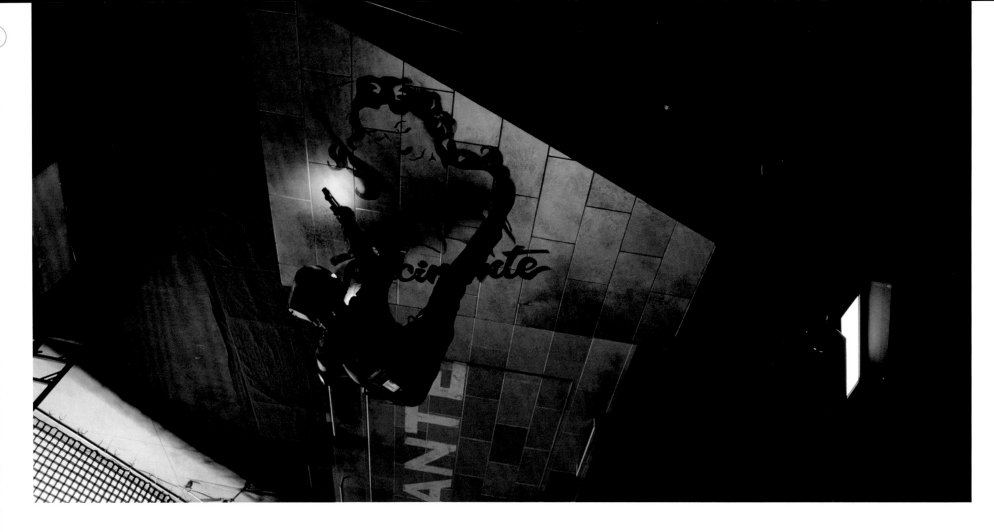

"The challenge was to build a set that technically allowed for zero-g scenes to be staged, with the film crew able to work quickly during the shoot days, as well as facilitating the multiple non-traditional camera angles that science-fiction shows often employ. We needed to give a sense of the stacked architecture of a vertical spacecraft. Of course, we couldn't build a 60ft-high set, so the rest of the *Roci* decks are all single-level and clustered around the flight deck on the same soundstage."

Robert Valeriote, construction coordinator ↘

ABOVE: Having learned that Earth and Mars are now at war with each other, Amos (Wes Chatham) erases the *Roci*'s name and logo as the crew prepares to go incognito.
BELOW: More *Rocinante* set photos.

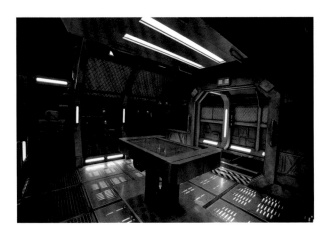
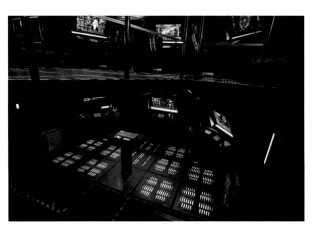
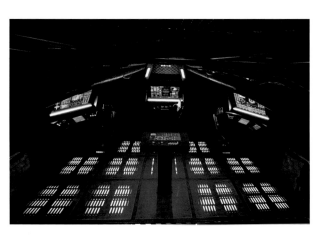

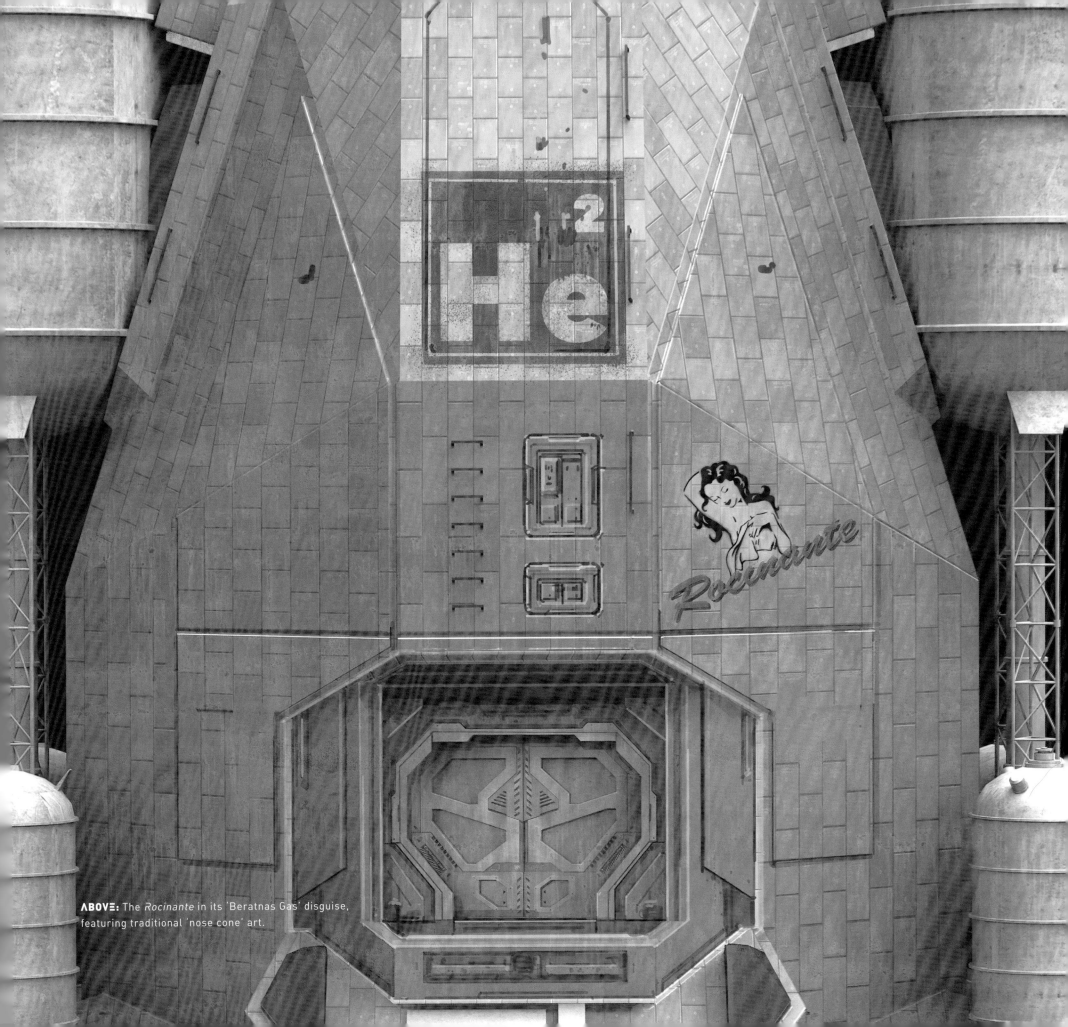

He ²

Rocinante

ABOVE: The *Rocinante* in its 'Beratnas Gas' disguise, featuring traditional 'nose cone' art.

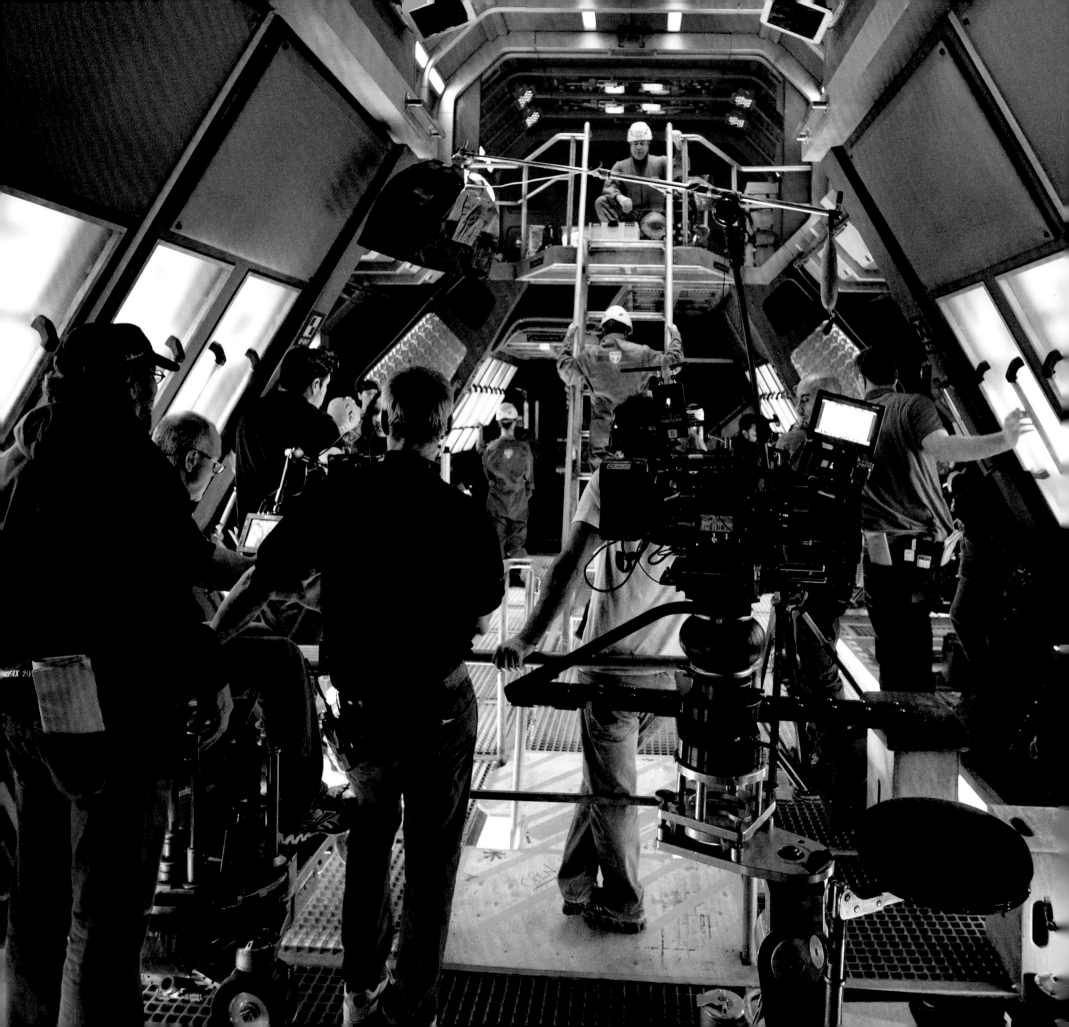

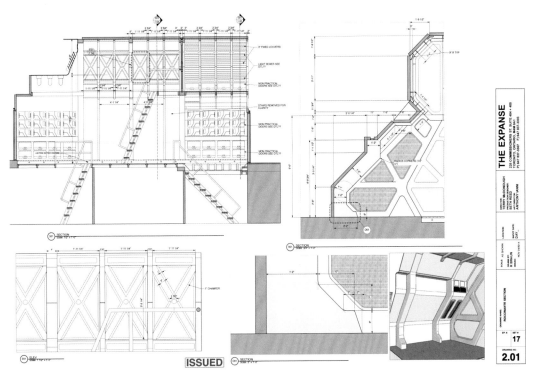

THE EXPANSE

228 COMMISSIONERS ST. SUITE 404 + 405
TORONTO, ONTARIO, M4M 0A1
Ph 647 427 1007 · Fl 647 427 0093

EP #: **17**

DRAWING NO.: **2.01**

ISSUED

"The upper section of the *Roci* was built as a single tall set. In one continuous take we could shoot a character walking through the airlock, going up a ladder onto the ops deck, then up another ladder to the flight deck. The central portion of the ceiling is designed to open up, allowing us to use wires when we need to 'fly' a character in zero-g."

Naren Shankar, showrunner ↘

LEFT: Technical drawings of the *Roci*'s interiors.
FAR LEFT: Crew working in the sometimes cramped *Roci* set.
BELOW: Shooting publicity photos of the *Rocinante* crew.

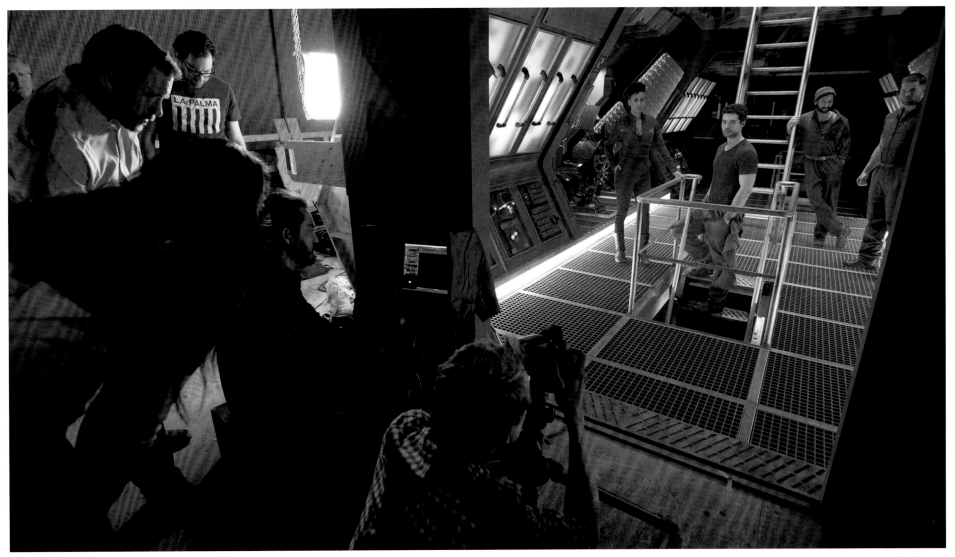

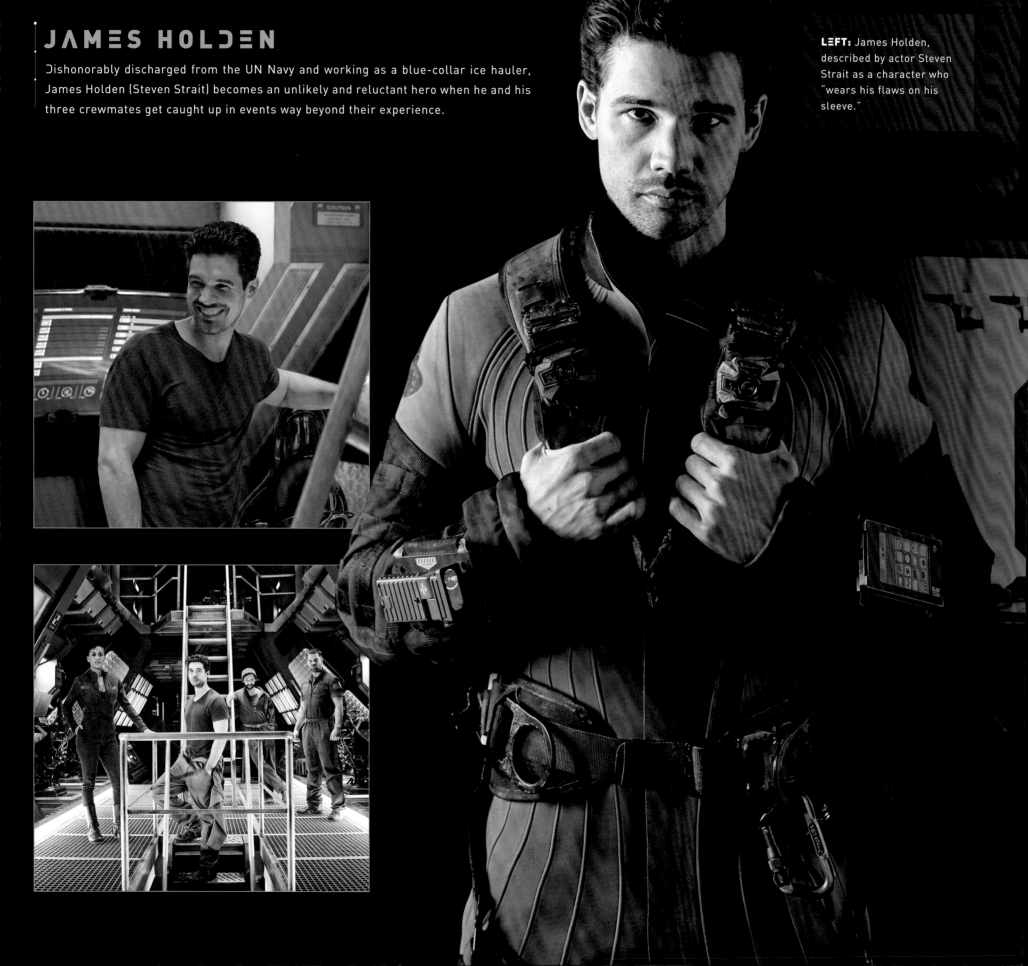

JAMES HOLDEN

Dishonorably discharged from the UN Navy and working as a blue-collar ice hauler, James Holden (Steven Strait) becomes an unlikely and reluctant hero when he and his three crewmates get caught up in events way beyond their experience.

LEFT: James Holden, described by actor Steven Strait as a character who "wears his flaws on his sleeve."

"I wanted to be sure to show how difficult it is for Holden becoming a competent, passionate leader. You see him struggle and stumble and hurt. I didn't want it to be a clean trajectory, from him being a kind of slacker on the *Canterbury* to becoming this up-front, forthright hero. It's hard for him to get there."

Steven Strait ↘

NAOMI NAGATA

Naomi (Dominique Tipper) is the *Rocinante*'s XO, chief engineer, and conscience. Growing up poor in the Belt, she has experienced first-hand both the discrimination of the inner planets and the violence of the militant branches of the OPA.

"I think for Naomi, she's very much a 'fixer': she freaks out if there's not something for her to fix. I don't think she's very good at fixing people... but when it comes to the *Roci* crew, they're like her family, so I think, if anyone, she's probably the first to fix them."

Dominique Tipper ↘

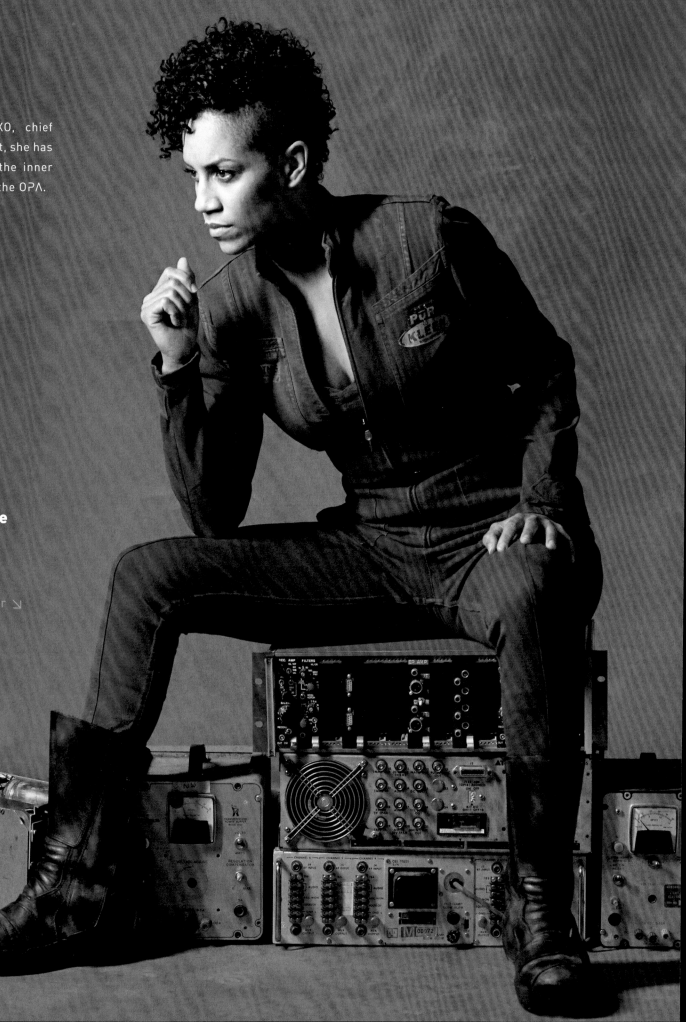

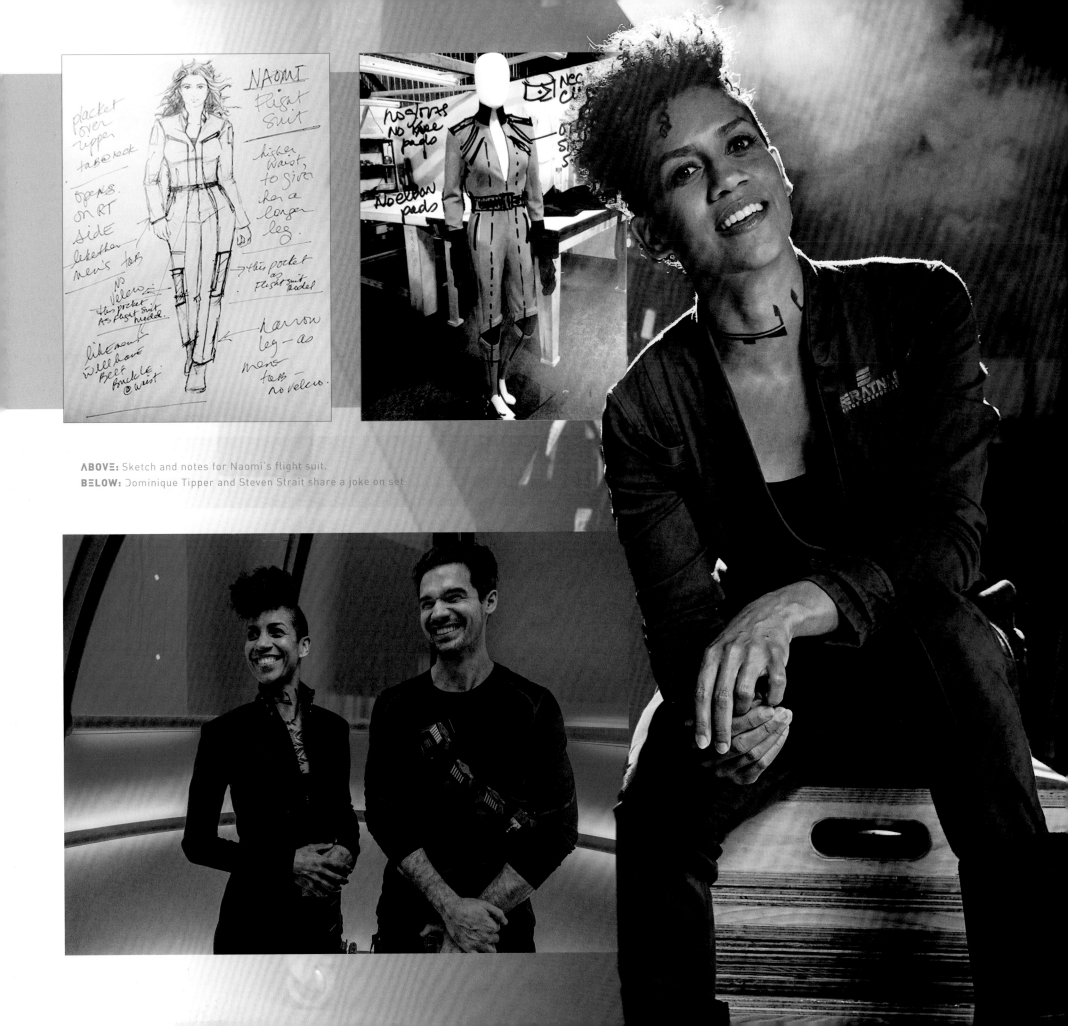

ABOVE: Sketch and notes for Naomi's flight suit.
BELOW: Dominique Tipper and Steven Strait share a joke on set.

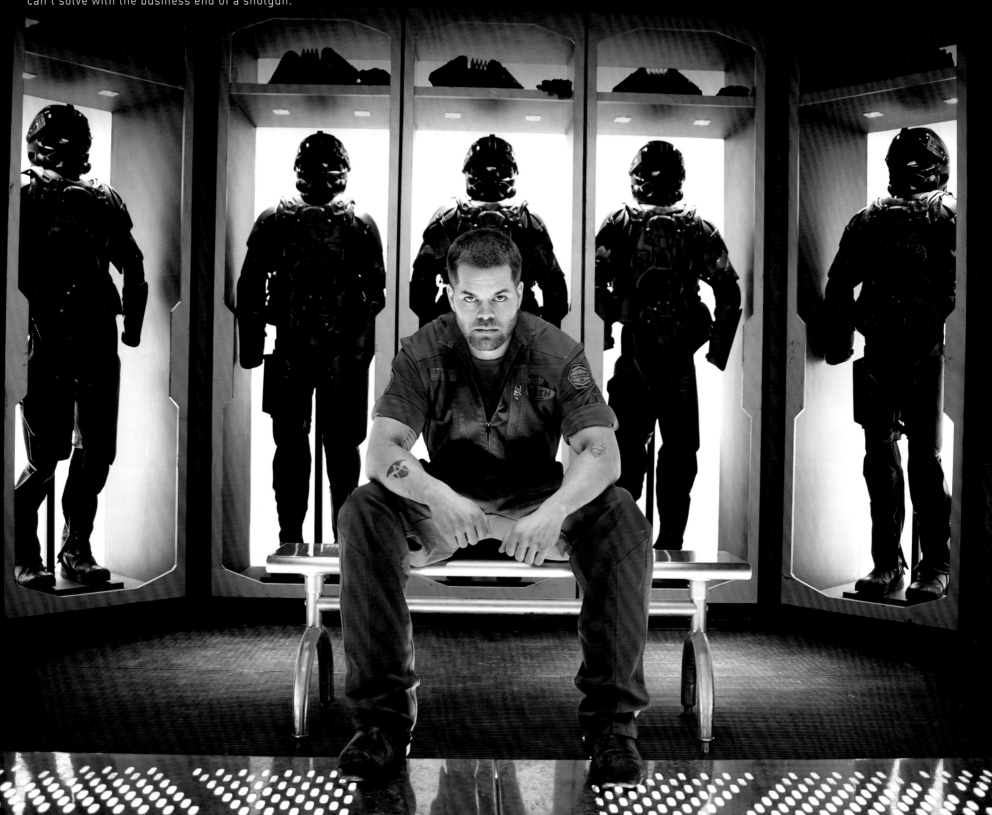

AMOS BURTON

Amos (Wes Chatham) grew up in the slums of Baltimore, where life is primarily harsh, brutal, and short. On board the *Roci* he serves as the ship's mechanic and, when necessary, its 'muscle.' With a pragmatic approach to life, Amos lets his crewmates deal with any ethical issues that he can't solve with the business end of a shotgun.

"What really drew me to Amos at the beginning was that he doesn't have an ego in that way. He doesn't see himself as a tough guy, he sees himself as somebody that is ultimately a survivor first. He's very tribal with the people that are close to him, and when there is a threat he systematically takes care of that threat. It all stems from him having had to survive in a very hostile environment."

Wes Chatham ↘

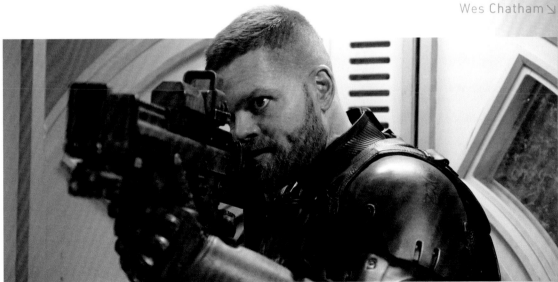

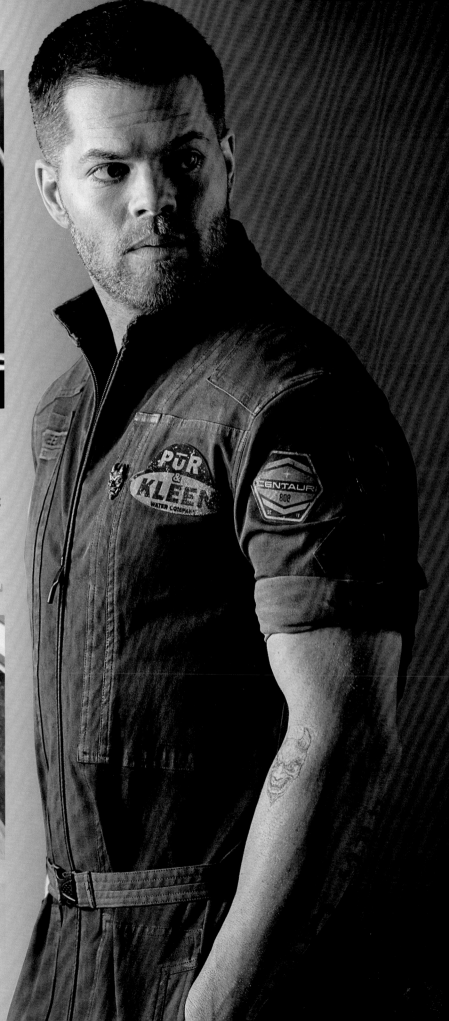

ABOVE: No stranger to violence, Amos prepares to resolve a particularly tense situation at the Protogen facility on Io.

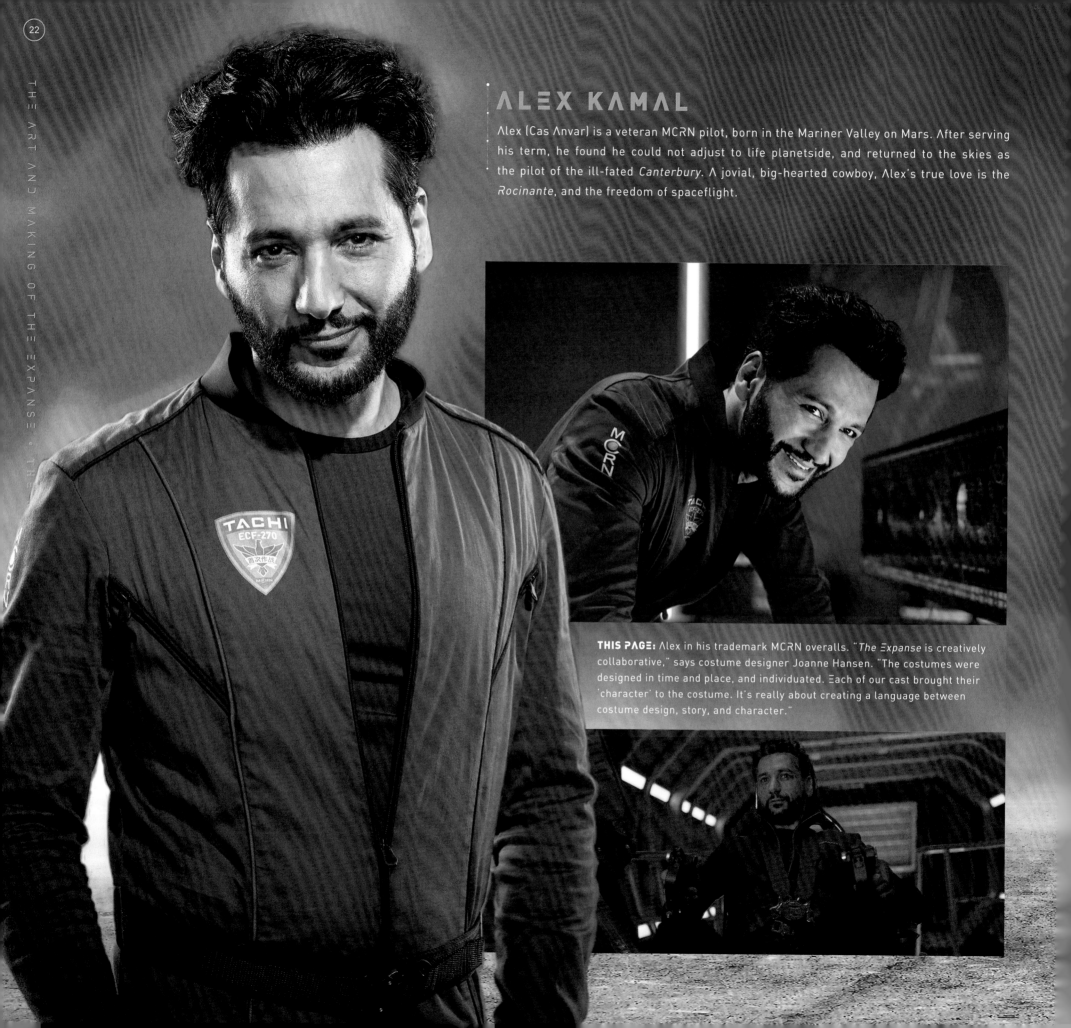

ALEX KAMAL

Alex (Cas Anvar) is a veteran MCRN pilot, born in the Mariner Valley on Mars. After serving his term, he found he could not adjust to life planetside, and returned to the skies as the pilot of the ill-fated *Canterbury*. A jovial, big-hearted cowboy, Alex's true love is the *Rocinante*, and the freedom of spaceflight.

THIS PAGE: Alex in his trademark MCRN overalls. "*The Expanse* is creatively collaborative," says costume designer Joanne Hansen. "The costumes were designed in time and place, and individuated. Each of our cast brought their 'character' to the costume. It's really about creating a language between costume design, story, and character."

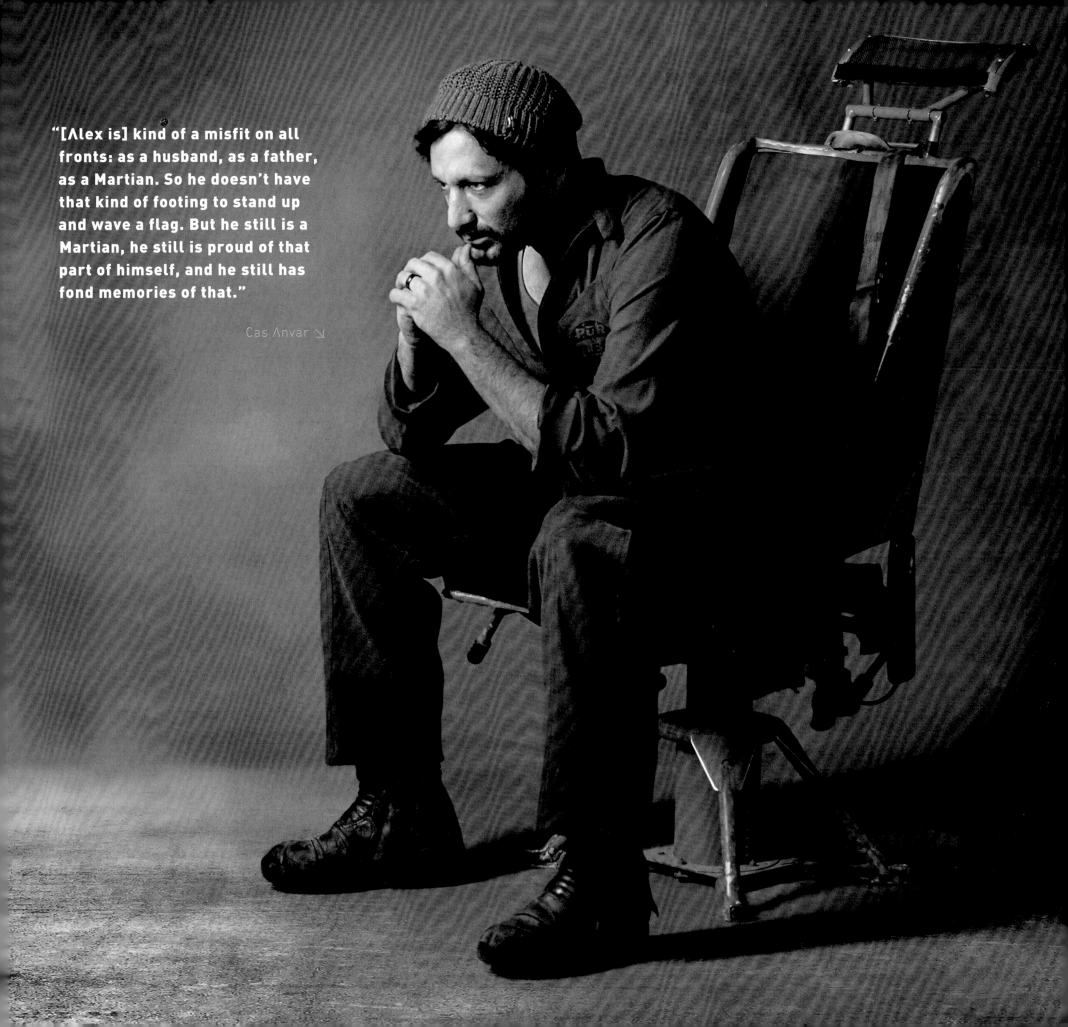

"[Alex is] kind of a misfit on all fronts: as a husband, as a father, as a Martian. So he doesn't have that kind of footing to stand up and wave a flag. But he still is a Martian, he still is proud of that part of himself, and he still has fond memories of that."

Cas Anvar ↘

UNITED NATIONS

Naren Shankar: "In *The Expanse*, Earth under the UN is a still powerful, though fading, empire. There are visual nods to history wherever you look: structural additions to the UN building, the Resolute Desk in Avasarala's office, elements of traditional military uniforms in the UNN. On Earth we try to showcase the natural environment as much as possible—it's the strongest contrast to the lifeless void of space."

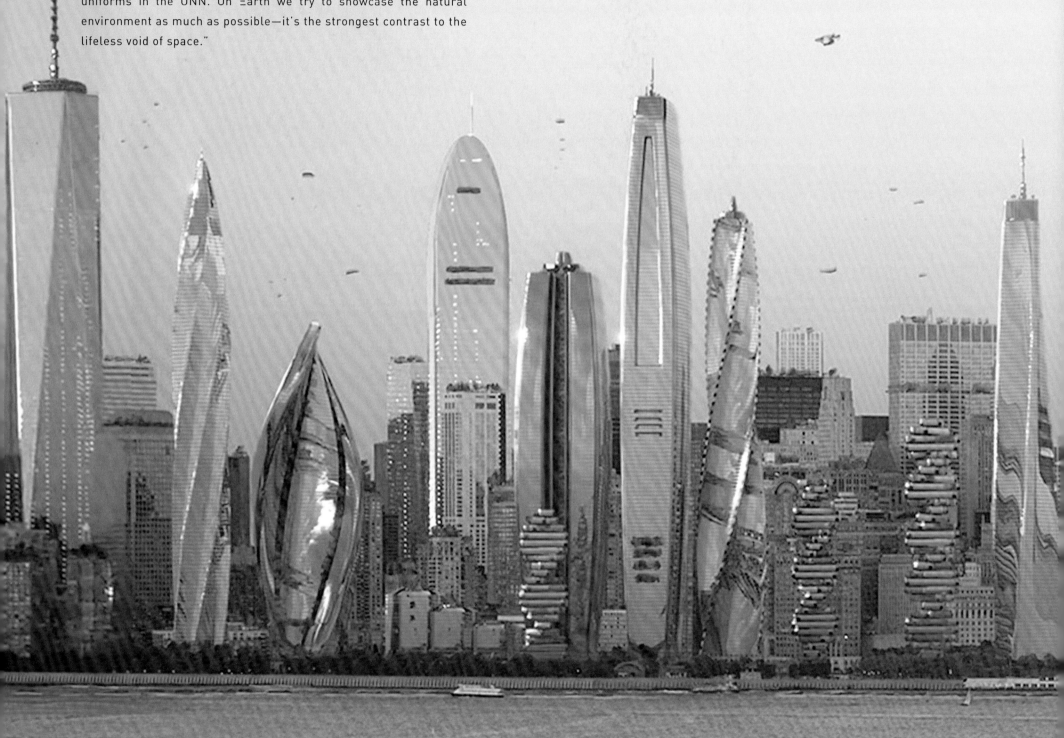

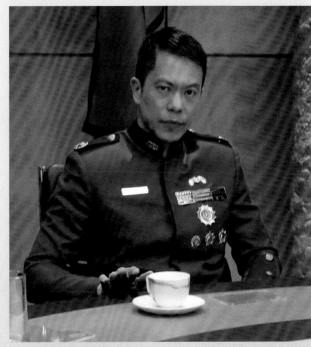

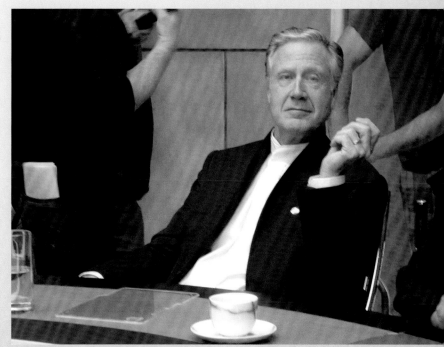

RIGHT: The warmongering of Admiral Augusto Nguyen (Byron Mann), and the more cautious diplomacy of Secretary-General Esteban Sorrento-Gillis (Jonathan Whittaker), often clash in UN meetings.

BELOW: Concept art of New York's 'futuristic' skyline, with drones filling the sky and new skyscrapers crowding the older, iconic buildings.

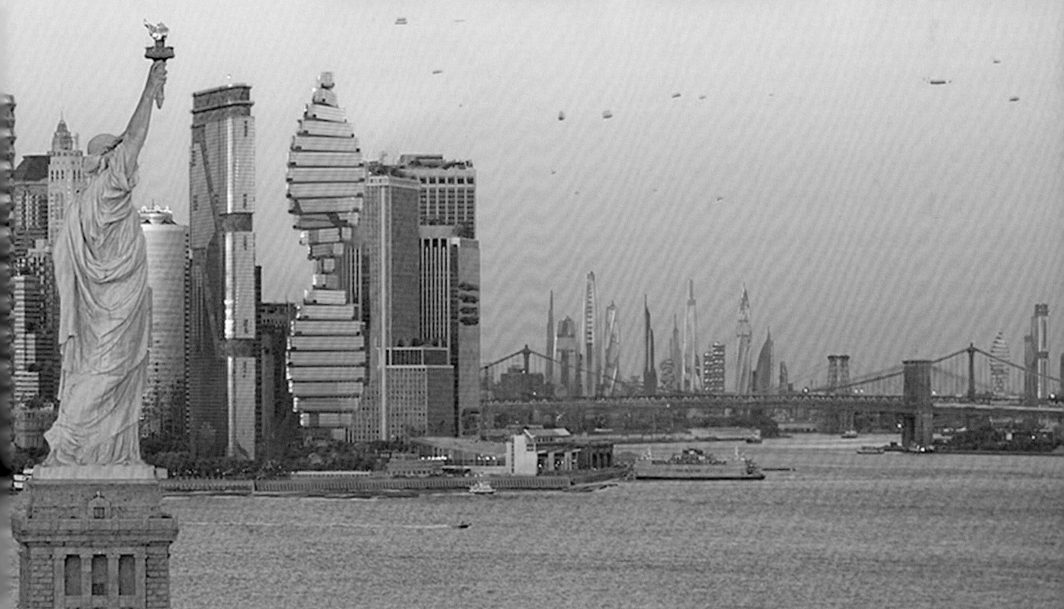

CHRISJEN AVASARALA

Few public servants have commanded the fearsome reputation of Chrisjen Avasarala (Shohreh Aghdashloo). As Deputy Undersecretary of the UN, Avasarala is a master of realpolitik, a consummate chess master always a step ahead of her political rivals. She works tirelessly for the betterment of humanity, with the survival and safety of Earth always her top priority.

"All of Avasarala's costumes are designed and built in our studio—'Avasarala's closet' holds upwards of 150 costumes. We source fabrics and elements throughout the world to build the unique foundation of the character, a great leader of the future, with deep roots in the past, [and] influences from many historical periods and cultures."

Joanne Hansen, costume designer

RIGHT: Shohreh Aghdashloo as Chrisjen Avasarala. She describes the challenges her character faces in the show: "Who is telling her the truth? Who is betraying her? She's wondering, trying to recruit her best friends to get out of this. She's a politician to the core."

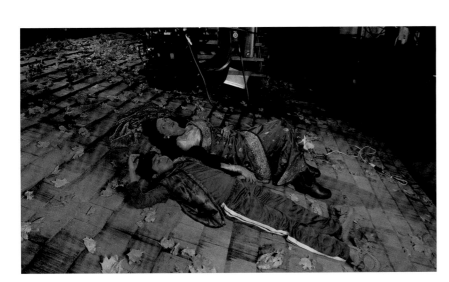

ABOVE AND RIGHT: Sketches and photos of some of Avasarala's many spectacular outfits.

BELOW: Shohreh Aghdashloo and Ty Franck share a moment on set.

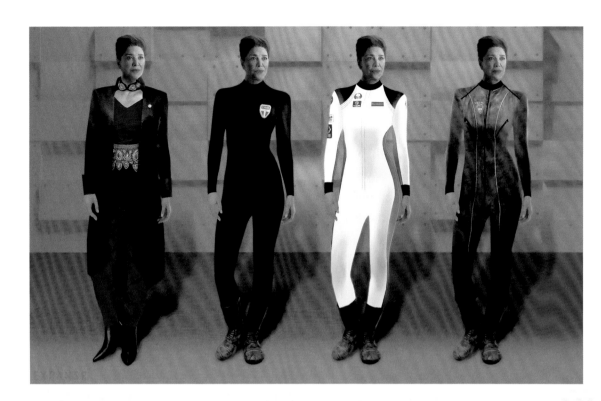

THIS PAGE: Avasarala's power dressing enhances her character's presence. As Shawn Doyle (Sadavir Errinwright) puts it: "It's like heavy lifting going on with that wardrobe. It's so intricate, those costumes. They're stunning."

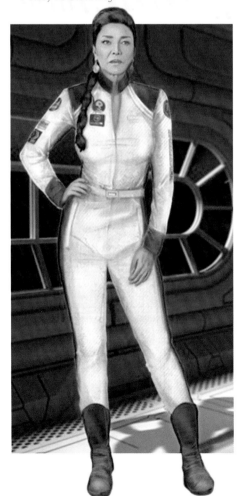

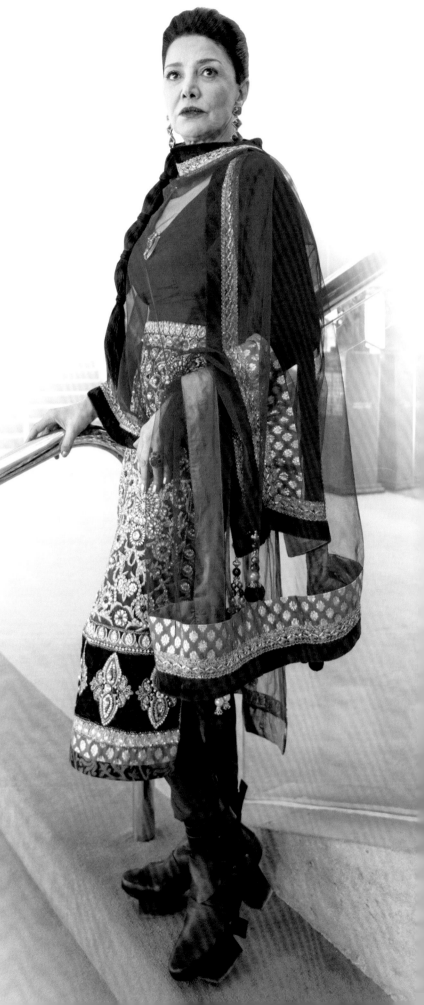

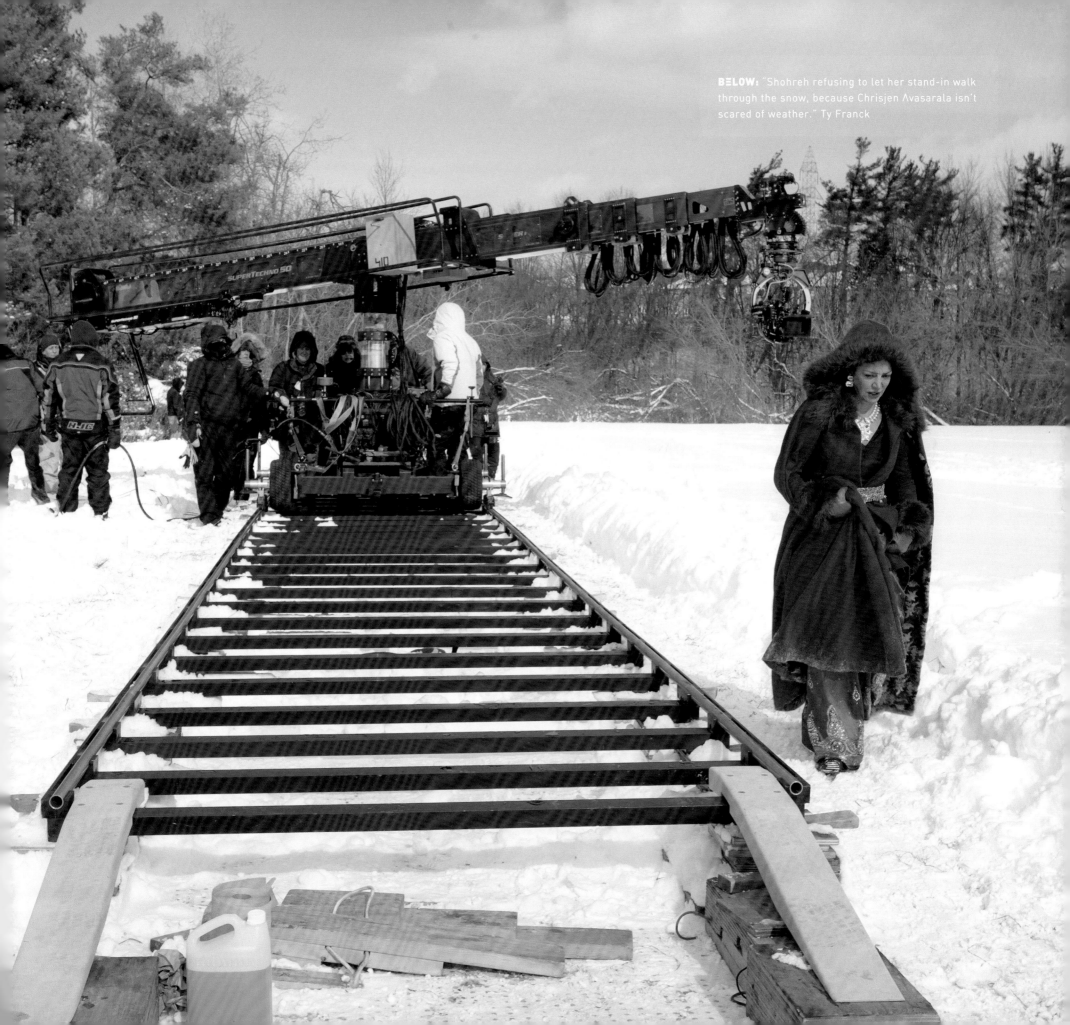

BELOW: "Shohreh refusing to let her stand-in walk through the snow, because Chrisjen Avasarala isn't scared of weather." Ty Franck

SADAVIR ERRINWRIGHT

Ever the consummate politician, UN Undersecretary Sadavir Errinwright (Shawn Doyle) is willing to dirty his hands in the name of protecting mankind's homeworld. Earth's continued supremacy is Errinwright's only priority; he believes that any action, including weaponizing the protomolecule, is justified.

"It's not important for me to determine whether my character is a villain or not, or if he's bad or good. All I can really do is try to be present in those moments, try to understand what the hell I'm talking about, try to get what I need out of another character in a scene. The way I approach that with this guy is his vulnerabilities, his fears about being in over his head."

Shawn Doyle

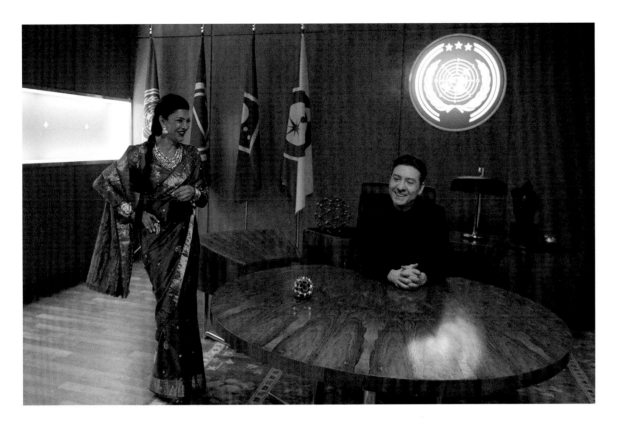

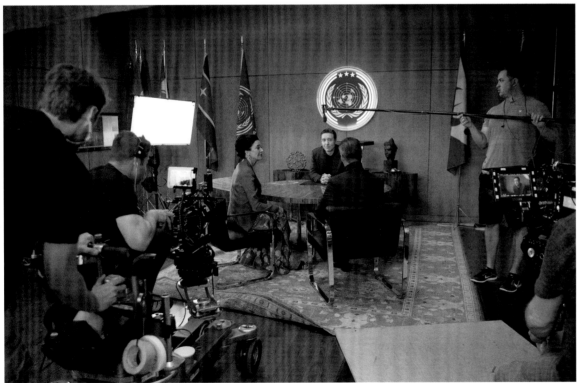

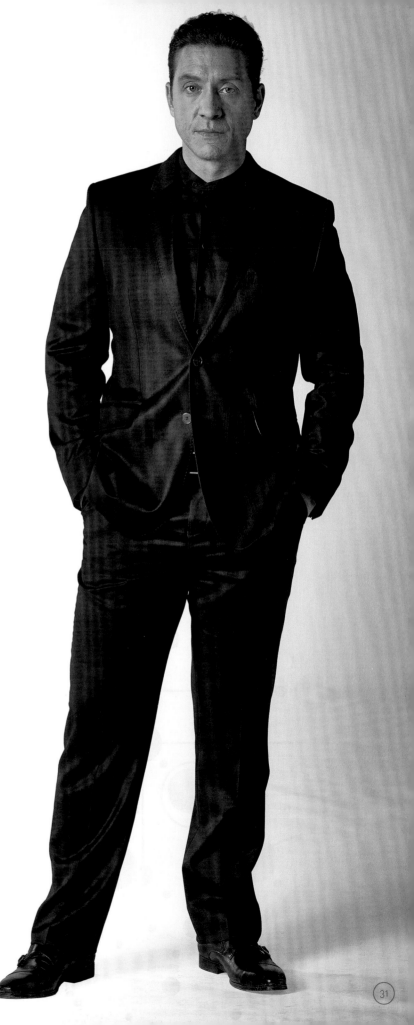

ABOVE: Shawn Doyle and Shohreh Aghdashloo shoot scenes in Errinwright's office.
RIGHT: Shawn Doyle as Sadavir Errinwright. "He has a fantastic poker face," says executive producer Daniel Abraham, "but you sense that there's a lot going on behind it."

LEFT AND ABOVE:
Concept art of one of the UNN's Leonidas-class escort ships.

UN NAVY AND MILITARY

The UN Navy is a reminder of the power of Earth—it is the largest fleet in the system, and the most powerful. However, Martian technology threatens to soon outstrip it. Still, the presence of a UNN Dreadnought is enough to make even the most hardened OPA pirate think twice.

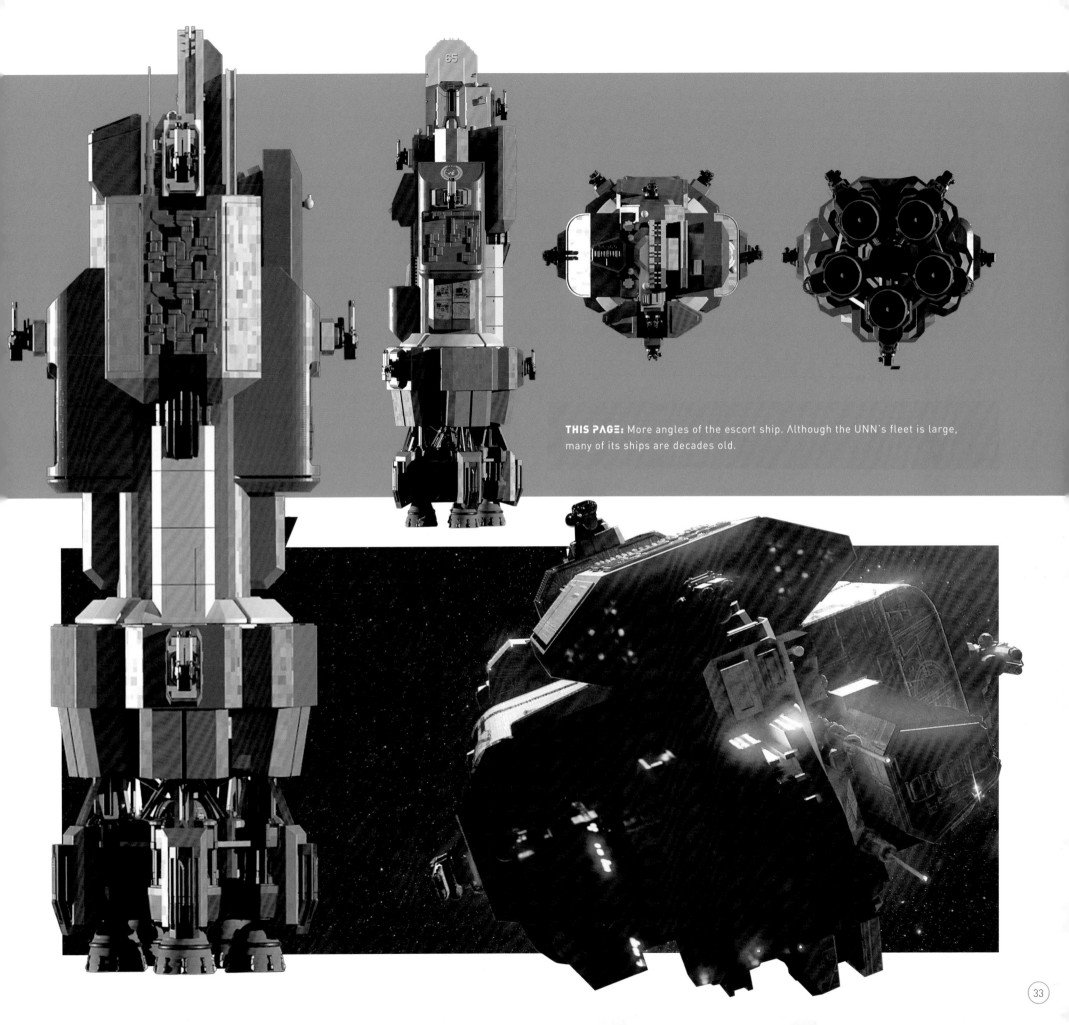

THIS PAGE: More angles of the escort ship. Although the UNN's fleet is large, many of its ships are decades old.

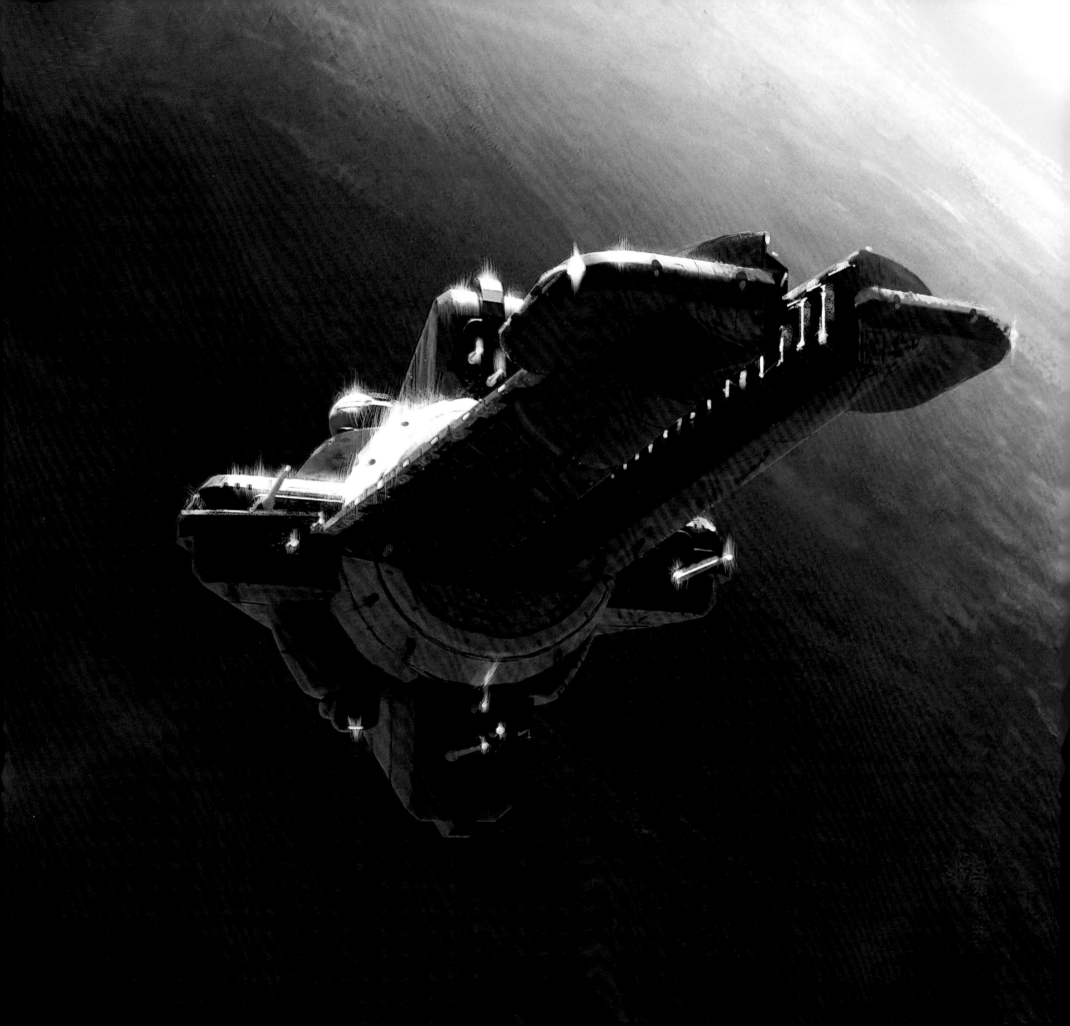

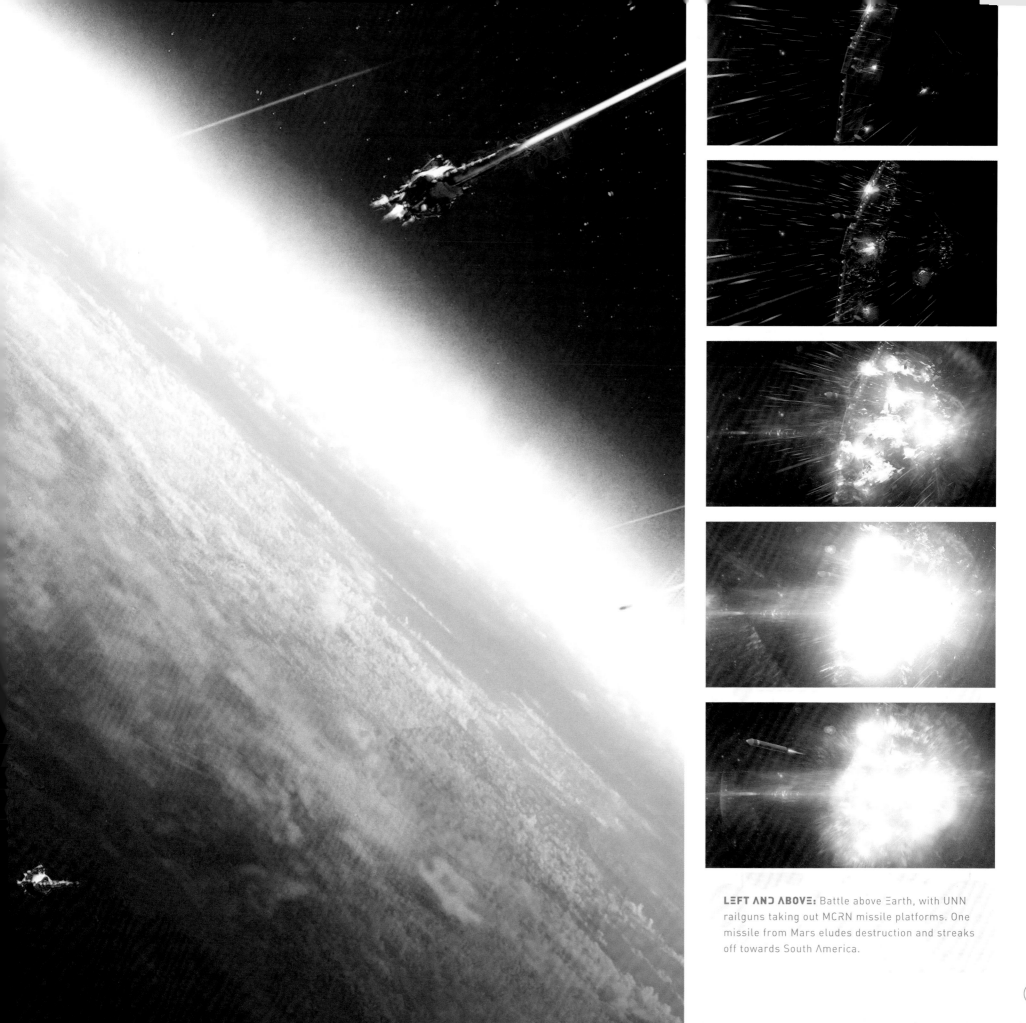

LEFT AND ABOVE: Battle above Earth, with UNN railguns taking out MCRN missile platforms. One missile from Mars eludes destruction and streaks off towards South America.

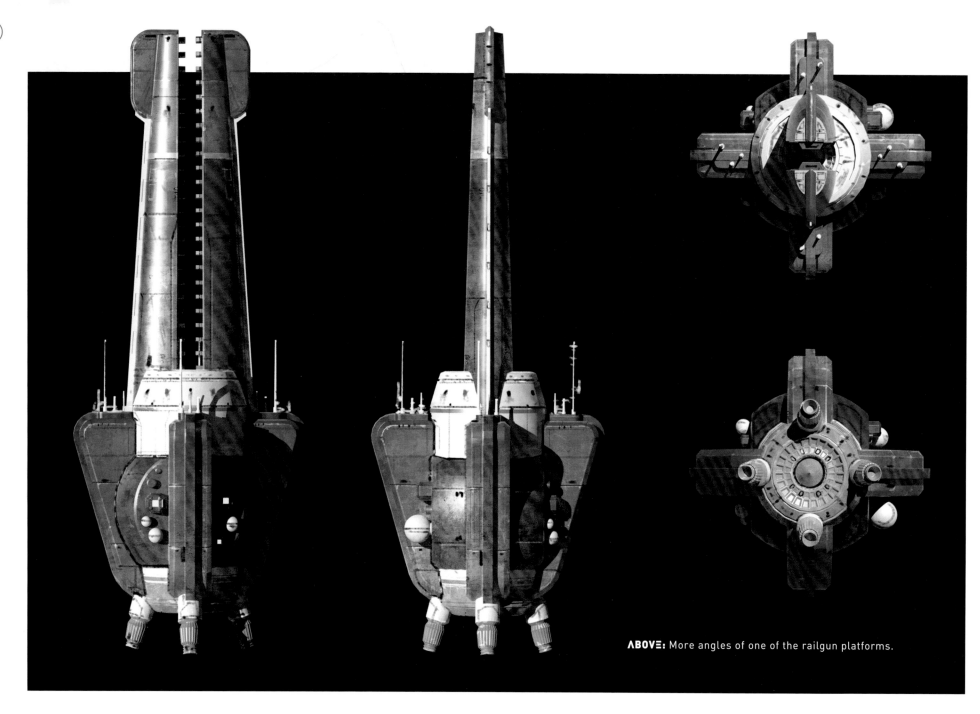

ABOVE: More angles of one of the railgun platforms.

BELOW: Railgun platform firing sequence.

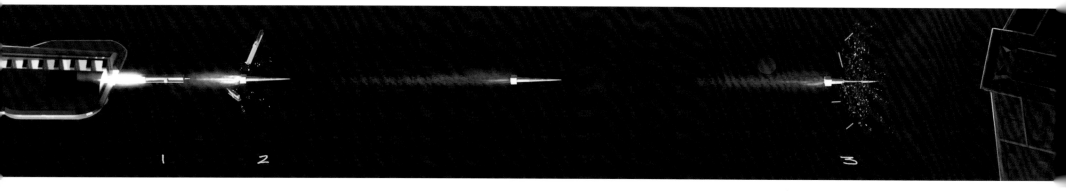

1 2 3

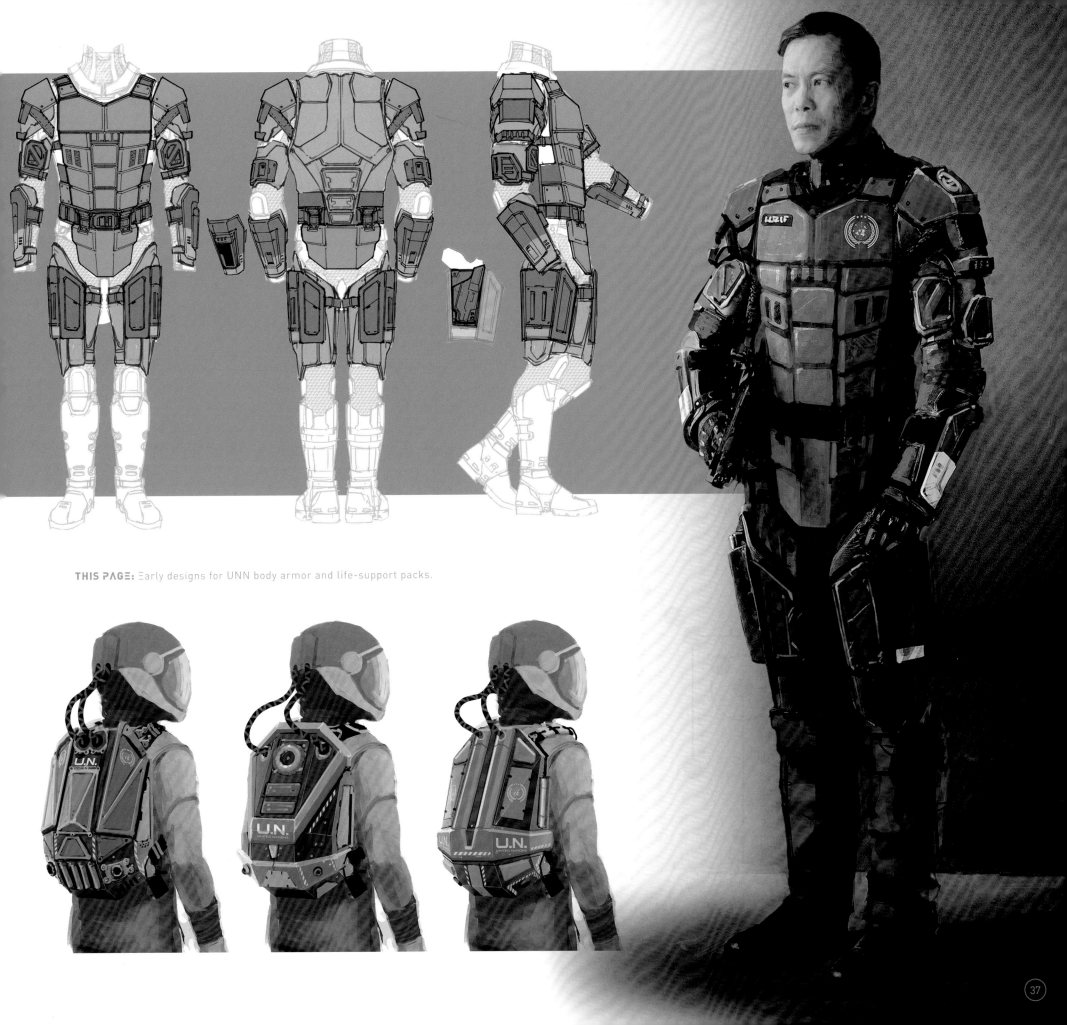

THIS PAGE: Early designs for UNN body armor and life-support packs.

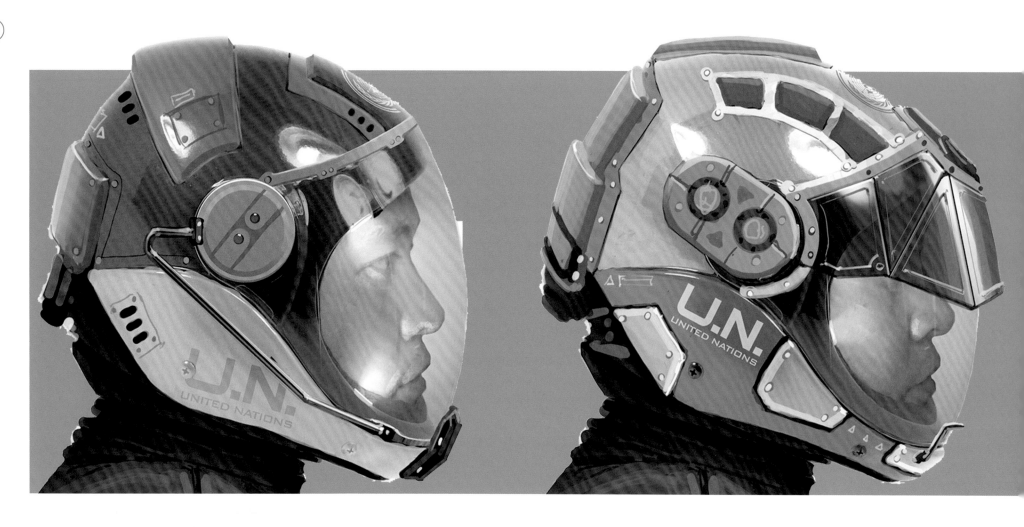

ABOVE: Various UNN helmet designs, with a final prop helmet at far right.

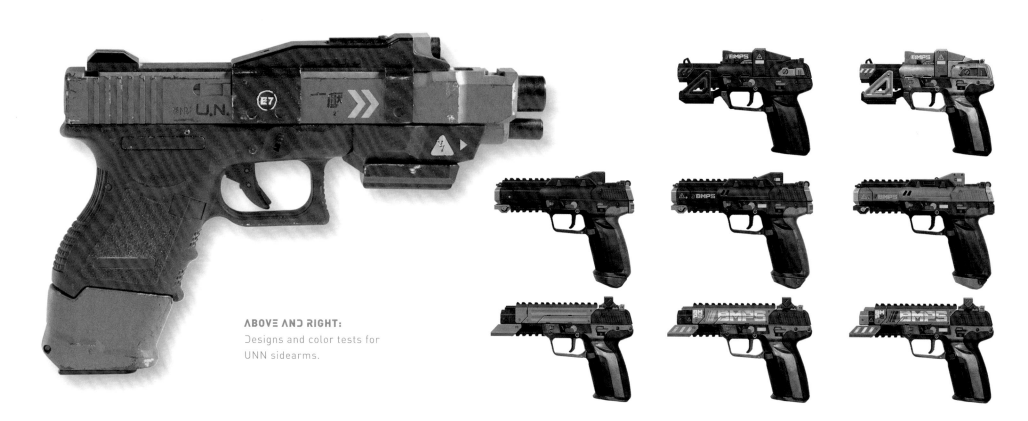

ABOVE AND RIGHT: Designs and color tests for UNN sidearms.

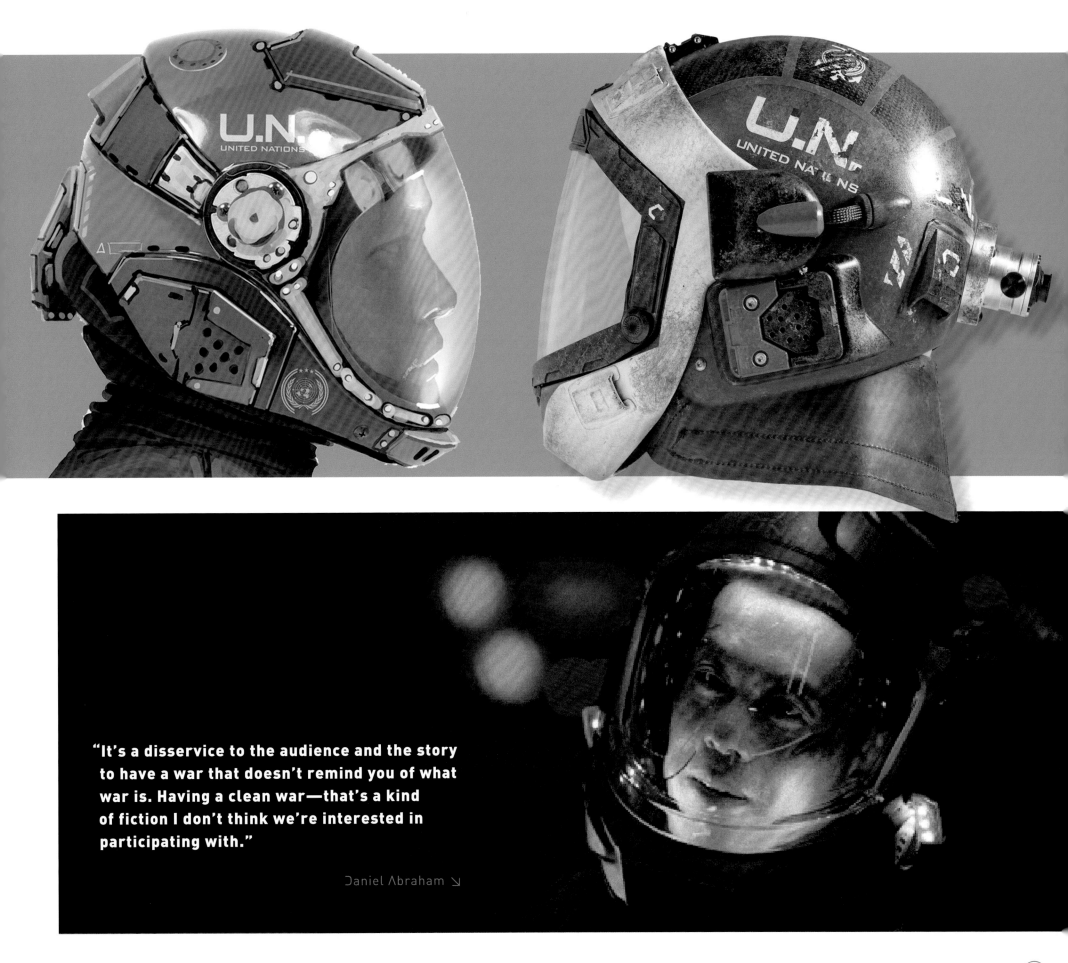

"It's a disservice to the audience and the story to have a war that doesn't remind you of what war is. Having a clean war—that's a kind of fiction I don't think we're interested in participating with."

Daniel Abraham ⅃

A

B

C

D

E

ABOVE: Sketches of a UN helicopter.

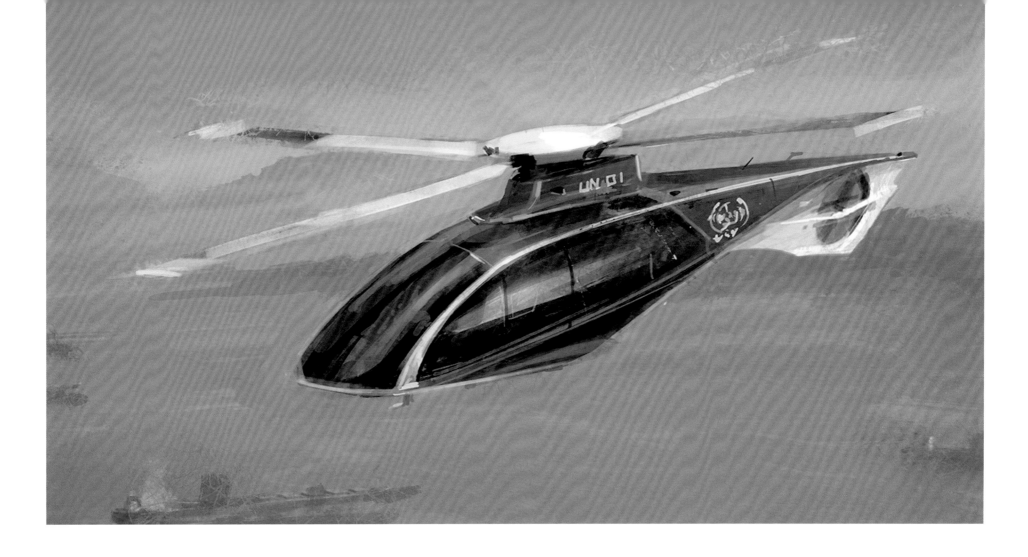

THIS PAGE: More concept art of UN helicopters.

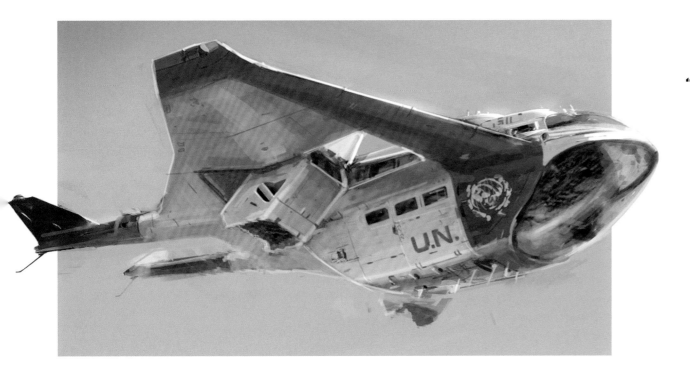

"The look of spaceships, helicopters, etcetera, was based on our research and best assessment at the time of how travel and flight would be accomplished in that setting. We wanted things to look interesting and 'cool.' Research and using real examples [provided] a great basis for achieving that. It was always our starting point."

Seth Reed, production designer ↘

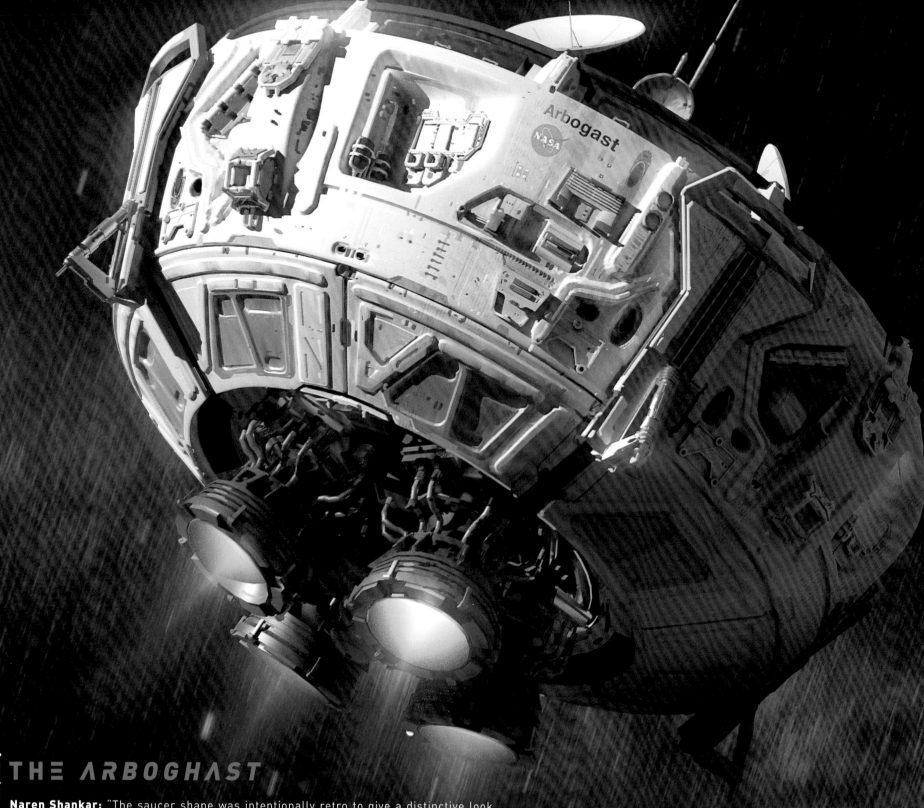

THE ARBOGHAST

Naren Shankar: "The saucer shape was intentionally retro to give a distinctive look to the civilian vessel... and a tip of the hat to the *Jupiter-2* from *Lost in Space*. The inflatable sail was inspired by a NASA probe concept. In the 'Caliban's War' episode, if you look closely when the ship is disassembled, you'll see my original whiteboard sketch of the design on one of the pieces (put there by VFX supervisor Bob Munroe)."

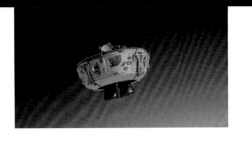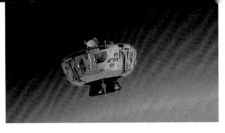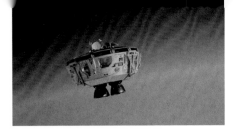
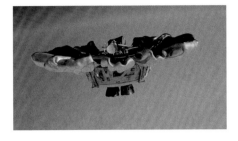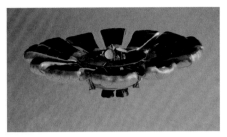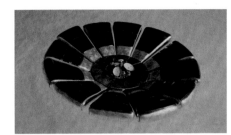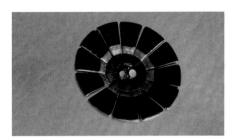

ΛBOVΞ: Sequence showing the *Arboghast* preparing for atmospheric entry.

BΞLOW: Set photographs of the *Arboghast*'s interior, showing 'alert' lighting (left) and normal lighting (right).

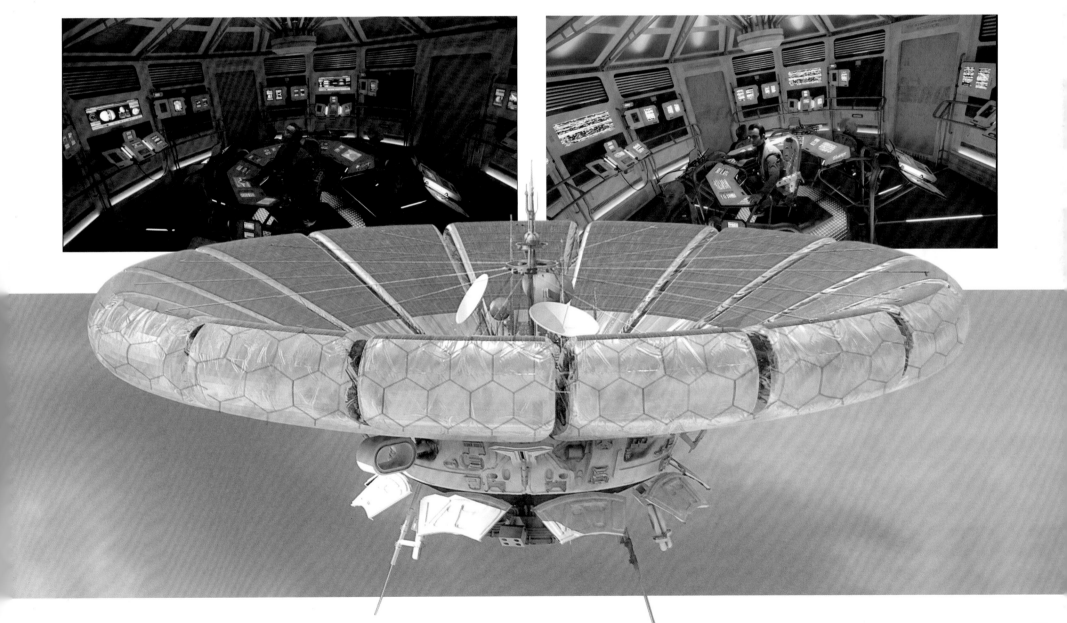

THE AGATHA KING

Naren Shankar: "The *Agatha King* was designed to evoke WW2 battleships and submarines, with a claustrophobic and 'cluttered' interior, and lots of physical buttons and switches (in a little nod to *Apollo*-era controls)."

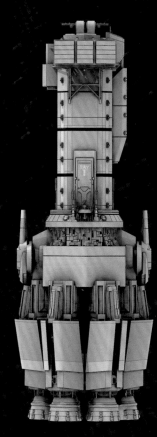

THIS PAGE: Views of the *Agatha King*, UNN dreadnought and scene of Admiral Souther's mutiny against Fleet Admiral Nguyen.

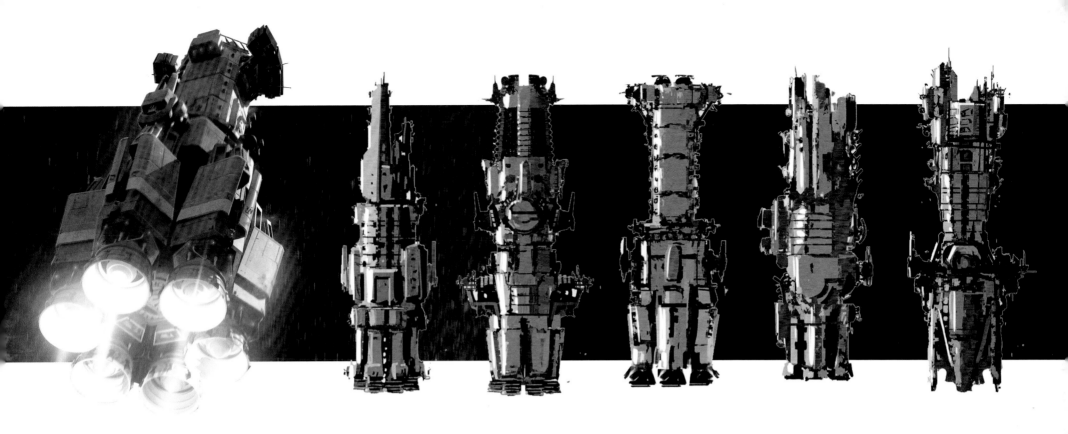

ΛBOVΞ: More design ideas for the *Λgatha King*.

"The *Λgatha King* looks very practical, and did take inspiration from contemporary naval design. This allows the audience to connect it to something familiar and earthbound. However, it was a very difficult build, taking us four months to complete. We were very proud that our working, see-thru elevator performed perfectly the first time!"

Robert Valeriote, construction coordinator ↘

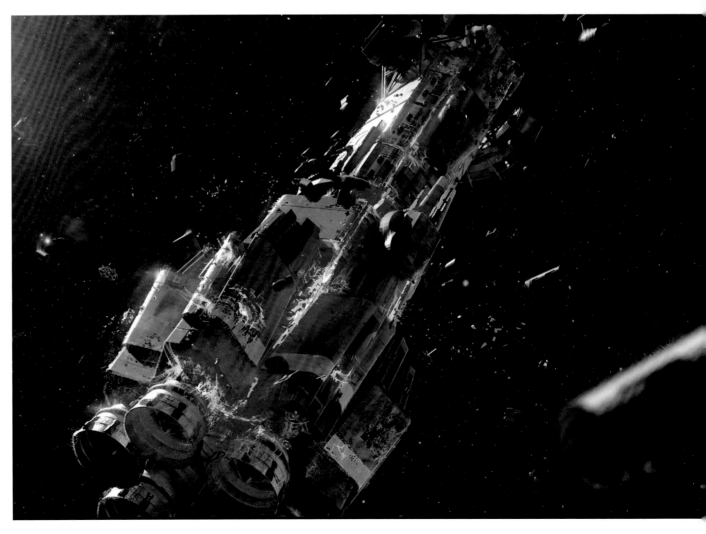

RIGHT: Concept art of the moment the *Λgatha King* becomes overwhelmed by the protomolecule.

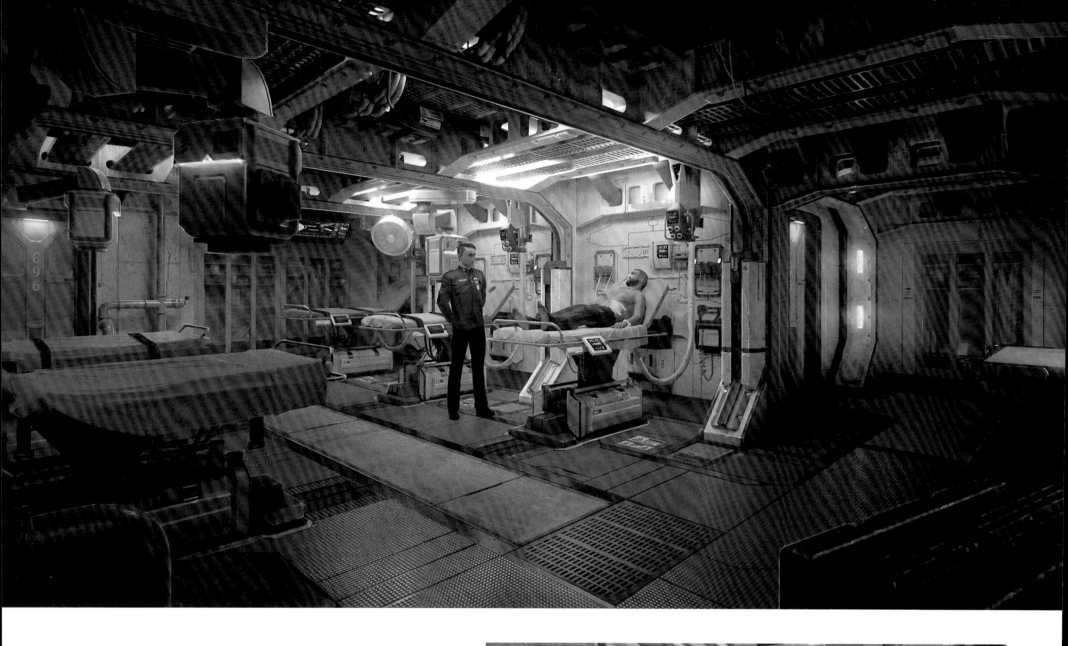

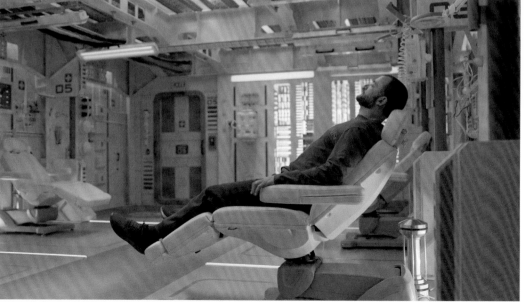

ΛBOVΞ: Concept art of the *Agatha King*'s state-of-the-art medical bay.

RIGHT: Cotyar Ghazi (Nick Ξ. Tarabay) recuperates in the medical bay following his rescue from the *Guanshiyin*'s dropship.

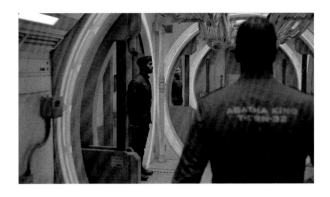

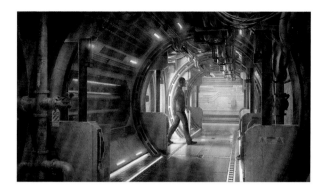

ABOVE: Photography and concept art of the *Agatha King*'s corridors, which are bare bones and functional, as befits a military vessel.

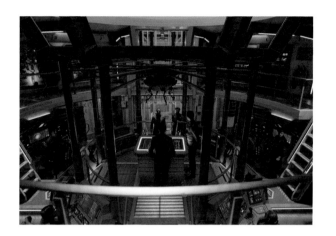

"We had some limited exterior views, and we definitely designed based on real Navy vessels. We wanted to show that the UN was slightly behind Mars in both technology and 'style,' opting for a more plain 'gray-ish' look, and with ship silhouettes that were more blocky, less refined."

Seth Reed, production designer ↘

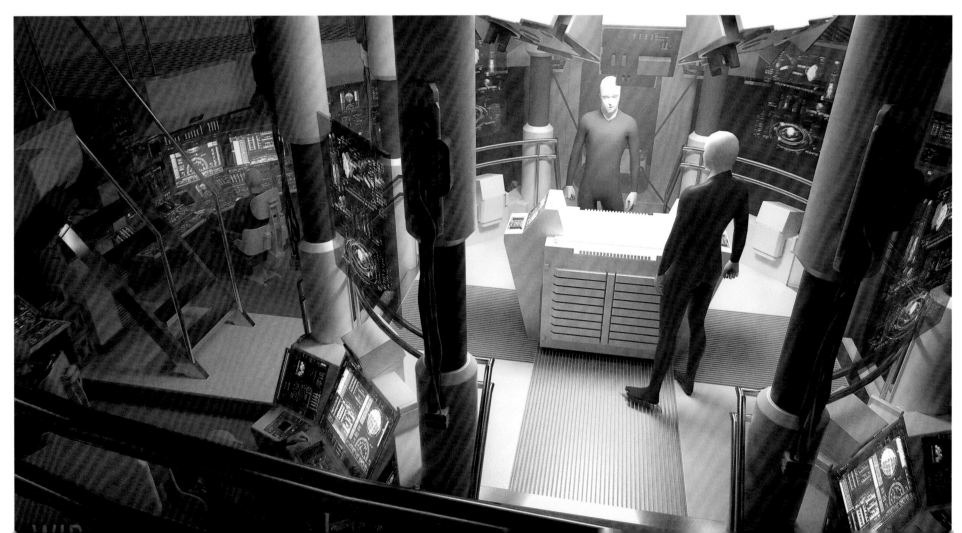

THE JONNAGER

At close to 500 meters long, the MCRN *Jonnager* dwarfs many UNN ships. As the first vessel to reach Holden and company's damaged *Knight* shuttle, the *Jonnager* is initially a prison to them, but it soon becomes their salvation in the form of the *Tachi* docked within it.

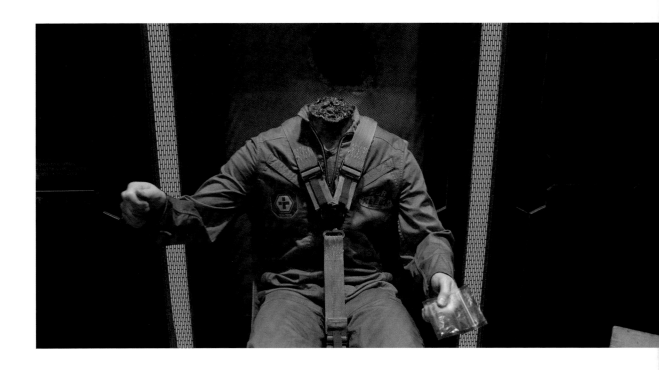

ABOVE: The incredibly lifelike cast of Shed Garvey's (Paul Costanzo) headless corpse provides one of the first season's most shocking, yet also darkly humorous moments.
BELOW: On a blue-screen stage, Steven Strait and Dominique Tipper film the scene where Holden and Naomi scramble aboard the *Tachi* in zero gravity.

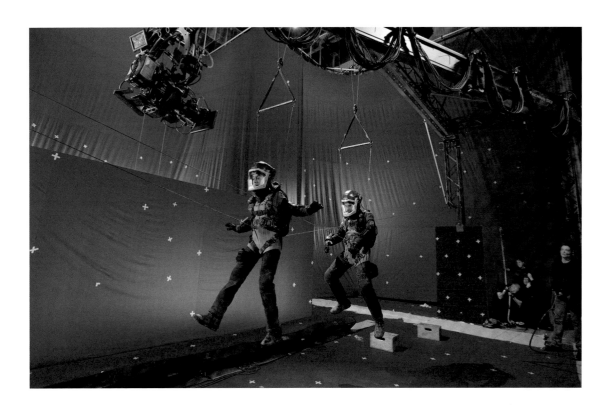

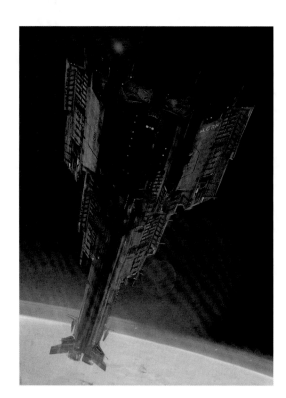

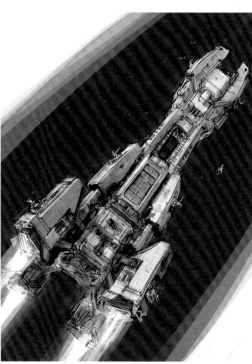

ABOVE: Early concepts of the *Donnager*.
RIGHT: Art showing the *Tachi* blasting its way out of the severely damaged *Donnager*.

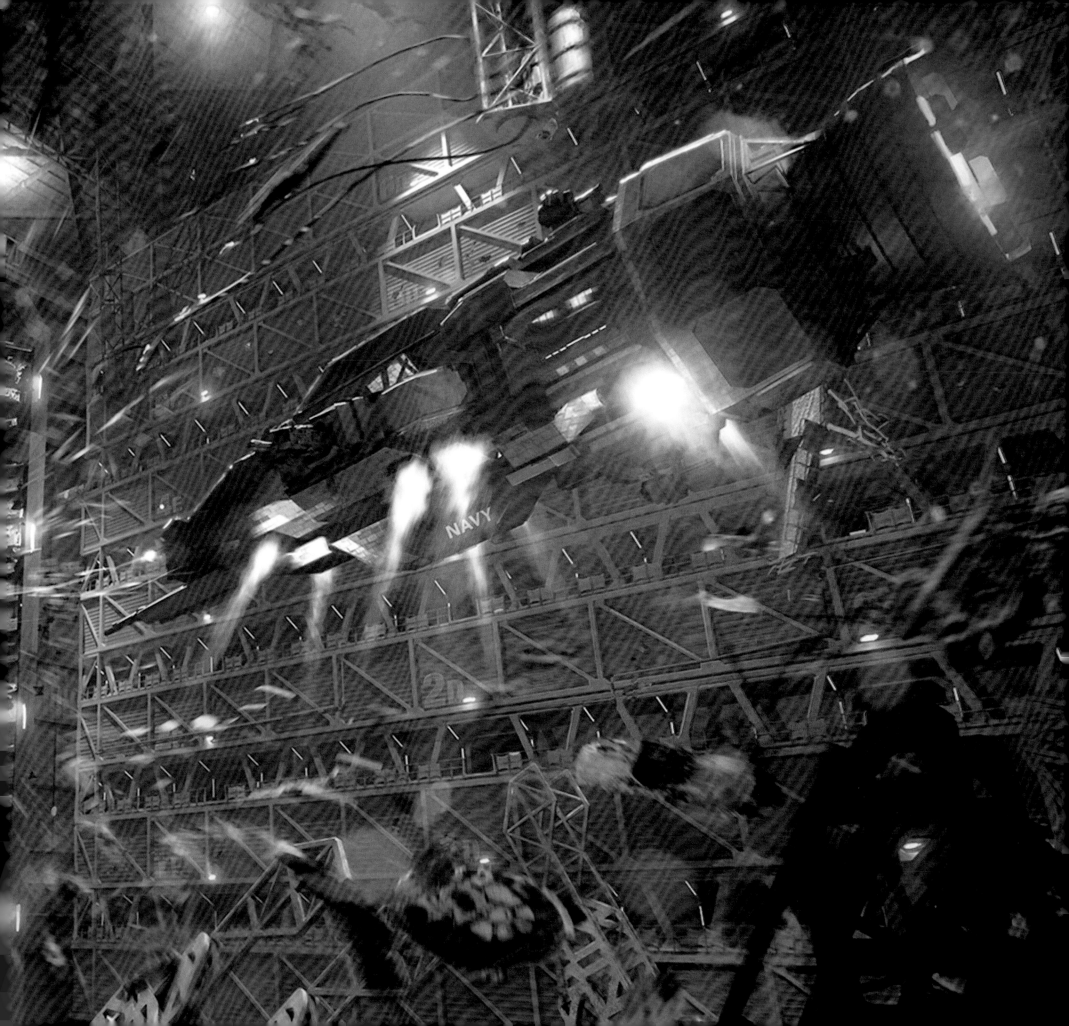

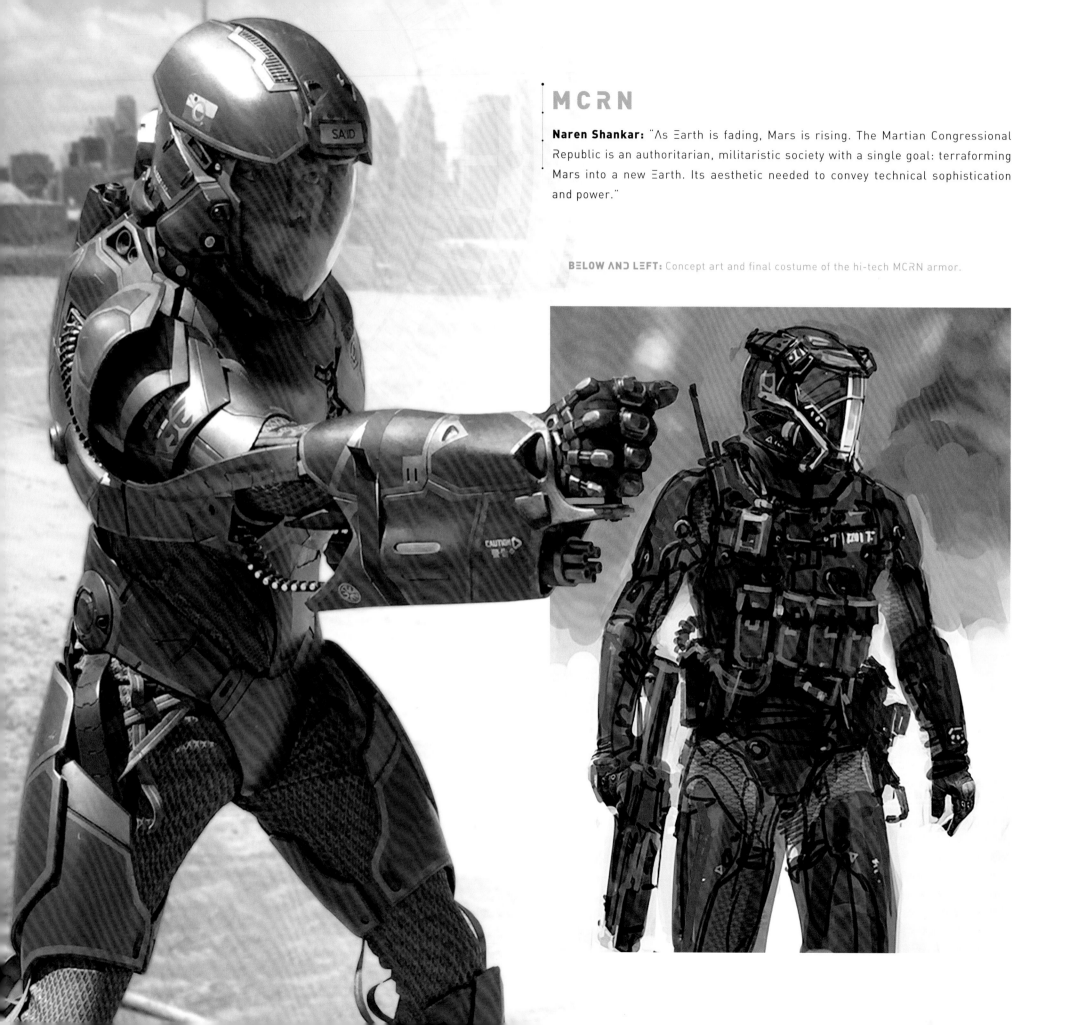

MCRN

Naren Shankar: "As Earth is fading, Mars is rising. The Martian Congressional Republic is an authoritarian, militaristic society with a single goal: terraforming Mars into a new Earth. Its aesthetic needed to convey technical sophistication and power."

BELOW AND LEFT: Concept art and final costume of the hi-tech MCRN armor.

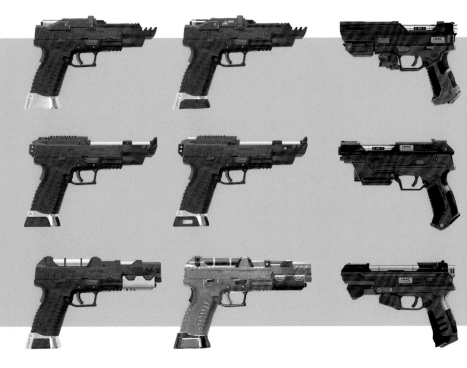

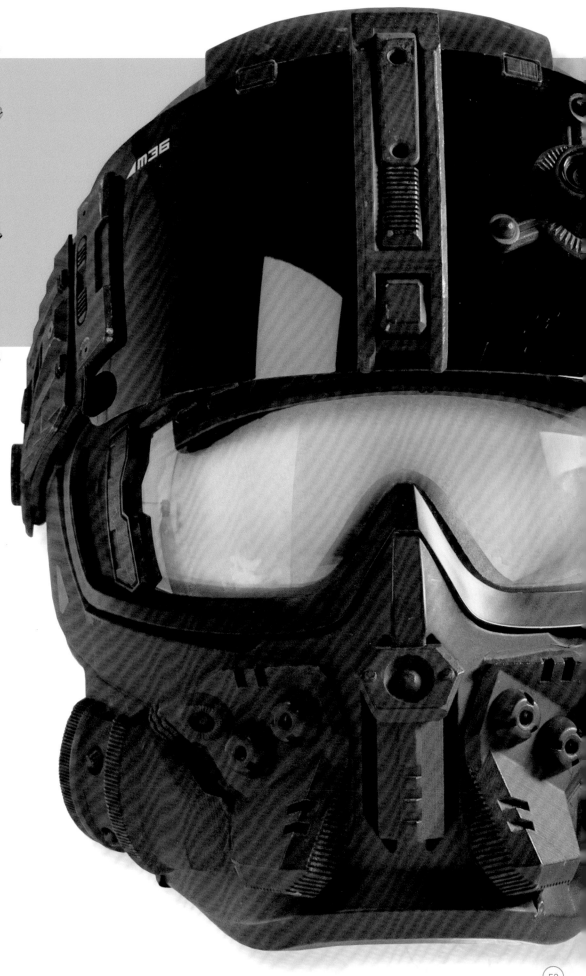

ABOVE: Ideas for MCRN handgun designs.
BOTTOM: Filming Bobbie and her squad on a blue-screen stage.

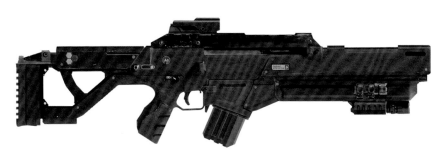

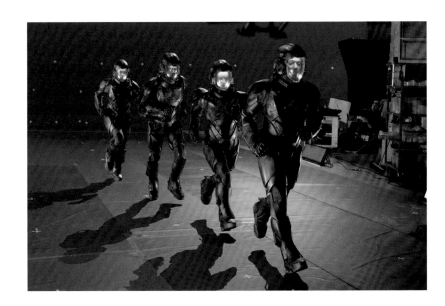

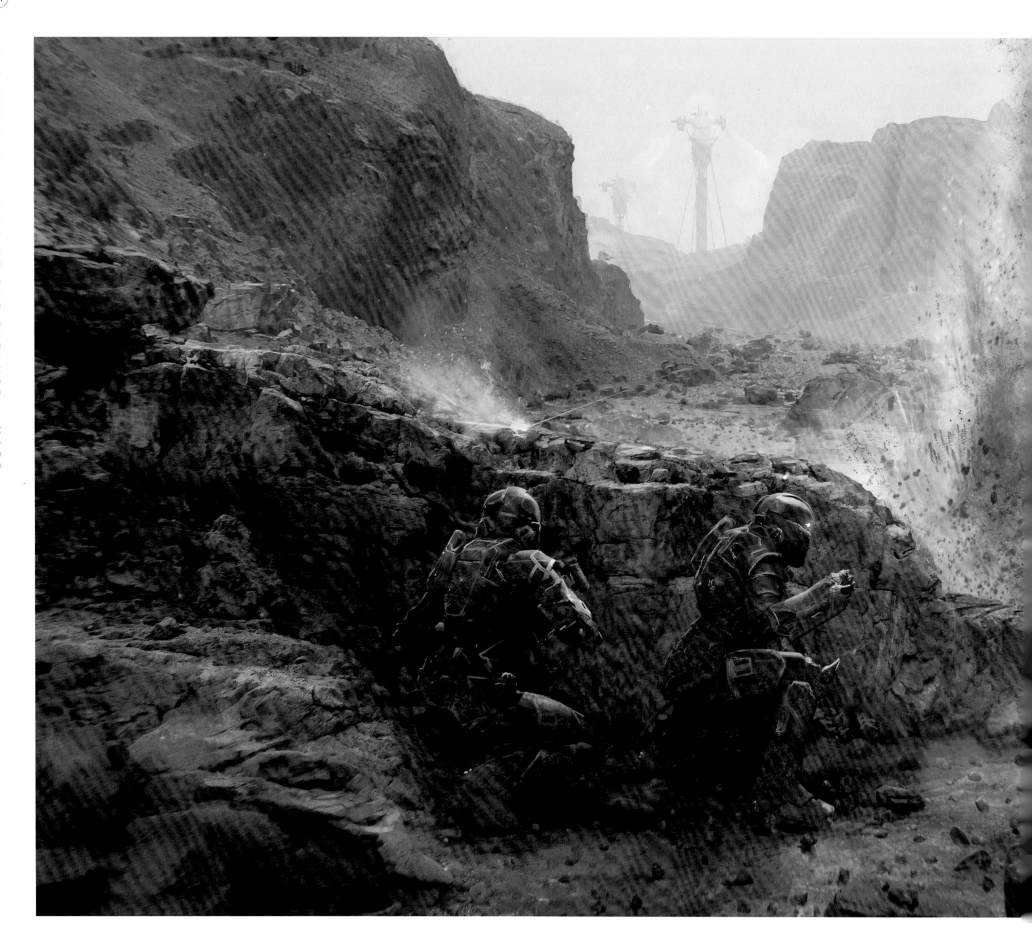

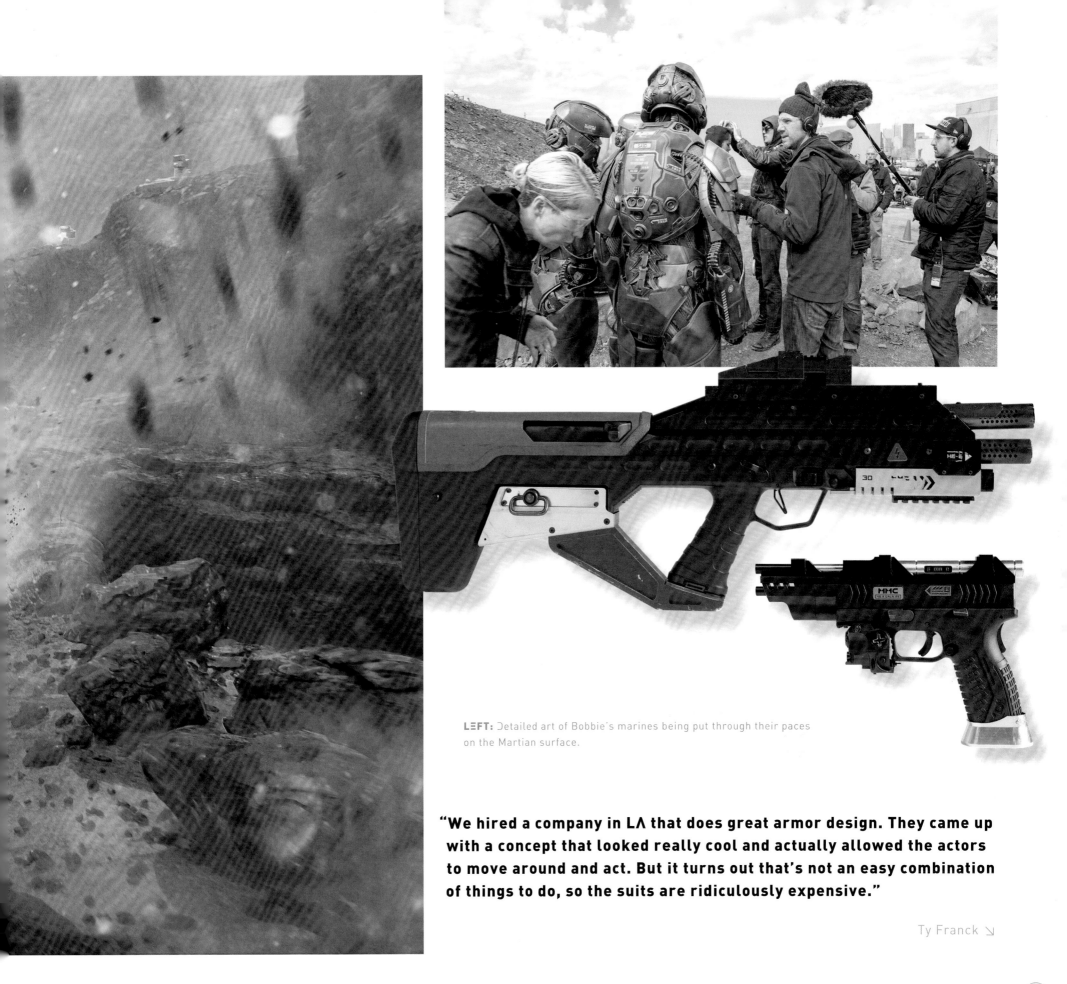

LEFT: Detailed art of Bobbie's marines being put through their paces on the Martian surface.

"We hired a company in LΛ that does great armor design. They came up with a concept that looked really cool and actually allowed the actors to move around and act. But it turns out that's not an easy combination of things to do, so the suits are ridiculously expensive."

Ty Franck ↘

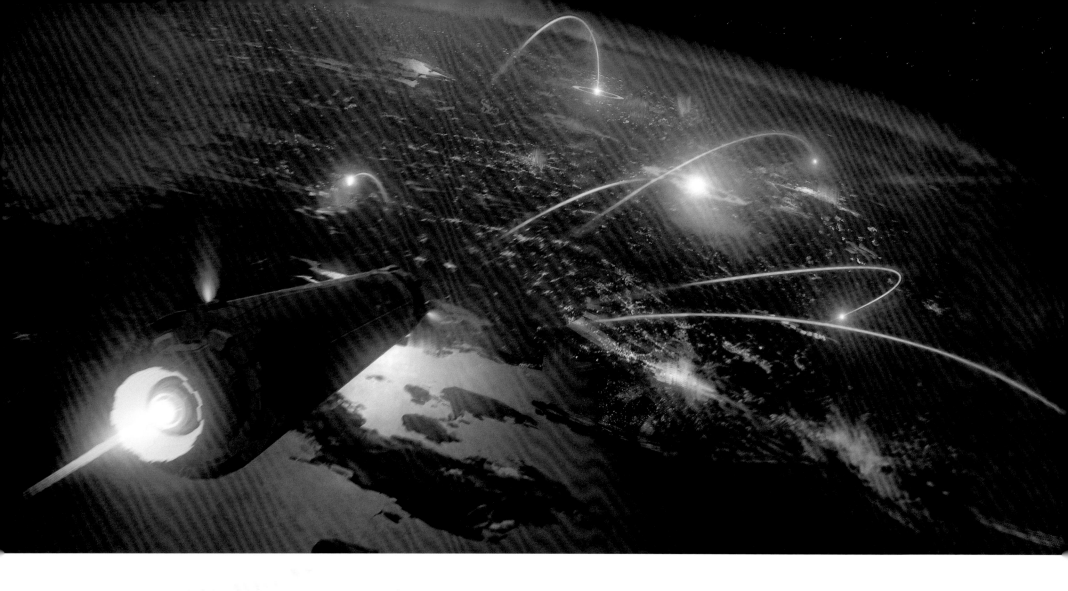

THIS PAGE: Art of one of the MCRN's stealth ships and MIRV (Multiple Independently-targetable Reentry Vehicle) missiles.

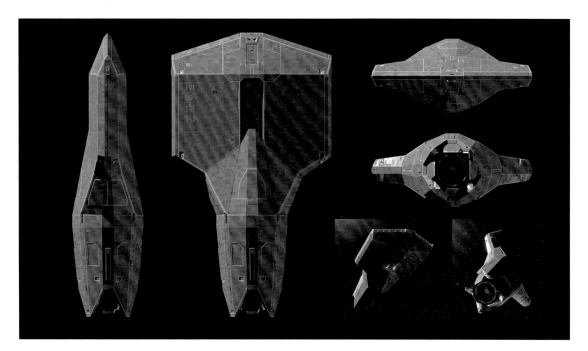

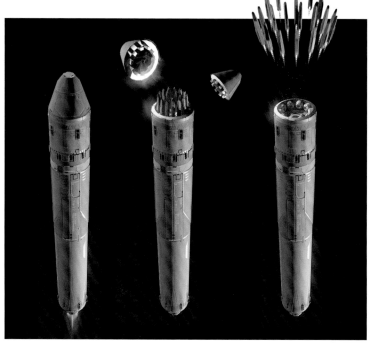

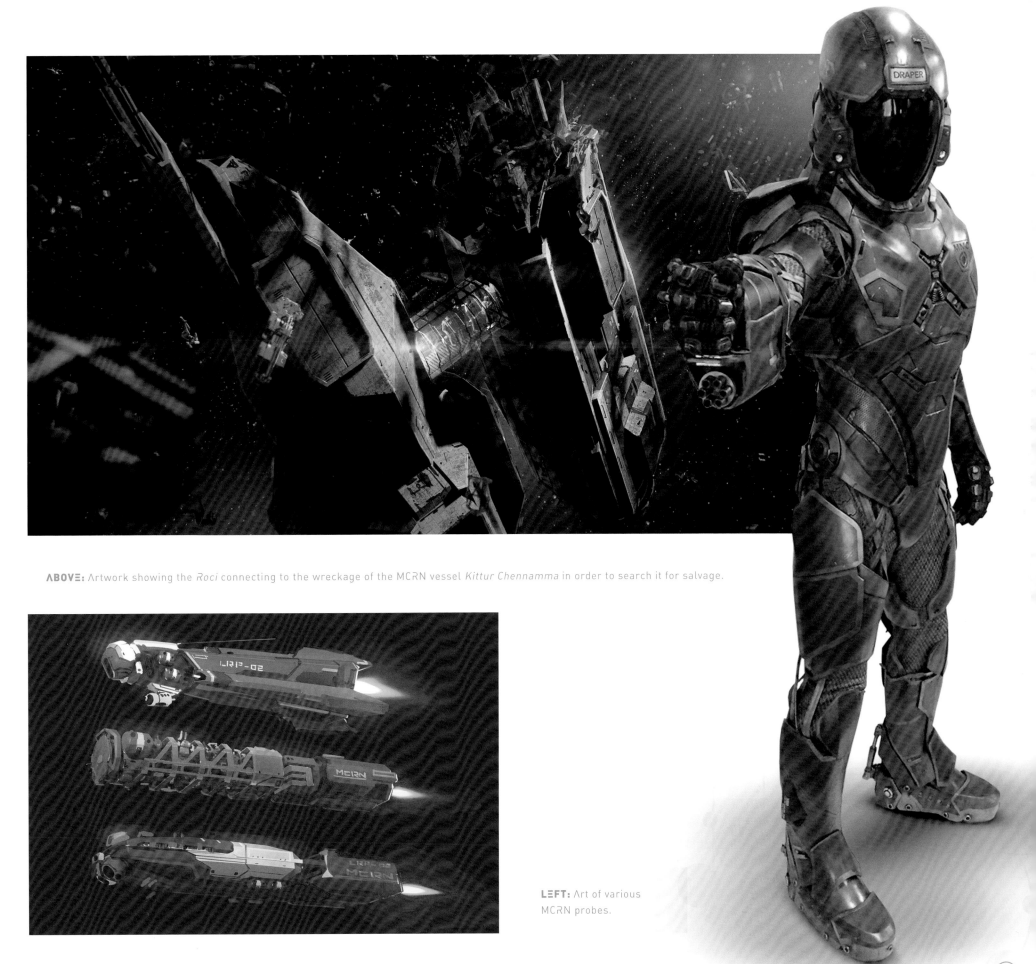

ABOVE: Artwork showing the *Roci* connecting to the wreckage of the MCRN vessel *Kittur Chennamma* in order to search it for salvage.

LEFT: Art of various MCRN probes.

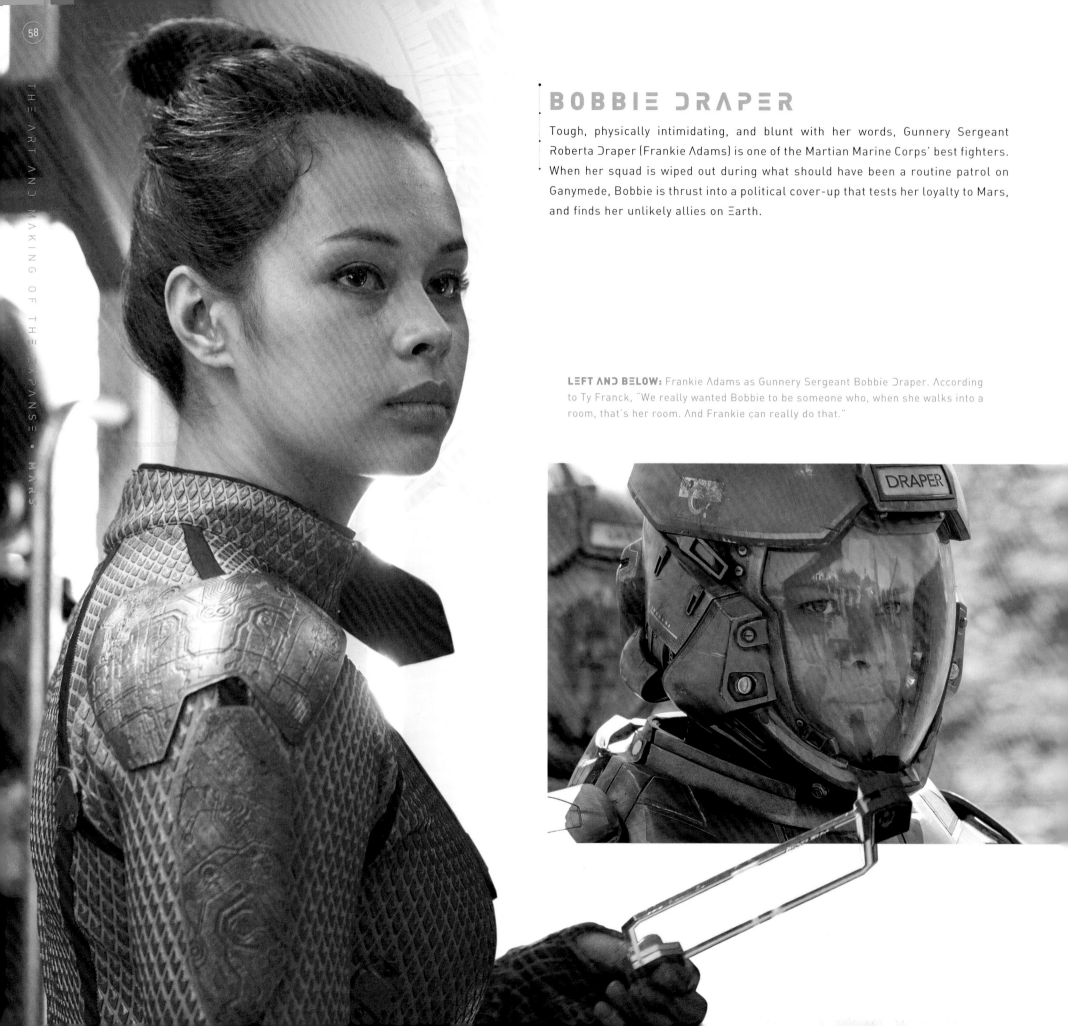

BOBBIE DRAPER

Tough, physically intimidating, and blunt with her words, Gunnery Sergeant Roberta Draper (Frankie Adams) is one of the Martian Marine Corps' best fighters. When her squad is wiped out during what should have been a routine patrol on Ganymede, Bobbie is thrust into a political cover-up that tests her loyalty to Mars, and finds her unlikely allies on Earth.

LEFT AND BELOW: Frankie Adams as Gunnery Sergeant Bobbie Draper. According to Ty Franck, "We really wanted Bobbie to be someone who, when she walks into a room, that's her room. And Frankie can really do that."

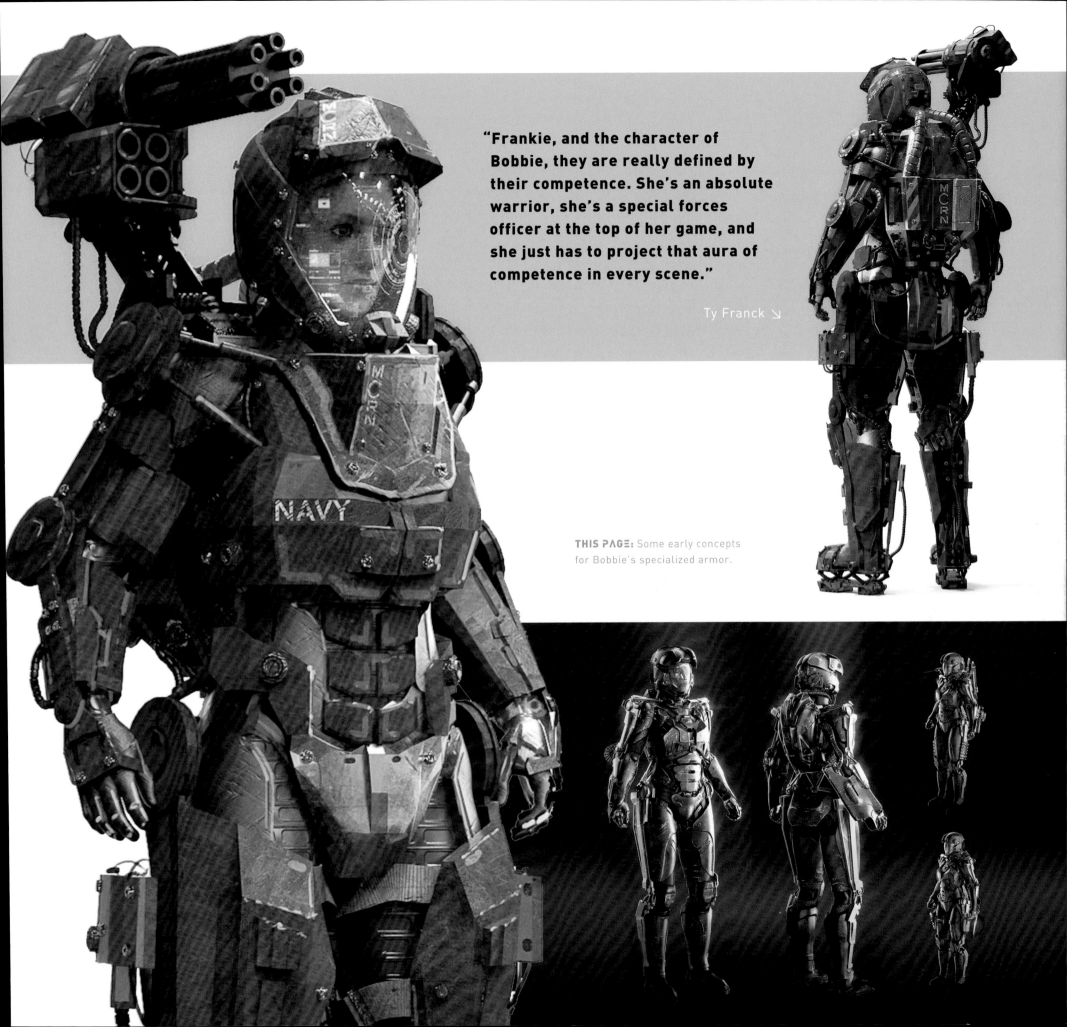

"Frankie, and the character of Bobbie, they are really defined by their competence. She's an absolute warrior, she's a special forces officer at the top of her game, and she just has to project that aura of competence in every scene."

Ty Franck ↘

THIS PAGE: Some early concepts for Bobbie's specialized armor.

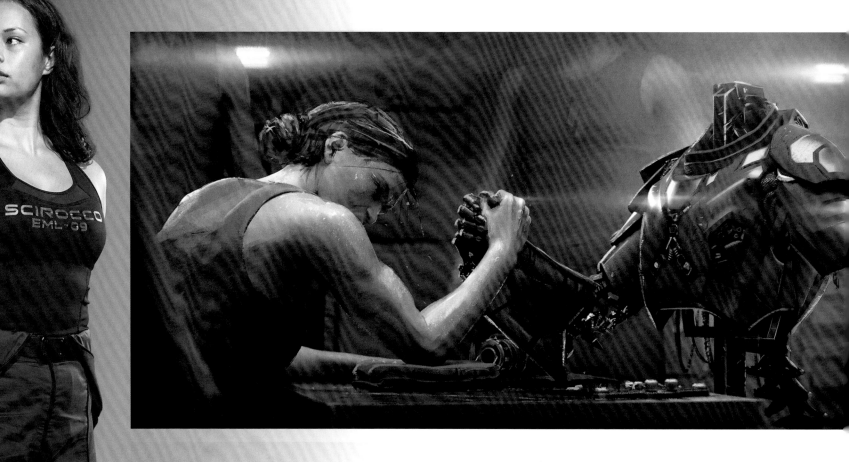

ABOVE AND BELOW: Bobbie arm-wrestles her powered armor and does a bit of maintenance in these detailed concept visuals.

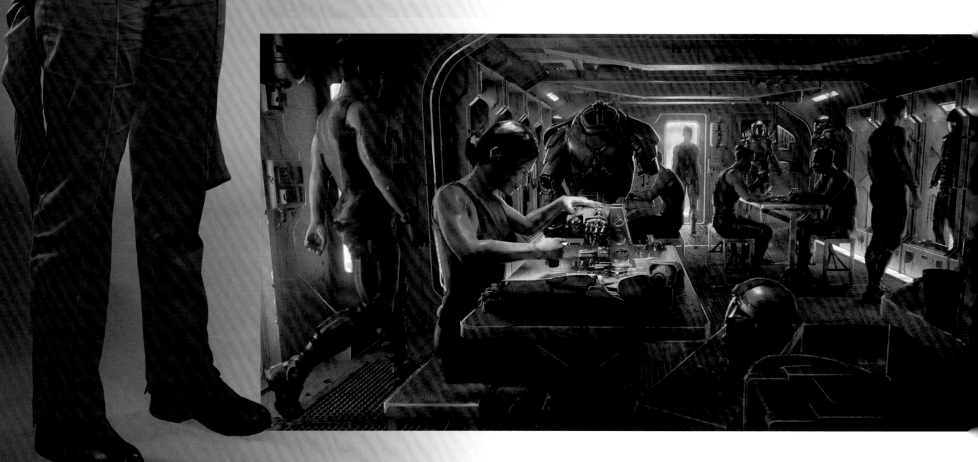

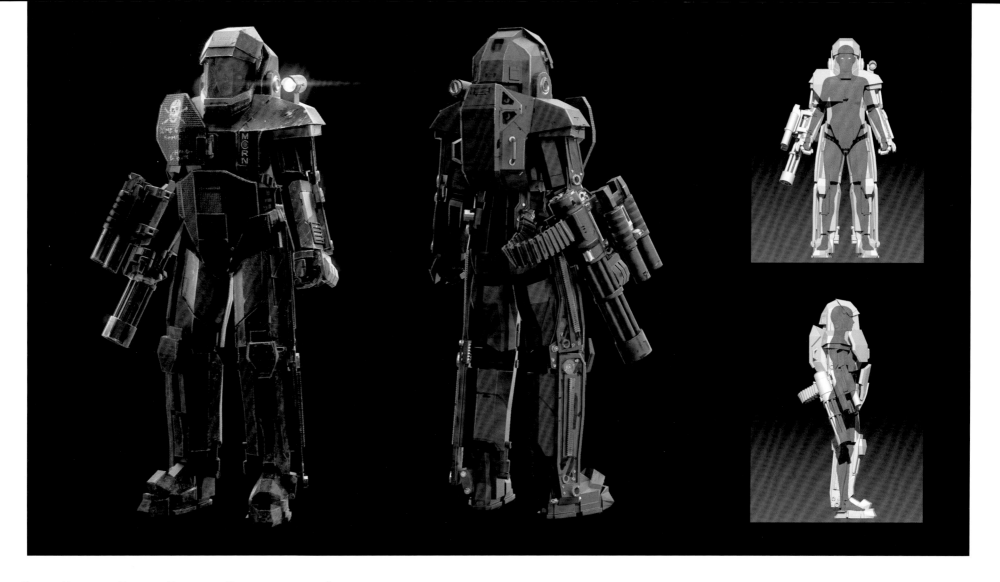

"The [armor] that [Bobbie] wears is a $150,000 suit. It's really tough to make one of those at home... the rule on set is that if there's about to be an accident, save the suit, we can get another actor."

Ty Franck ↘

THIS PAGE: Further concepts for Bobbie's armor.

THE *SCIROCCO*

Naren Shankar: "I liked the look of the *Scirocco*'s multi-level flight deck so much that in Season 3 we used the bones of that set to create the *Roci*'s machine shop. Since both ships were Martian Navy, it made perfect visual sense."

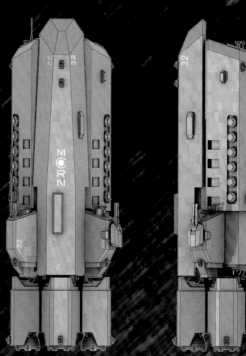

ABOVE: As an assault cruiser, one of the *Scirocco*'s main functions is to carry Martian Marines into battle.

"For the *Scirocco* [we] wanted to evoke the sense of a different class of warship—older, larger, and designed to deliver troops to a planet or asteroid, but still retaining a coherent Martian military design, [something] akin to a newer battleship support corvette like the *Roci*."

Robert Valeriote, construction coordinator ↘

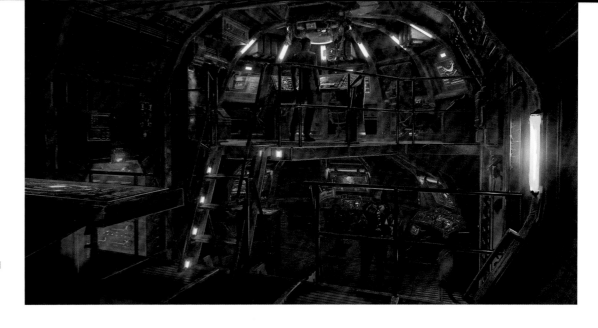

BELOW: An atmospheric piece of art showing Bobbie rallying her troops aboard the *Scirocco*.

ABOVE: The low-lit *Scirocco* command deck set.

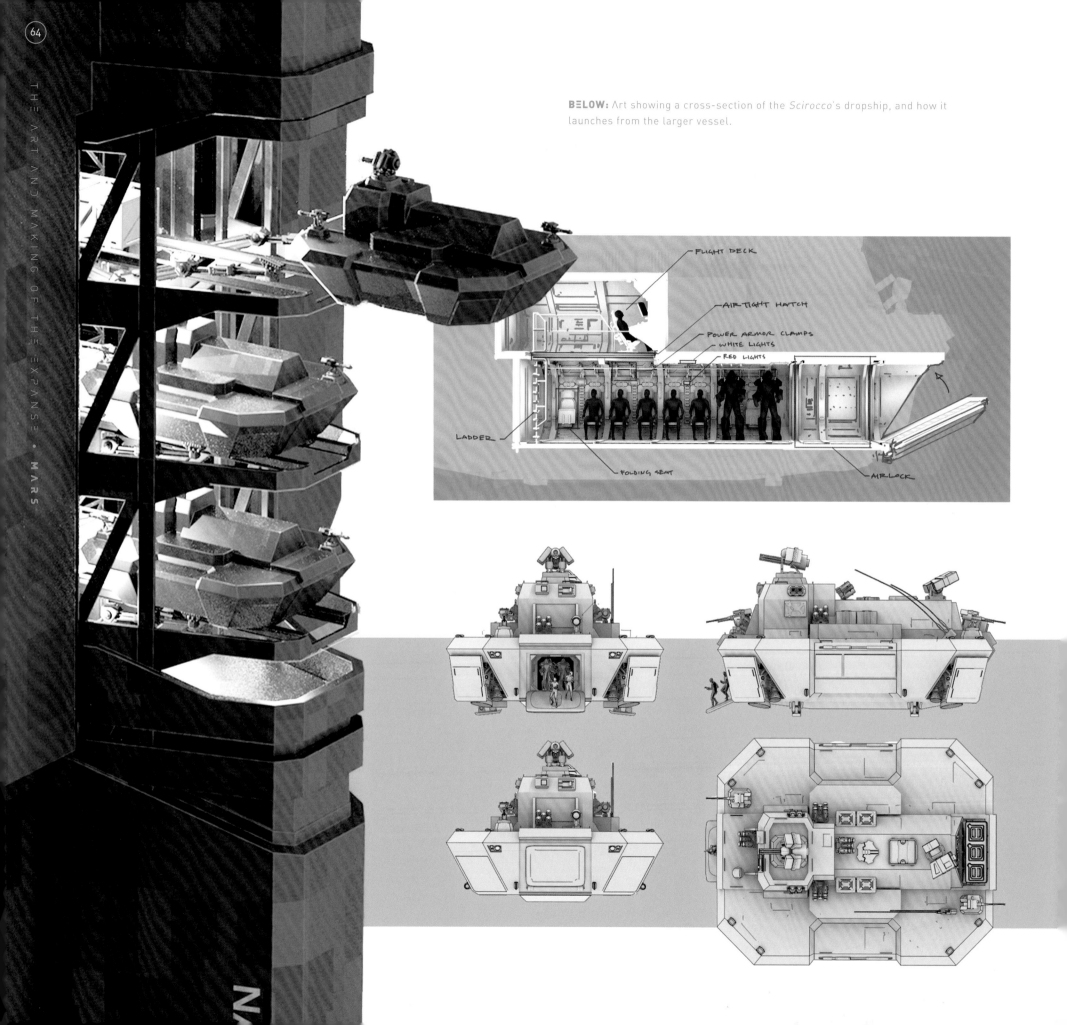

BELOW: Art showing a cross-section of the *Scirocco*'s dropship, and how it launches from the larger vessel.

FLIGHT DECK

AIRTIGHT HATCH

POWER ARMOR CLAMPS

WHITE LIGHTS

RED LIGHTS

LADDER

FOLDING SEAT

AIRLOCK

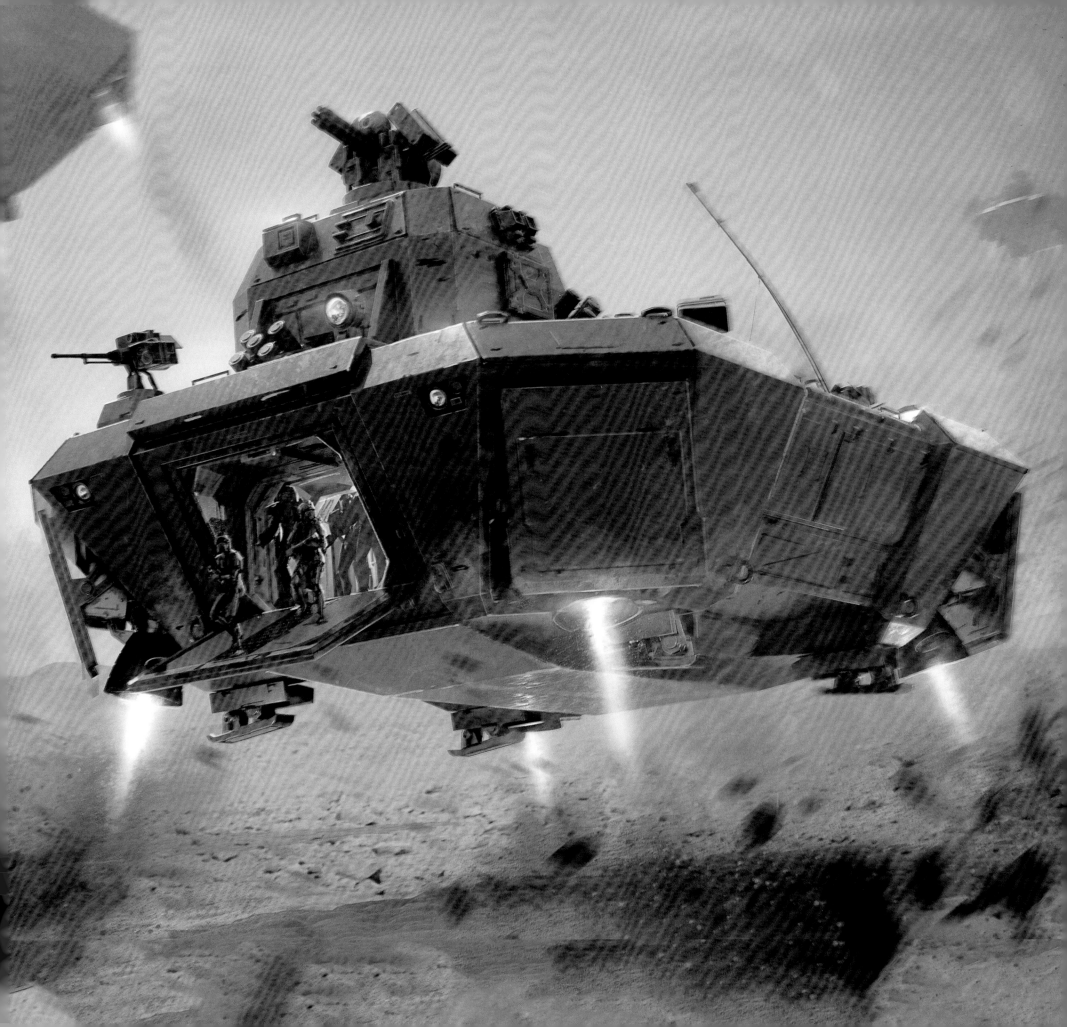

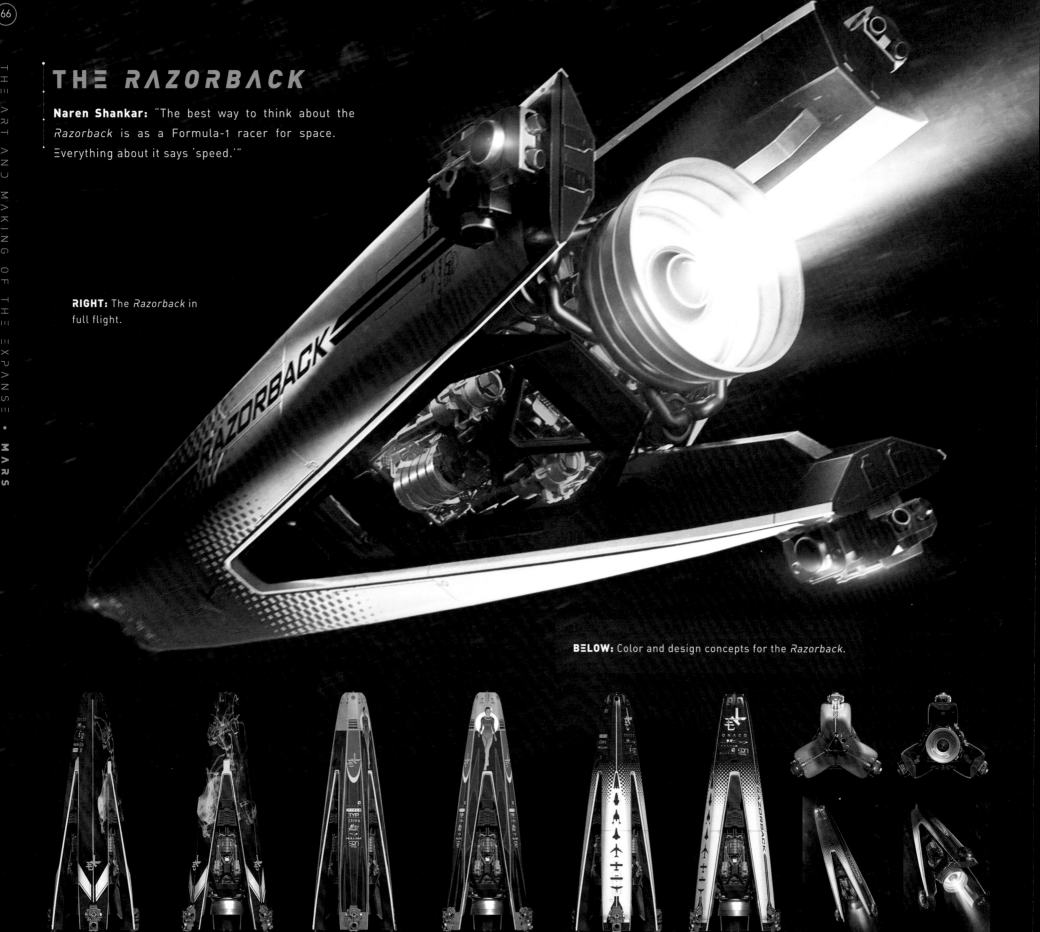

THE *RAZORBACK*

Naren Shankar: "The best way to think about the *Razorback* is as a Formula-1 racer for space. Everything about it says 'speed.'"

RIGHT: The *Razorback* in full flight.

BELOW: Color and design concepts for the *Razorback*.

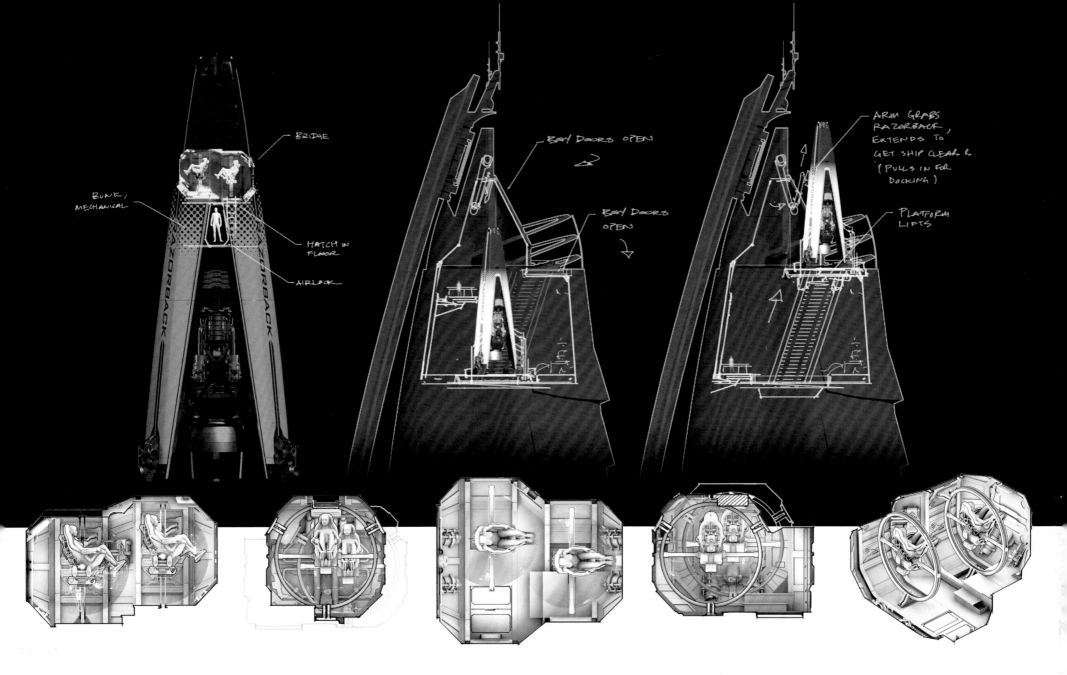

BRIDGE

BUNK, MECHANICAL

HATCH IN FLOOR

AIRLOCK

BAY DOORS OPEN

BAY DOORS OPEN

ARM GRABS RAZORBACK, EXTENDS TO GET SHIP CLEAR (PULLS IN FOR DOCKING)

PLATFORM LIFTS

ΛBOVΞ: Cross-section of the *Razorback*, its emergence from the *Guanshiyin*, and twin gyroscopic seat configurations.

BΞLOW: Ξarly *Razorback* computer models.

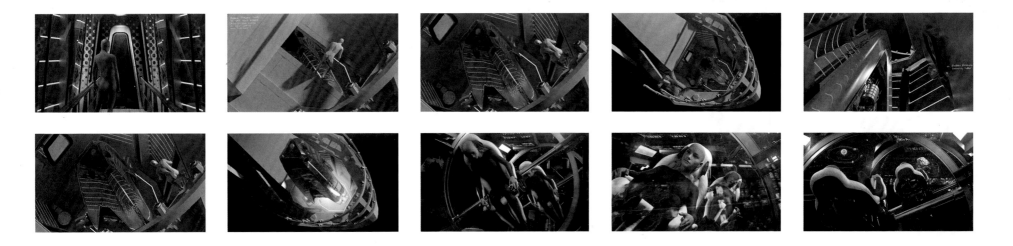

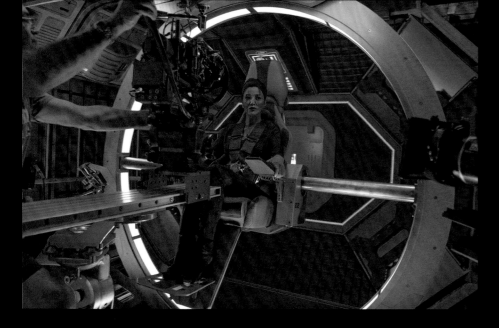

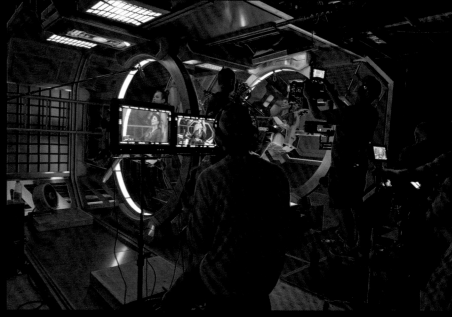

ABOVE: Shohreh Aghdashloo (Avasarala) and Frankie Adams (Bobbie Draper) shoot scenes aboard the *Razorback*.

BELOW: More computer models showing the complex movements of the gyroscopic seats.

"Both wheels rotate about 70 degrees in each direction, and inside of that rotating wheel the chairs can tilt completely flat forward or back. It was all computer controlled so that when the camera move did a certain thing the chair move did a certain thing. The camera, crane and chairs were all tied into a single computer to make all the moves work."

Ty Franck ↘

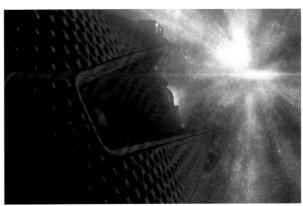
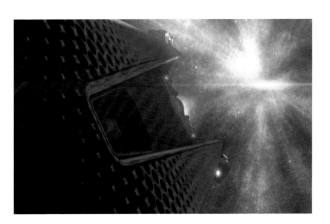

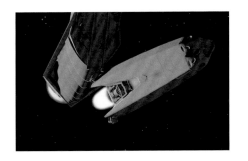
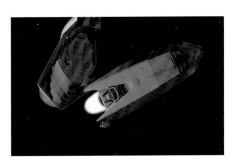
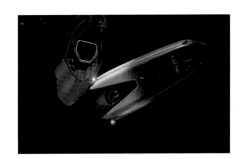
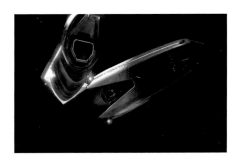

THIS PAGE: Series of computer images of the sequence showing the *Razorback*'s desperate rush to safety following the *Guanshiyin*'s destruction.

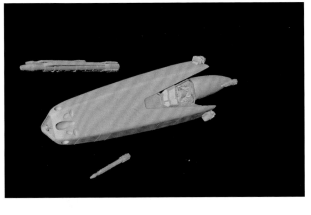

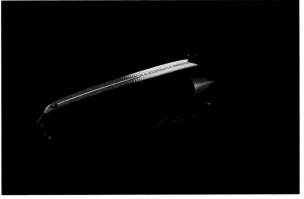

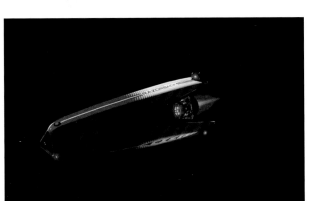
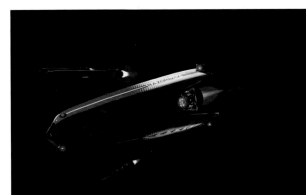
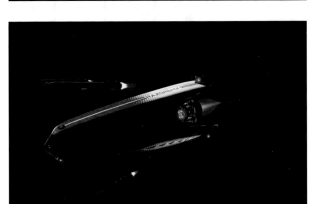

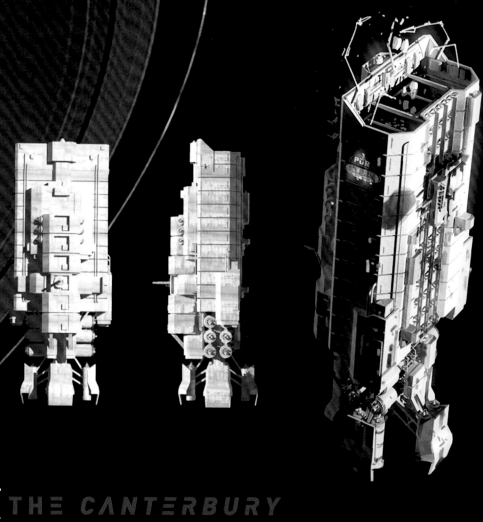

THE CANTERBURY

Naren Shankar: "The *Canterbury* began as a massive Earth colony ship and ended as a dilapidated old truck used to haul ice from the Belt. We spent a great deal of time and money creating something that gets vaporized in episode 1!"

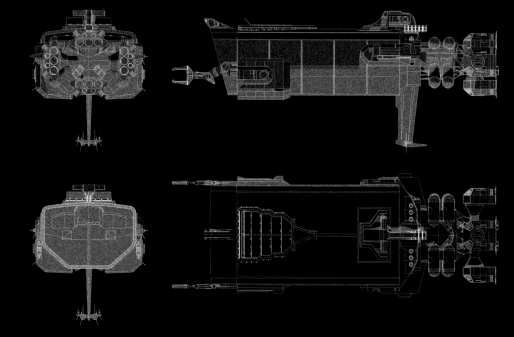

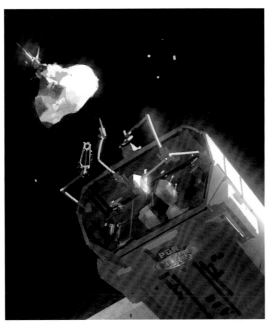
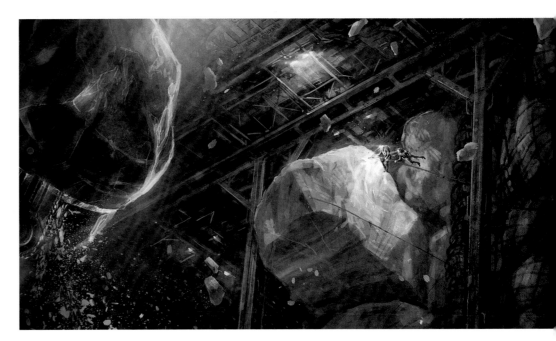
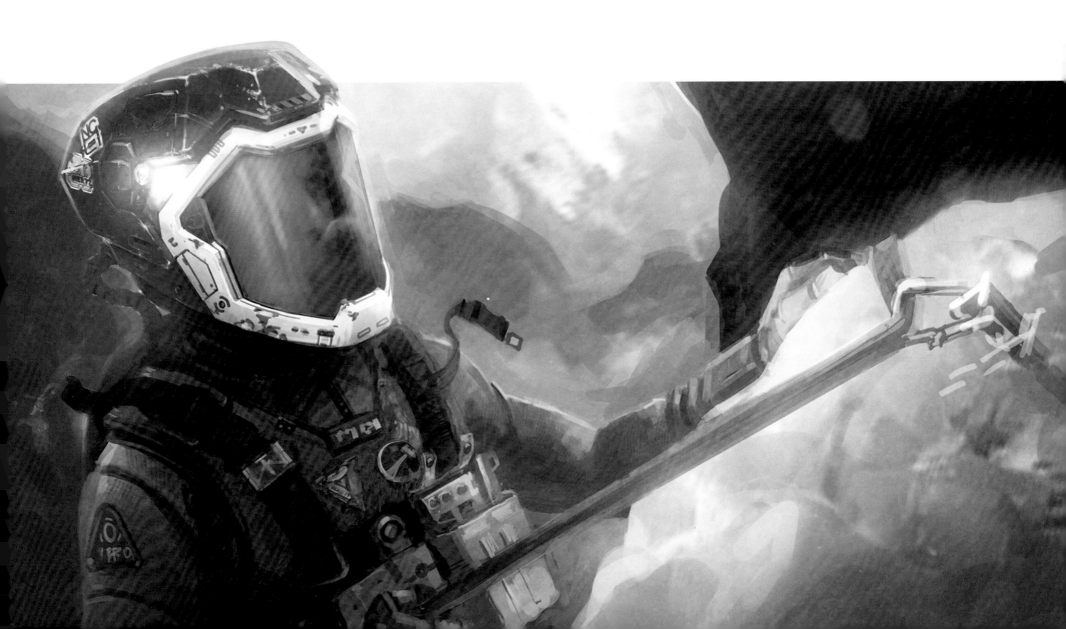

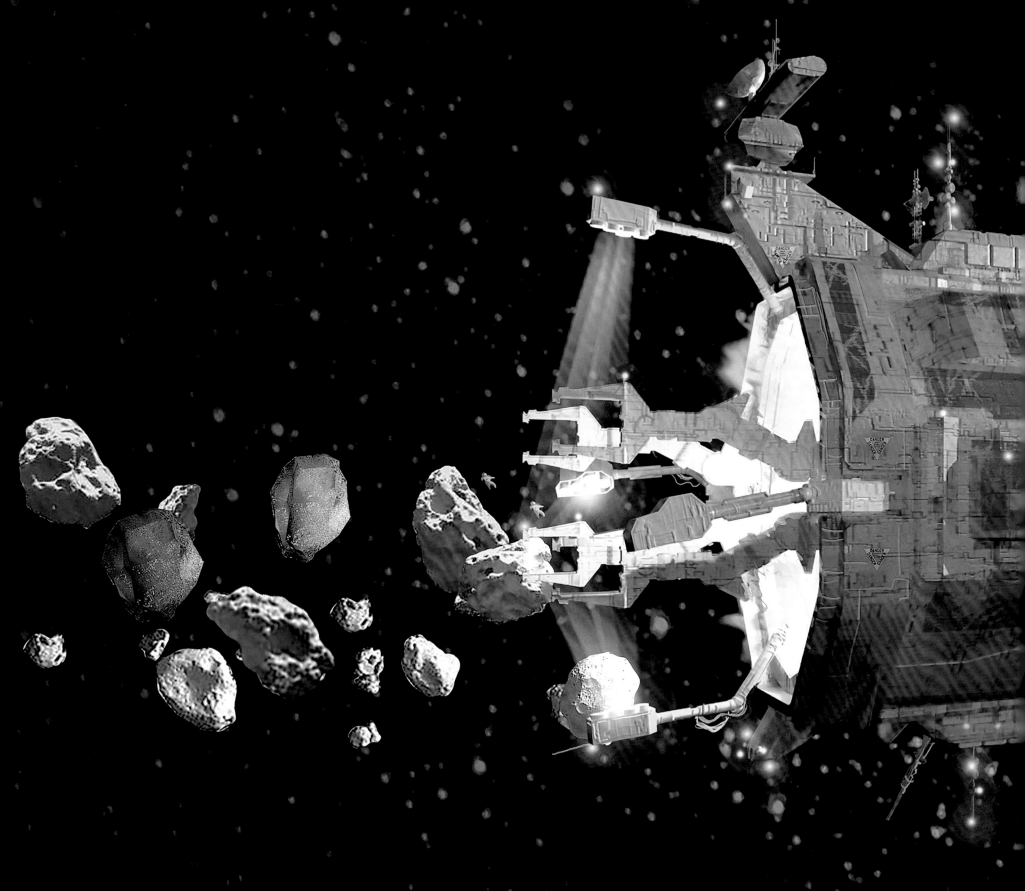

ABOVE: The *Canterbury* at work in a very early rendering.

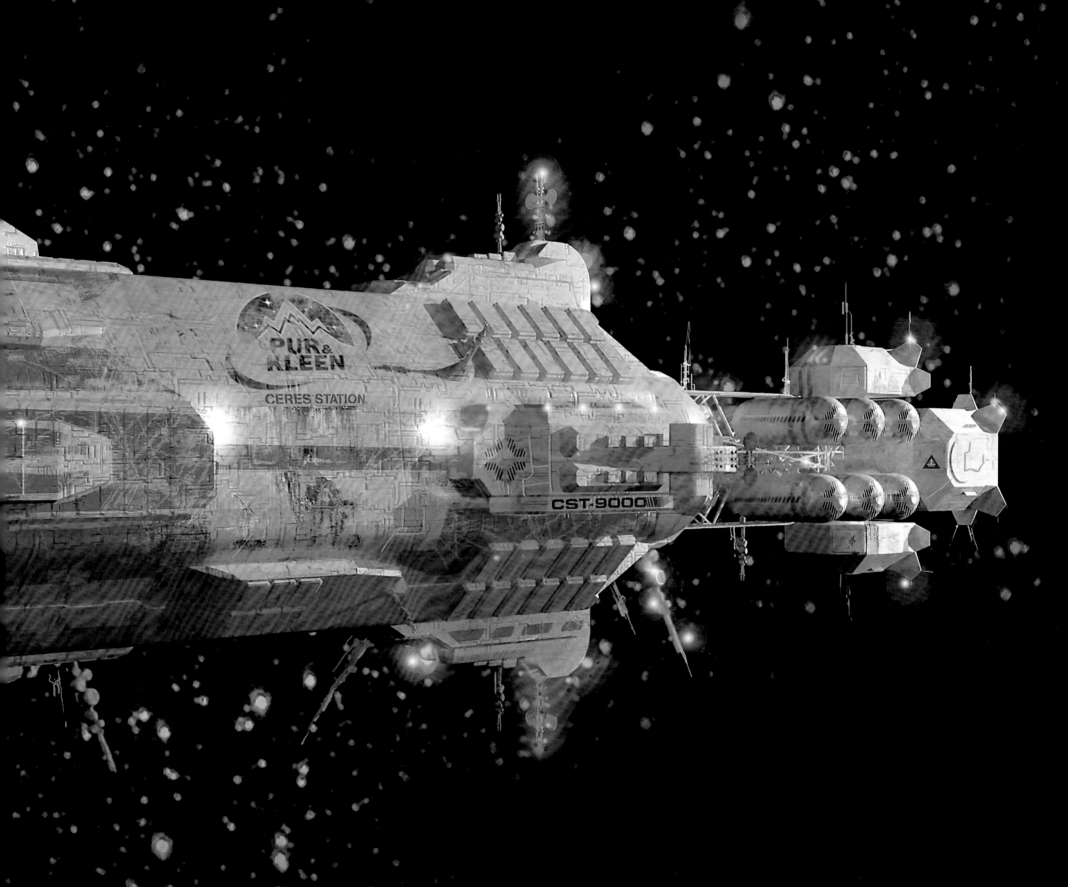

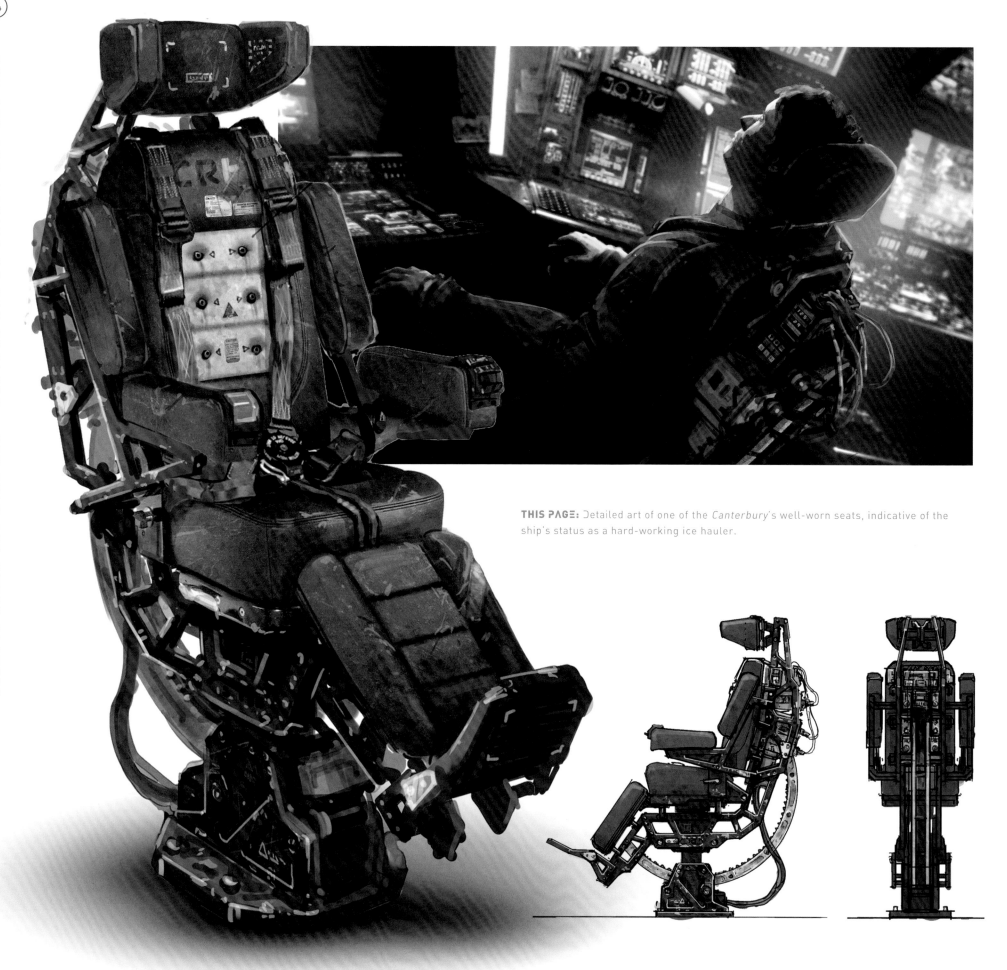

THIS PAGE: Detailed art of one of the *Canterbury*'s well-worn seats, indicative of the ship's status as a hard-working ice hauler.

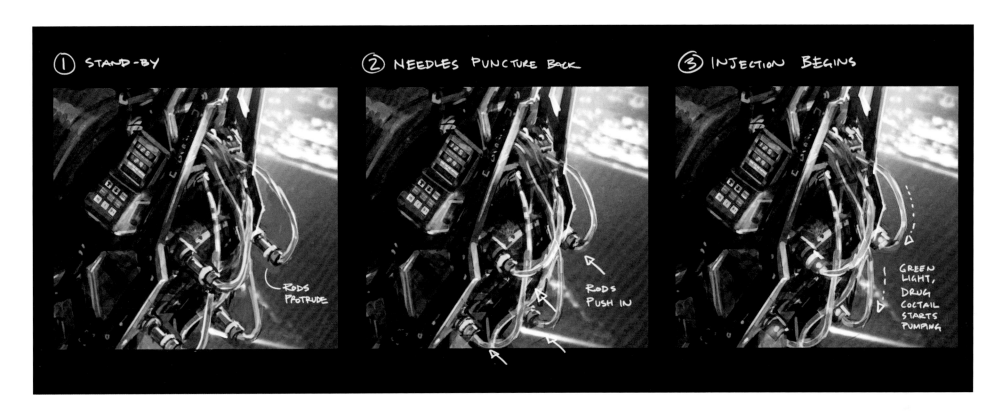

(1) STAND-BY
RODS PROTRUDE

(2) NEEDLES PUNCTURE BACK
RODS PUSH IN

(3) INJECTION BEGINS
GREEN LIGHT, DRUG COCTAIL STARTS PUMPING

ABOVE: Artwork showing how biological stress is mitigated by injection of a potent drug cocktail aboard the *Cant*.
BELOW: Alternative concepts of the *Cant*.

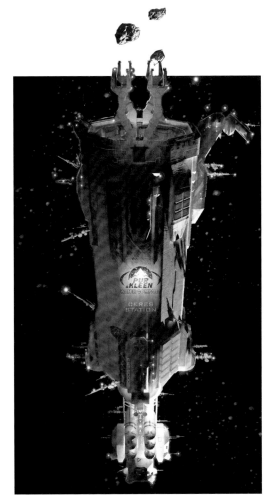

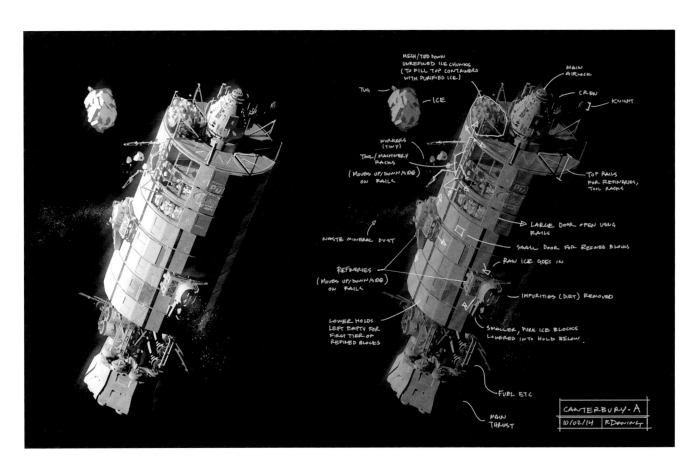

MECH/TIED DOWN UNREFINED ICE CHUNKS (TO FILL TOP CONTAINERS WITH PURIFIED ICE)

MAIN AIRLOCK

TUG

ICE

CREW

KNIGHT

WORKERS (TINY)

TOOL/MACHINERY RACKS

(MOVES UP/DOWN/SIDE) ON RAILS

TOP RAILS FOR REFINERIES, TOOL RACKS

WASTE MINERAL DUST

LARGE DOOR OPEN USING RAILS

SMALL DOOR FOR REFINED BLOCKS

RAW ICE GOES IN

REFINERIES (MOVES UP/DOWN/SIDE) ON RAILS

IMPURITIES (DIRT) REMOVED

LOWER HOLDS LEFT EMPTY FOR FIRST TIER OF REFINED BLOCKS

SMALLER, PURE ICE BLOCKS LOWERED INTO HOLD BELOW.

FUEL ETC

MAIN THRUST

CANTERBURY-A
10/02/14 R DOWNING

THE ART AND MAKING OF THE EXPANSE • THE BELT AND OUTER PLANETS

THIS PAGE: Art showing the cluttered, 'lived-in' look of the *Canterbury*'s interiors.

"The *Cant* was our first ship and [we] didn't want [it] to be perceived as a military vessel. We added a subtle soft texture to the surfaces to make it feel more like a home for the characters on the ship. And the hallways were carpeted."

Robert Valeriote, construction coordinator ↘

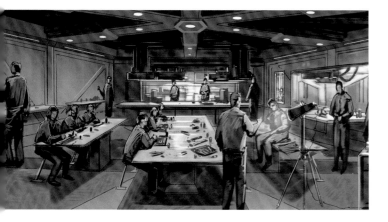

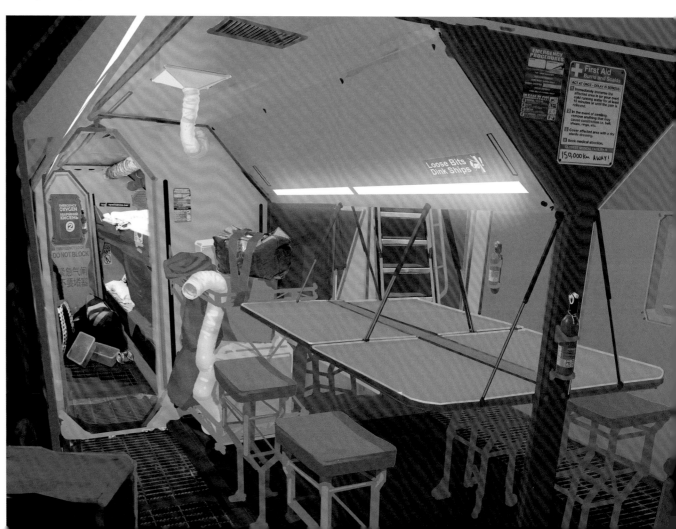

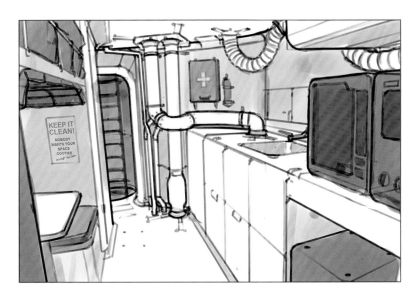
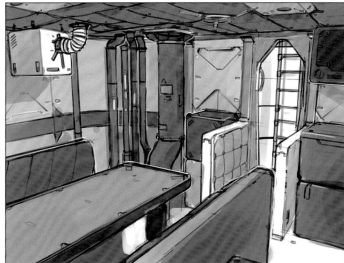

BELOW: More *Canterbury* interiors, including Holden's quarters.

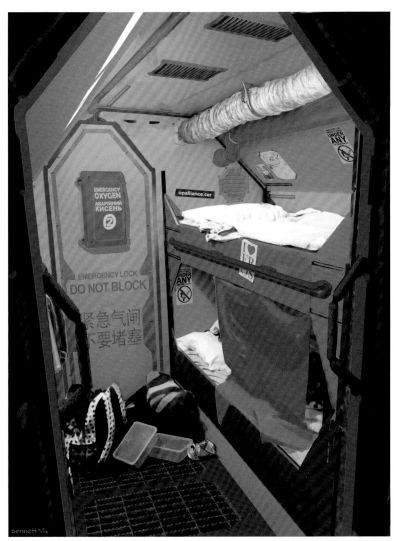

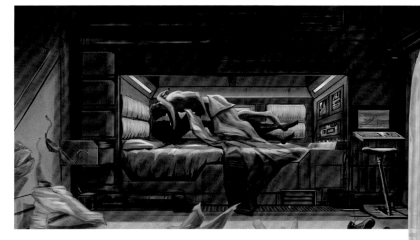

THE *KNIGHT*

Regulations require ice haulers to support at least one shuttle capable of entering atmosphere; on the *Canterbury*, this is the *Knight*. Not made for long-distance travel, the *Knight* isn't fitted with an Epstein drive, propelled instead by fusion torches—pressurized steam valves used for fine movement, essentially 'tea kettles.'

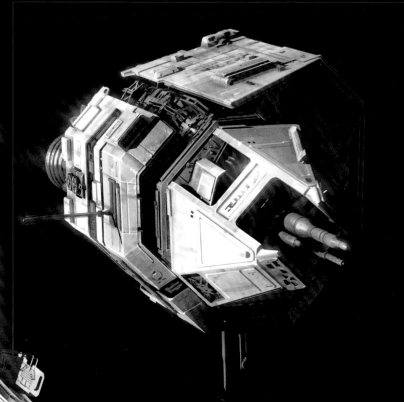

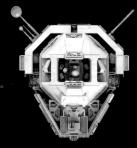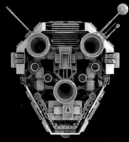

THIS PAGE: Views of the *Knight*, a tiny, humble shuttle that nevertheless becomes involved in events of galaxy-wide significance.

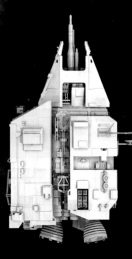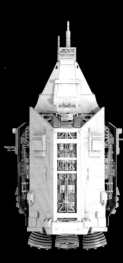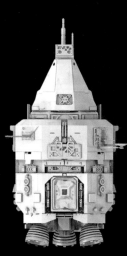

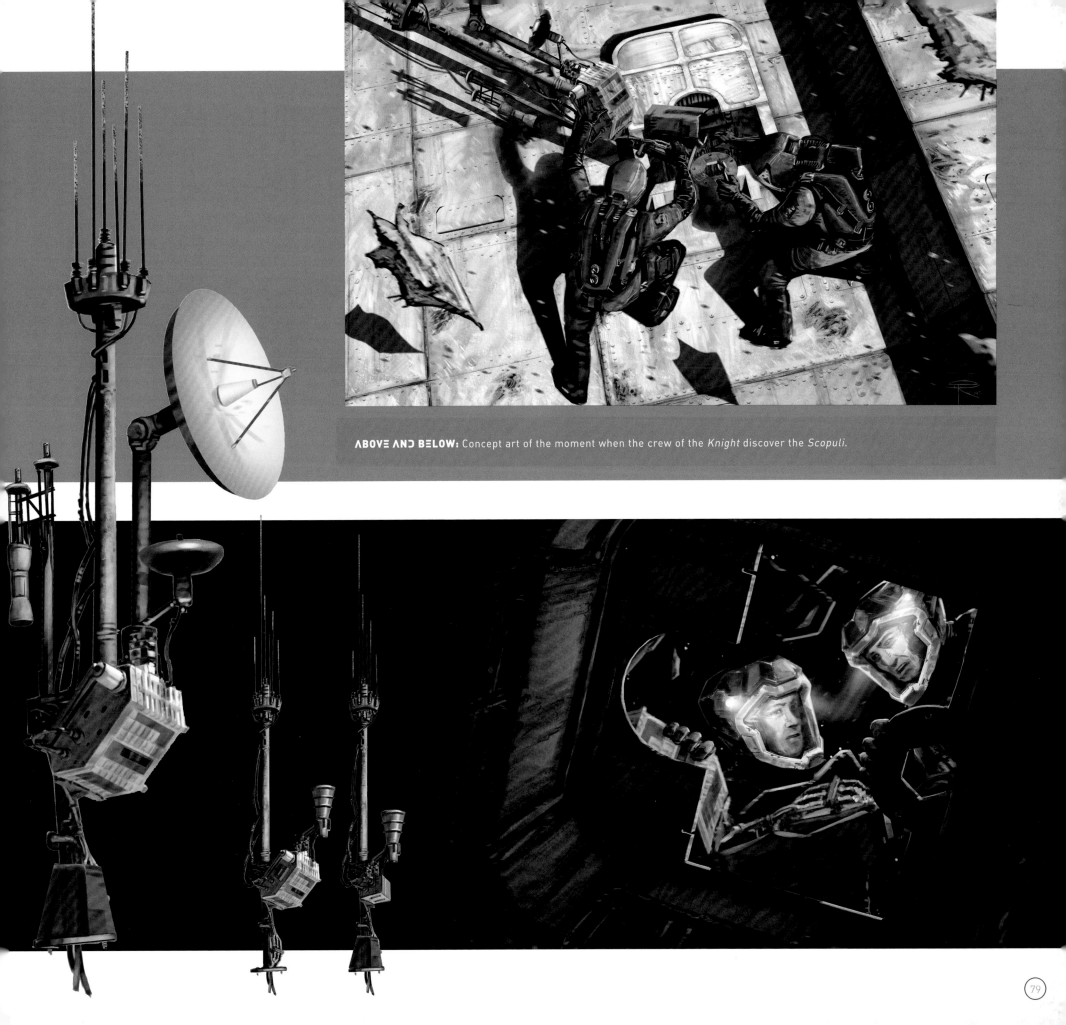

ABOVE AND BELOW: Concept art of the moment when the crew of the *Knight* discover the *Scopuli*.

ABOVE: Holden and Naomi preparing to leave the *Canterbury* for their fateful mission aboard the shuttle *Knight* (Season 1, episode 1, 'Dulcinea').

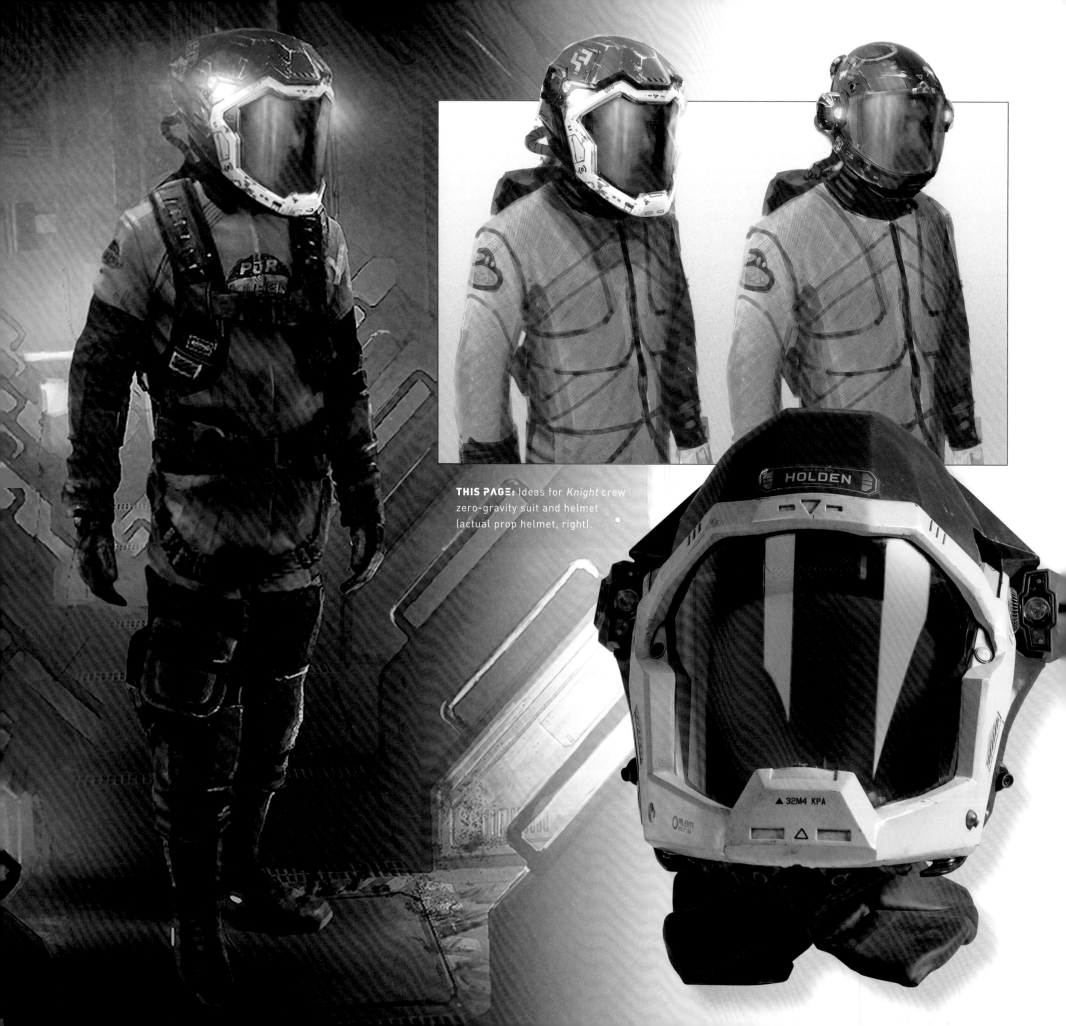

THIS PAGE: Ideas for *Knight* crew zero-gravity suit and helmet (actual prop helmet, right).

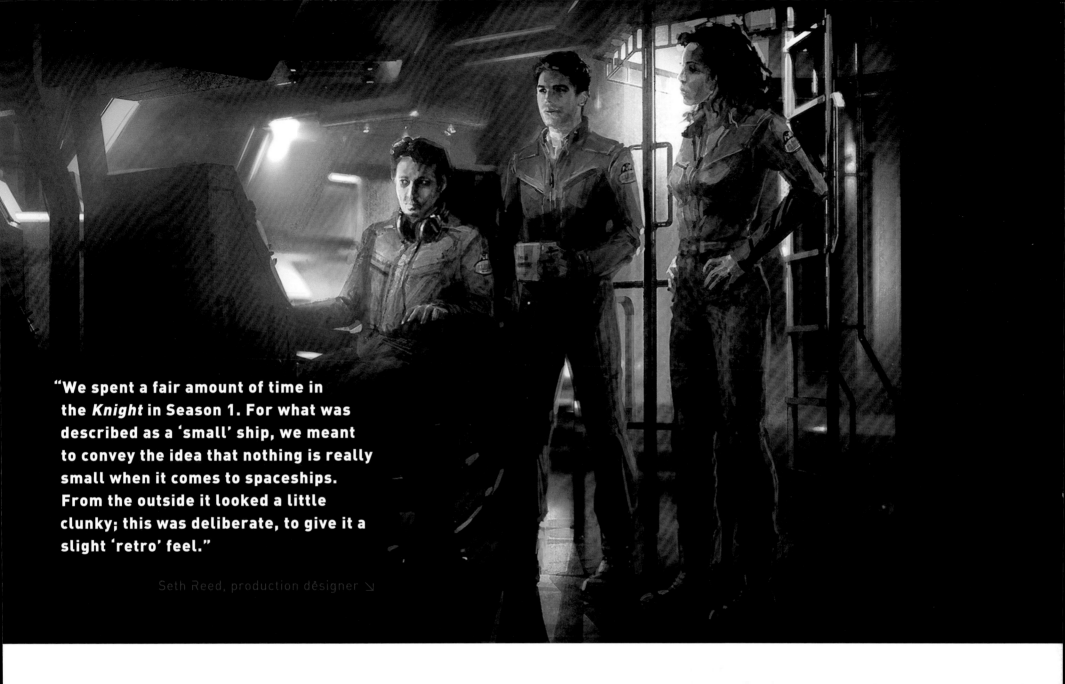

"We spent a fair amount of time in the *Knight* in Season 1. For what was described as a 'small' ship, we meant to convey the idea that nothing is really small when it comes to spaceships. From the outside it looked a little clunky; this was deliberate, to give it a slight 'retro' feel."

Seth Reed, production designer ↘

ABOVE: Concept piece of Holden, Naomi, and Alex aboard the *Knight*.

BELOW: Photos from the set of the *Knight*.

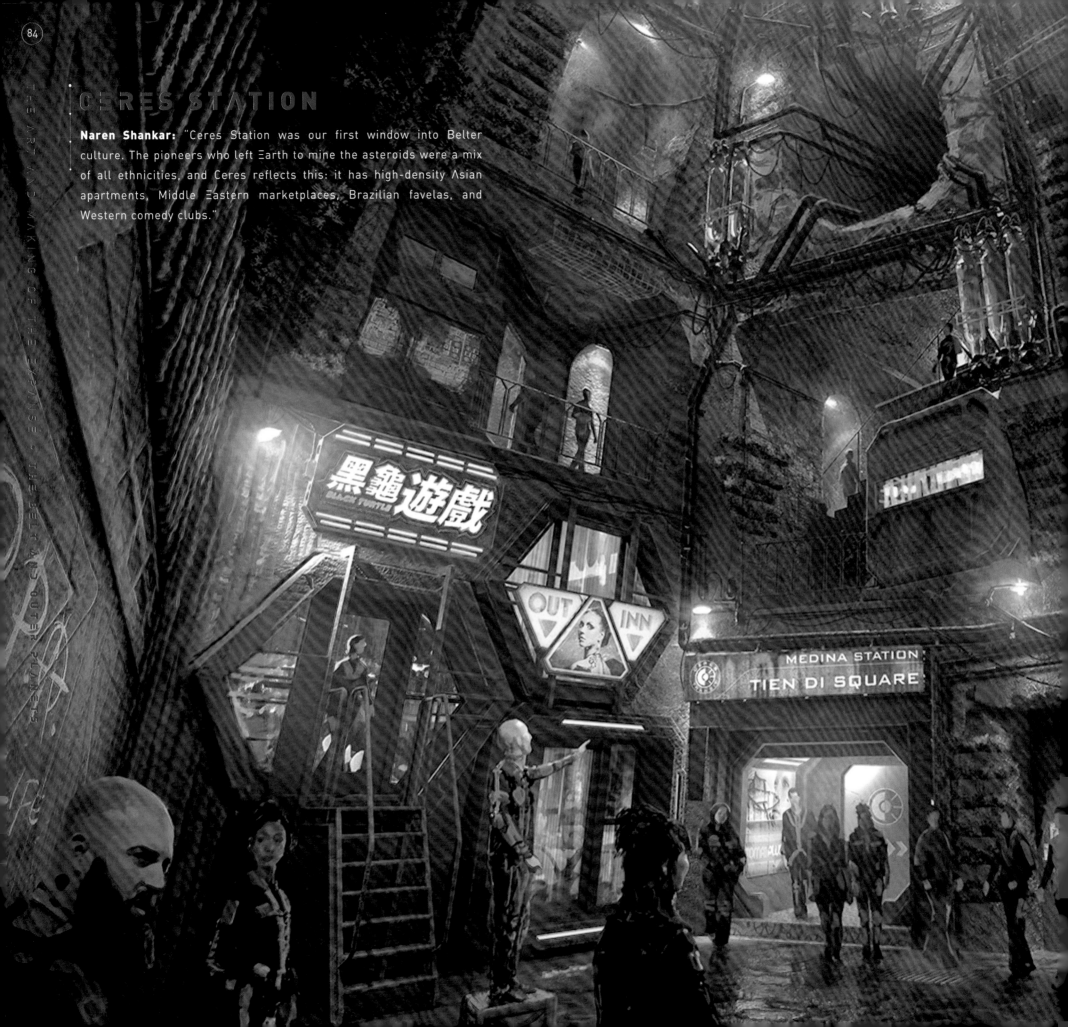

CERES STATION

Naren Shankar: "Ceres Station was our first window into Belter culture. The pioneers who left Earth to mine the asteroids were a mix of all ethnicities, and Ceres reflects this: it has high-density Asian apartments, Middle Eastern marketplaces, Brazilian favelas, and Western comedy clubs."

黑龜遊戲
BLACK TURTLE

OUT
INN

MEDINA STATION
TIEN DI SQUARE

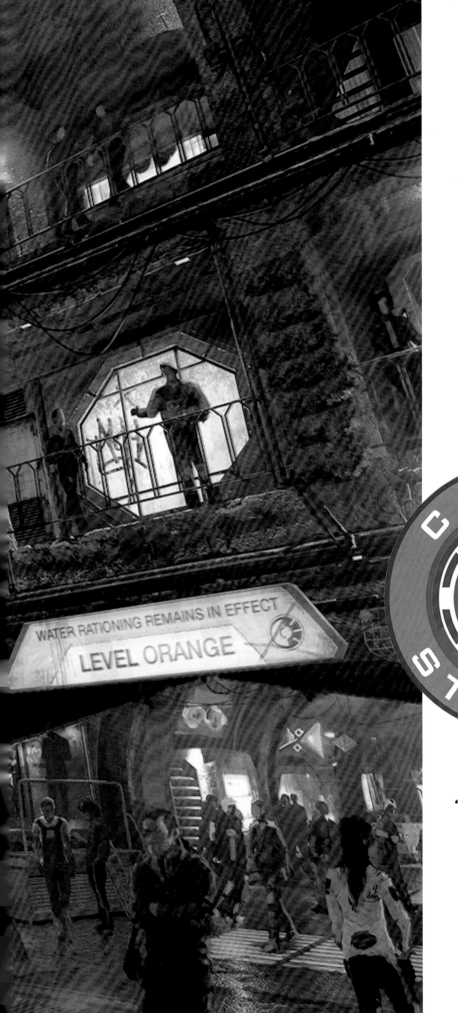

WATER RATIONING REMAINS IN EFFECT

LEVEL ORANGE

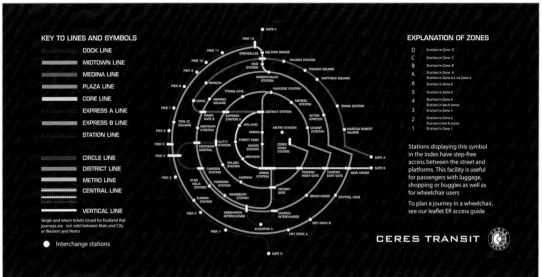

KEY TO LINES AND SYMBOLS

DOCK LINE
MIDTOWN LINE
MEDINA LINE
PLAZA LINE
CORE LINE
EXPRESS A LINE
EXPRESS B LINE
STATION LINE

CIRCLE LINE
DISTRICT LINE
METRO LINE
CENTRAL LINE
Under construction
VERTICAL LINE

Single and return tickets issued for Eastland Rail
journeys are not valid between Main and City
or Western and Metro

● Interchange stations

EXPLANATION OF ZONES

D Station in Zone D
C Station in Zone C
B Station in Zone B
A Station in Zone A
6 Station in Zone 6 and Zone A
5 Station in Zone 5
4 Station in Zone 4
 Station in both zones
3 Station in Zone 3
2 Station in Zone 2
 Station in both zones
1 Station in Zone 1

Stations displaying this symbol
in the index have step-free
access between the street and
platforms. This facility is useful
for passengers with luggage,
shopping or buggies as well as
for wheelchair users

To plan a journey in a wheelchair,
see our leaflet ER access guide

CERES TRANSIT

TIEN DI SQUARE STATION

TIEN DI SQUARE STATION

MEDINA STATION
TIEN DI SQUARE

"We were looking at places like Kowloon Walled City and other densely populated urban environments [for Ceres]. We see elements of what it would take to sustain life living underground on an asteroid; lots of plant life and air filtration. In upper Ceres there is an artificial sky, and all of the buildings are modular and look 3D-printed."

Tim Warnock, concept artist ↘

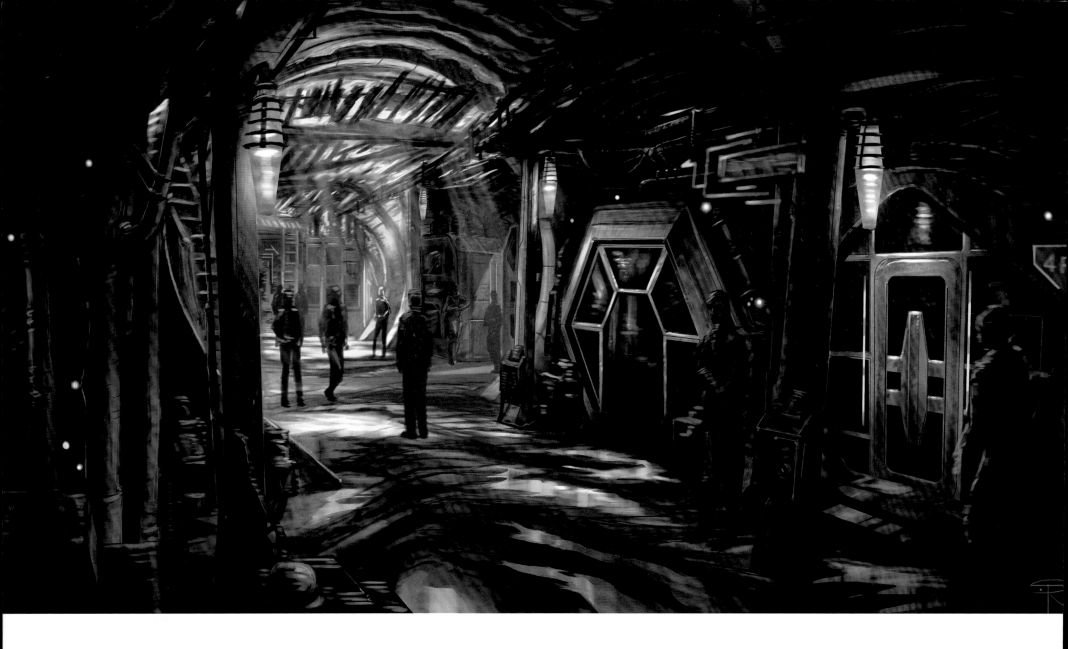

ΛBOVΞ: Ceres Station concept art, showing one of its many 'back alley' corridors. This rougher, less-maintained look was faithfully re-created for the production (right).

"It needed to be obvious that Ceres was a mining colony, so there are a lot [of] exposed rock tunnels and ventilation pipes. There are also industrial support structures in the lower parts that give the feel of a mine shaft as opposed to a natural cave."

Tim Warnock, concept artist ↘

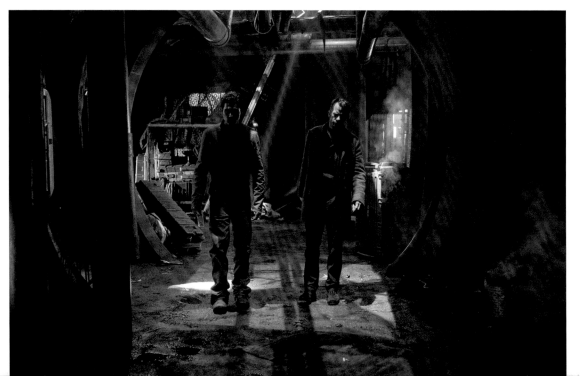

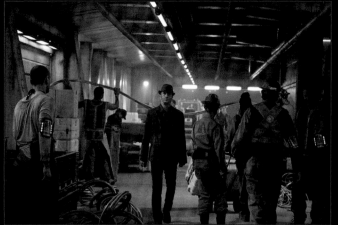

LEFT: As the largest and most important port in the Belt, Ceres is home to around six million people. The hustle and bustle of the station was captured on the large, open Ceres sets (concept art below).

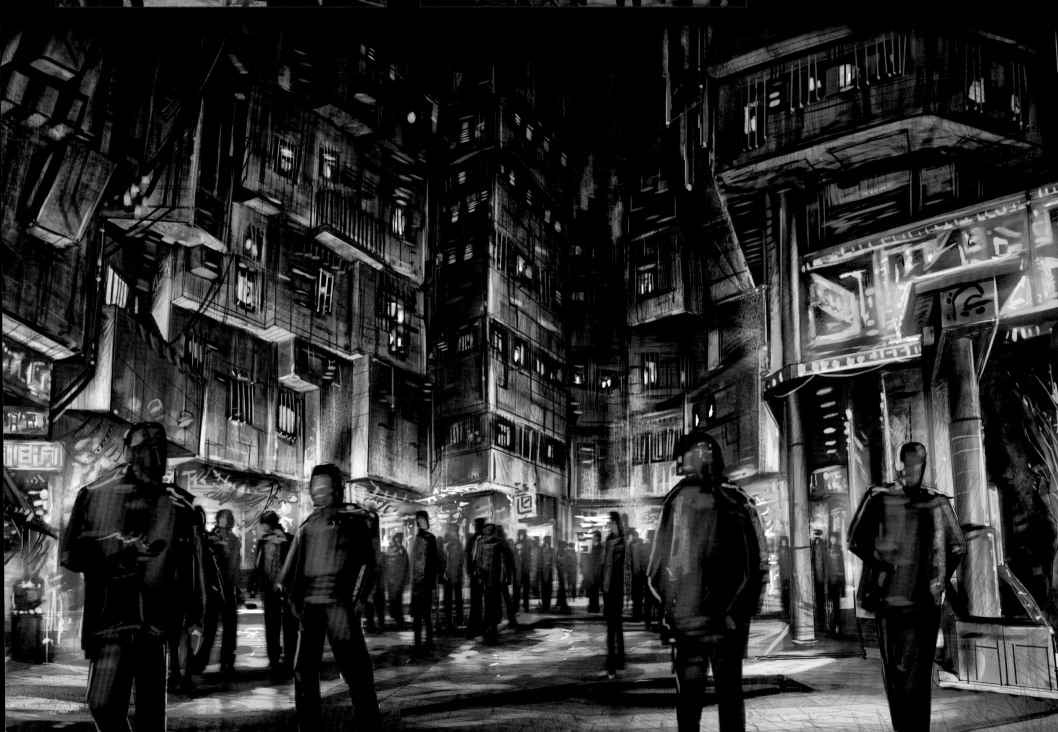

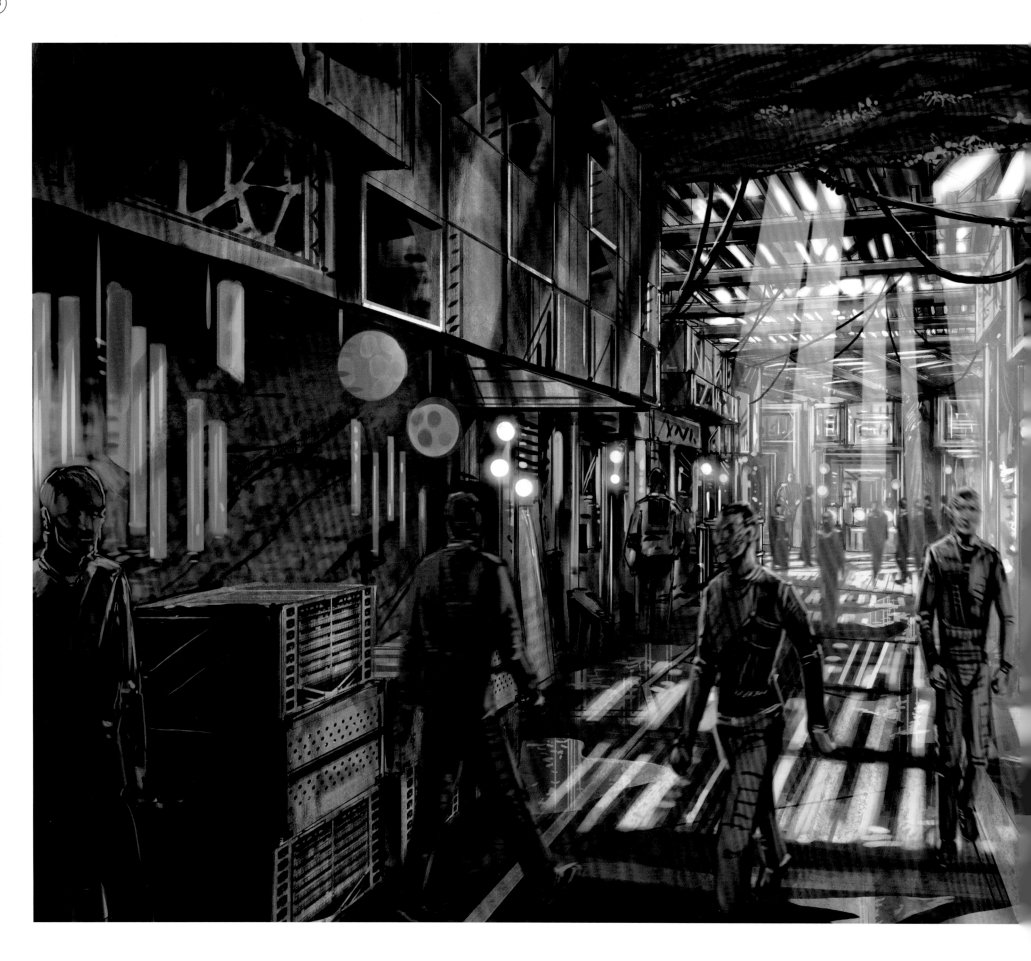

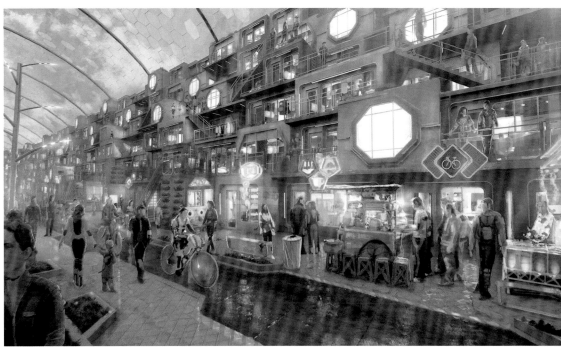

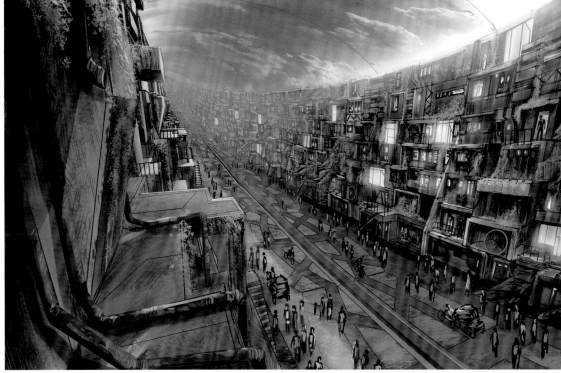

LEFT AND ABOVE: More art of Ceres Station. The residential areas (above) have an artificial sky projected across the facility's massive ceiling.

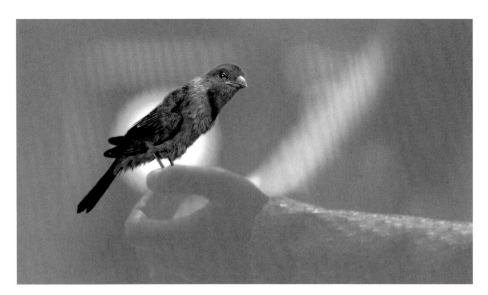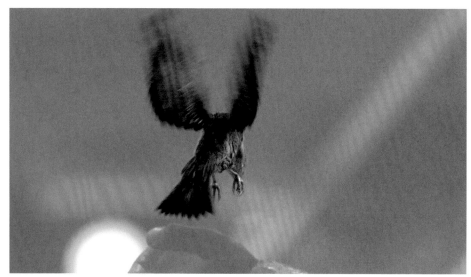

ABOVE AND BELOW: "The flapping of the bird's wings was painstakingly animated to convey the idea that the gravity on Ceres was less than that on Earth. Flying doesn't look quite the same in one-third-g," says showrunner Naren Shankar.

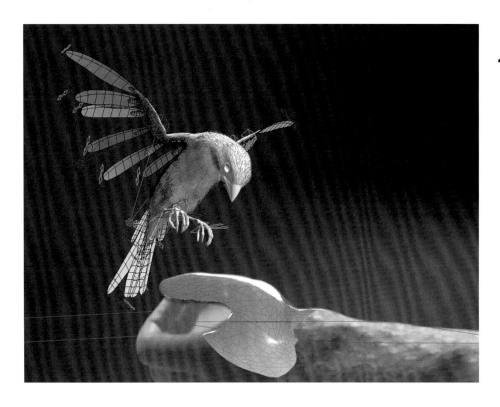

"I find that the bird is incredibly significant. It becomes a reflection of Miller in some way—alone and just a bit off. I don't know if that was the original intent, but it certainly became that, in my opinion. Is it real, or is it a figment of Miller's imagination? Seems real enough on Ceres, but what is it doing on Eros? To me, it's an extension of Miller—which gives me comfort and grounding when I see it. It was very difficult to animate properly. Many viewers thought it was poorly animated, but those viewers who really paid attention understood it to be suffering from the 1/3 g and mundaneness of Ceres—struggling to stay aloft, just like Miller. The animator, John Mariella, did a terrific job!"

Bob Munroe, senior VFX supervisor ⬎

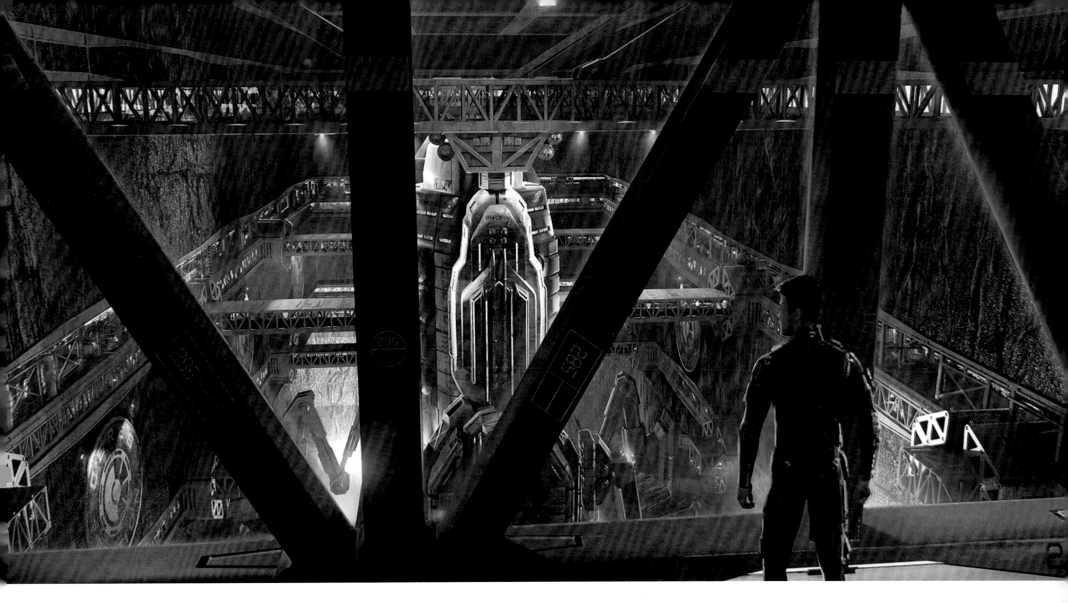

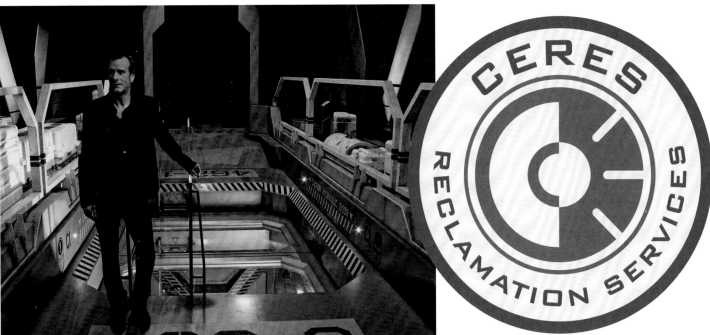

ΛBOVΞ: Ceres shipyard concept.

CERES RECLAMATION SERVICES

WASTE NOT WANT NOT

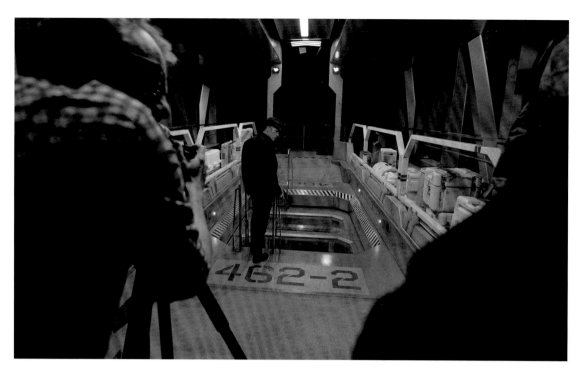

"The Ceres airlock was built 30 feet in the air so we could stack the vertical airlocks and shoot down through the layers. We built a very heavy horizontal set of airlock doors out of steel that could open on camera and support the crew when closed. It was then surrounded by a green screen so we could look out into the Ceres docks."

Robert Valeriote, construction coordinator ↘

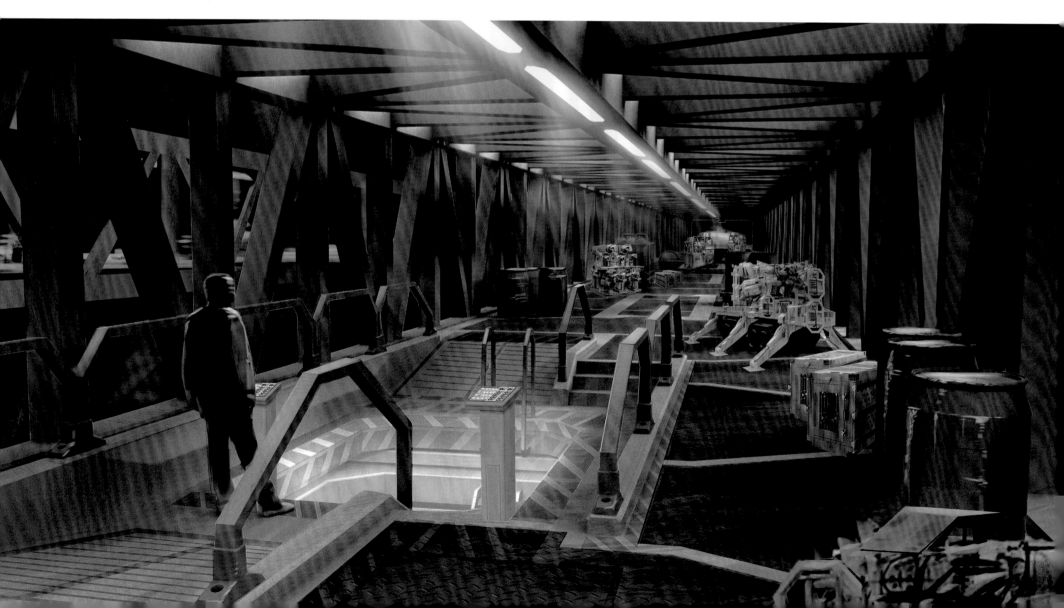

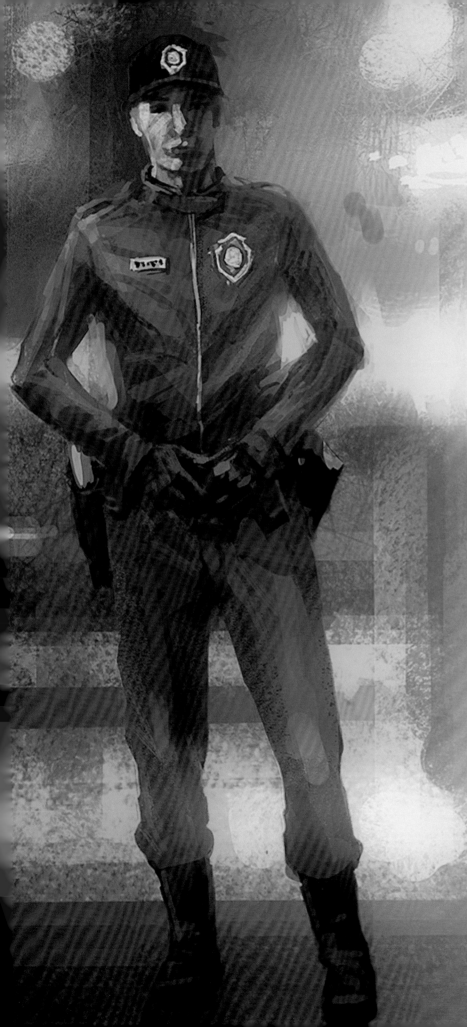

CRIME SCENE
TO BE OPENED BY AUTHORIZED PERSONNEL ONLY
DO NOT TAMPER WITH SEAL

EVIDENCE SEAL Tear to breach
IT IS A UNIVERSAL OFFENSE FOR NON-AUTHORIZED PERSONS TO TAMPER WITH A STAR HELIX SECURITY SEAL

TEAR HERE

CR-46587 CR-LVL-42
CASE NO. CASE LEVEL

HUNTER HIGH
OFFICER PRIORITY

68-078-1-605-89B

STAR HELIX
CERES STATION

"We wanted to ensure that the military presence is understood when it appears in the story, as it plays large in MCRN and UNN storylines. Star Helix is a corporate entity providing policing to the Belt, [so the uniform] should reflect just that."

Joanne Hansen, costume designer ↘

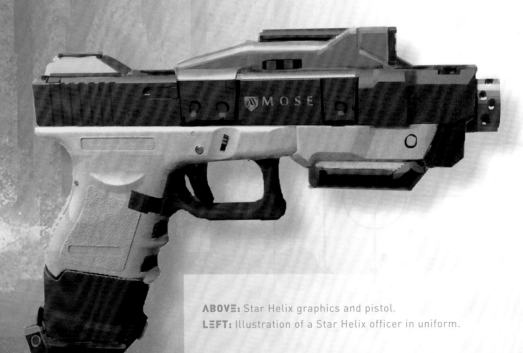

ABOVE: Star Helix graphics and pistol.
LEFT: Illustration of a Star Helix officer in uniform.

MILLER

Josephus 'Joe' Miller (Thomas Jane) is a world-weary Belter detective, working for Star Helix Security on Ceres. Disillusioned by life, distrusted by other Belters, Miller is only interested in getting by in the corrupt systems that run the Belt. But when assigned to the Julie Mao case, he begins to find meaning beyond just survival—a purpose bigger than himself.

ABOVE: Thomas Jane on the Ceres set where his character, Miller, almost spaces a Belter.

"I see him in both worlds—he's a Belter, a cop who's working for a foreign company, policing his own people, and so he is thought to be a traitor to his own people."

Thomas Jane ↘

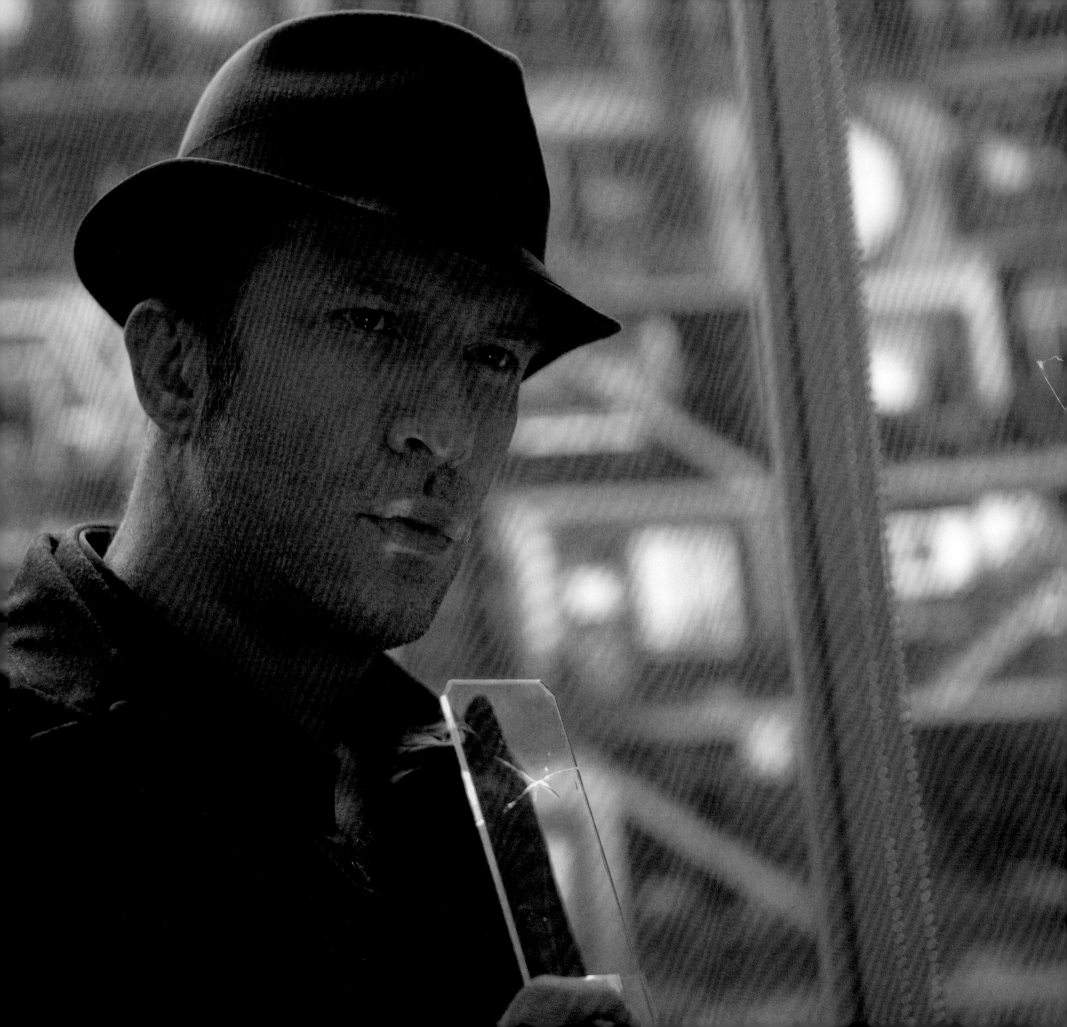

BELTERS

Belters are the descendants of those humans brave, foolhardy, or desperate enough to have colonized the asteroid belt between Mars and Jupiter. With their distinctive Creole dialect and elongated skeletons, Belters consider themselves a distinct ethnic and cultural group from those who reside in the inner planets. Resentment toward the exploitative Inners runs rampant, leading many Belters to demand the right of self-governance.

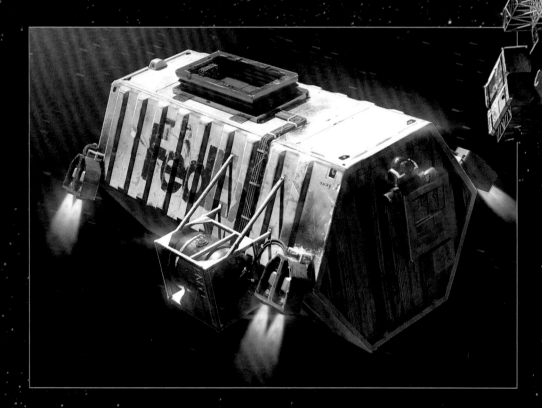

RIGHT: The Belter cargo vessel *Guy Molinari*, piloted by Fred Johnson and Camina Drummer during the assault on Thoth Station (one of the breaching pods disguised as a container, above). Showrunner Naren Shankar: "We asked Fred Smith, the founder of FedEx who also founded Alcon, for permission to put the FedEx logo on the side of the storage container used to breach Thoth Station in Season 2. He loved the idea and let us do it."

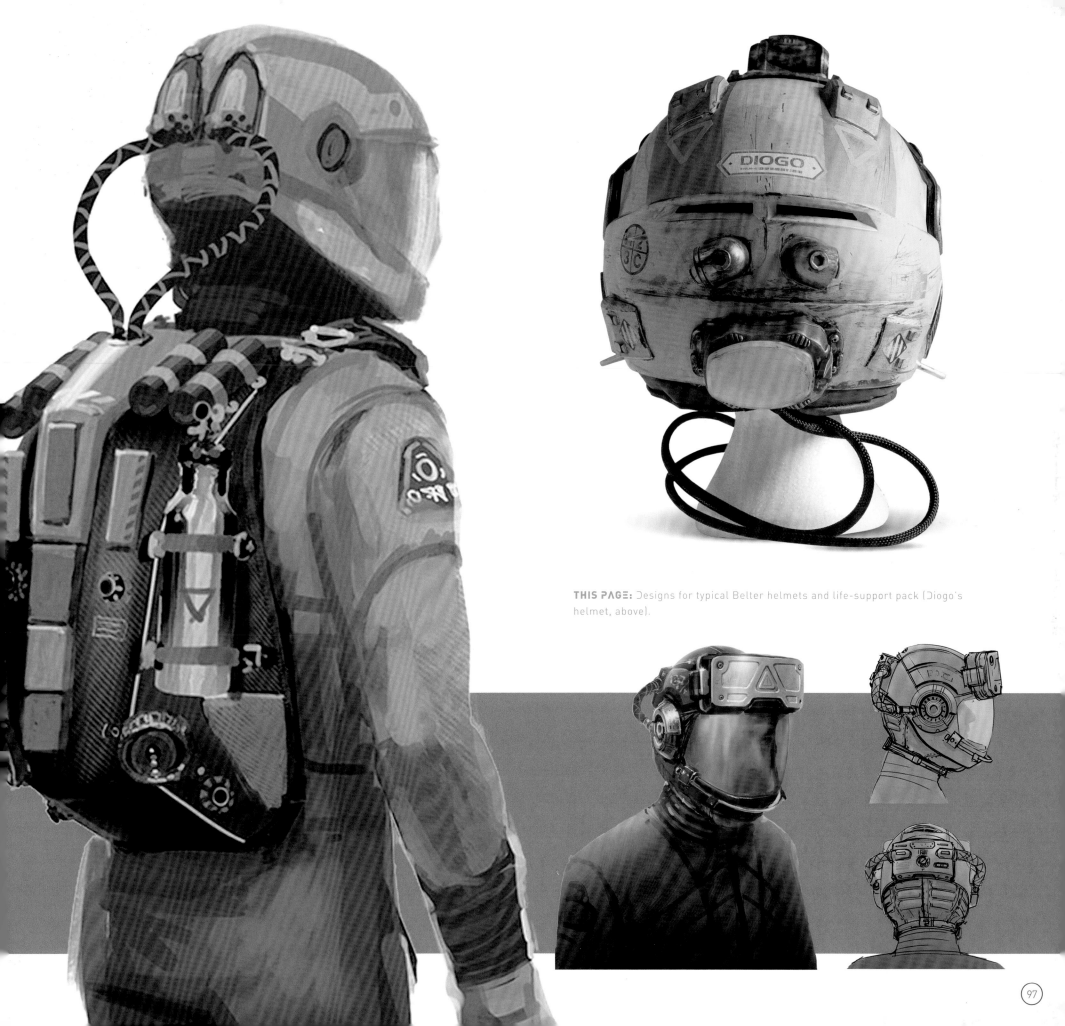

THIS PAGE: Designs for typical Belter helmets and life-support pack (Diogo's helmet, above).

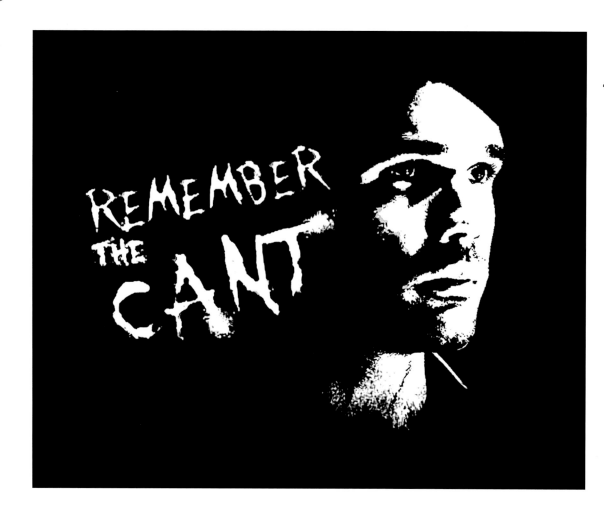

"I think we've evolved the idea of what a Belter is beyond the books a little, not because we think we're clever, but because we couldn't really figure out how to do it the way it is in the books, where everybody has a consistent kind of look."

Mark Fergus, executive producer ↘

BELOW: Background actors from the show cast as Belters. Ty Franck: "In the first season we had a makeup department that was responsible for getting a hold of all the various tattoos and worked closely with the art department to come up with the various designs and stuff. Naren Shankar, the showrunner, had a lot of input in that, Mark Fergus as well, who was on set for all of that, had a lot of input, so it really was kind of a team thing to come up with all that."

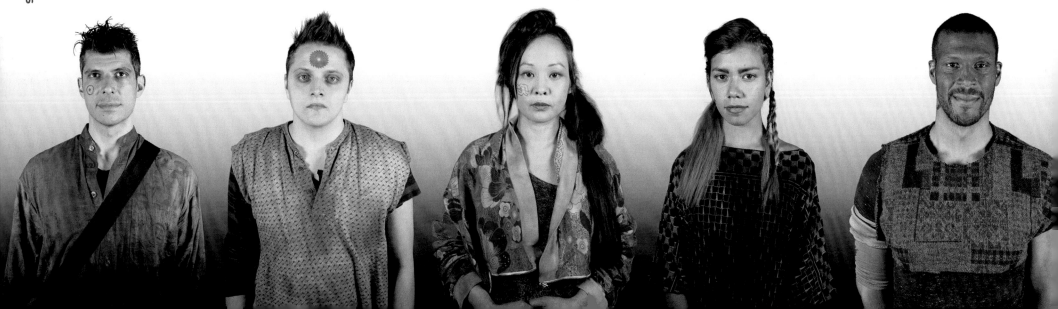

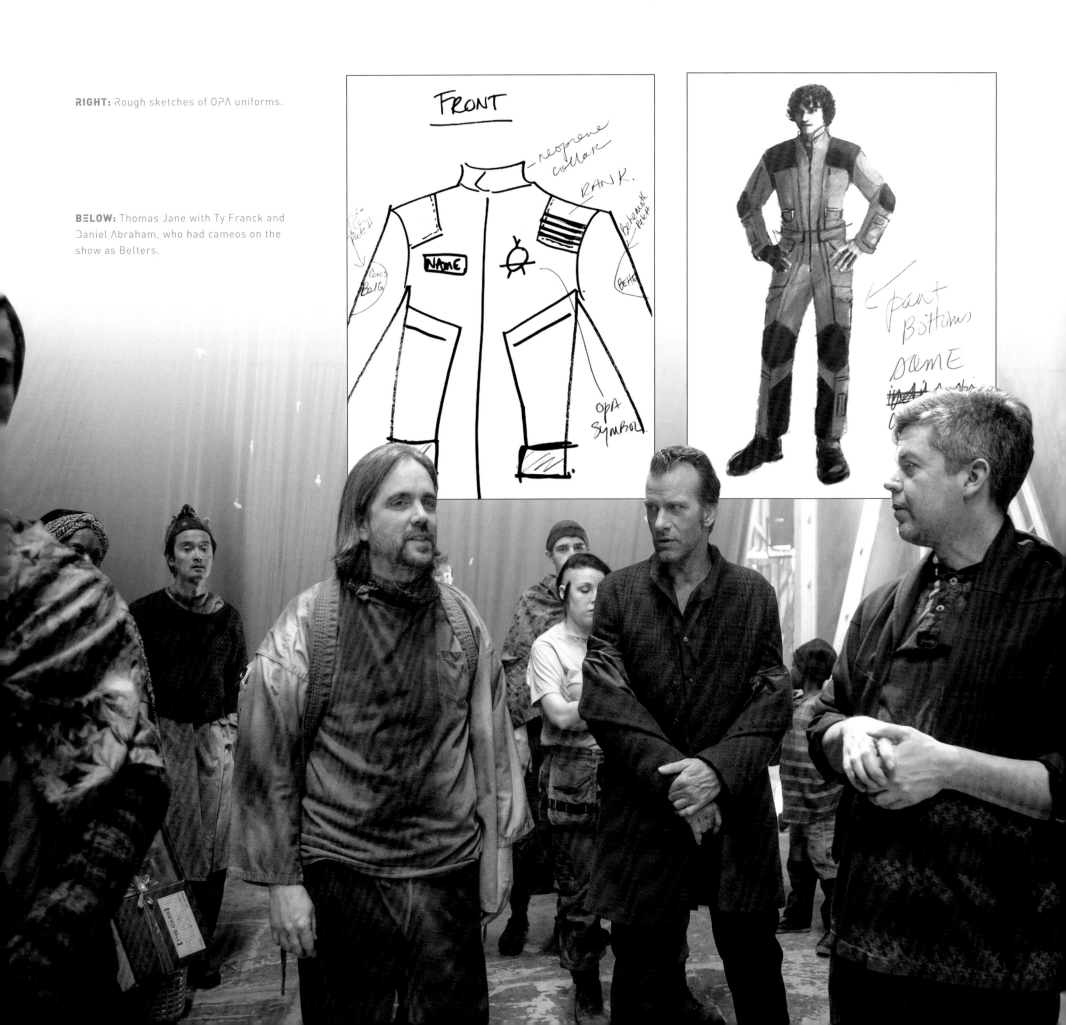

RIGHT: Rough sketches of OPA uniforms.

BELOW: Thomas Jane with Ty Franck and Daniel Abraham, who had cameos on the show as Belters.

FRONT

neoprene collar

RANK.

NAME

OPA SYMBOL.

pant Bottoms SAME

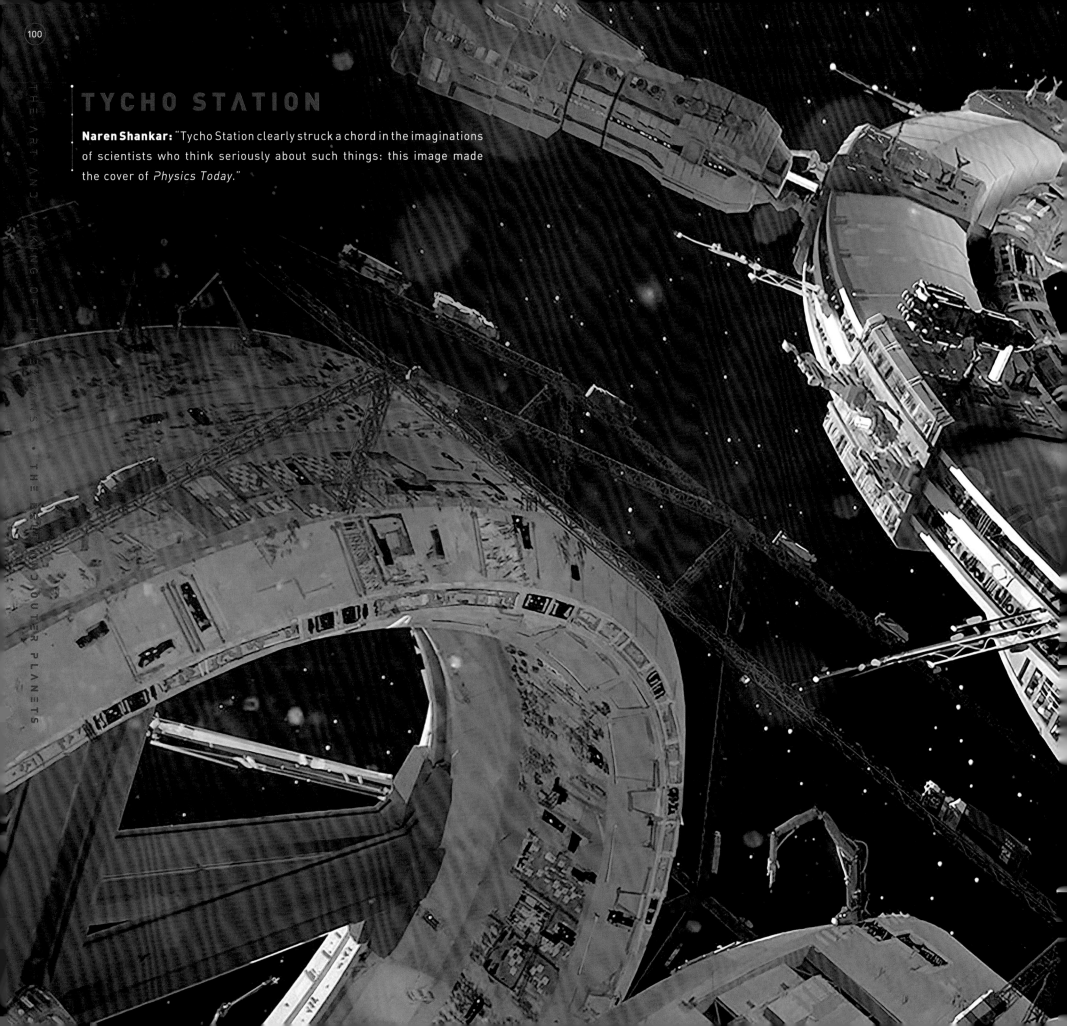

TYCHO STATION

Naren Shankar: "Tycho Station clearly struck a chord in the imaginations of scientists who think seriously about such things: this image made the cover of *Physics Today*."

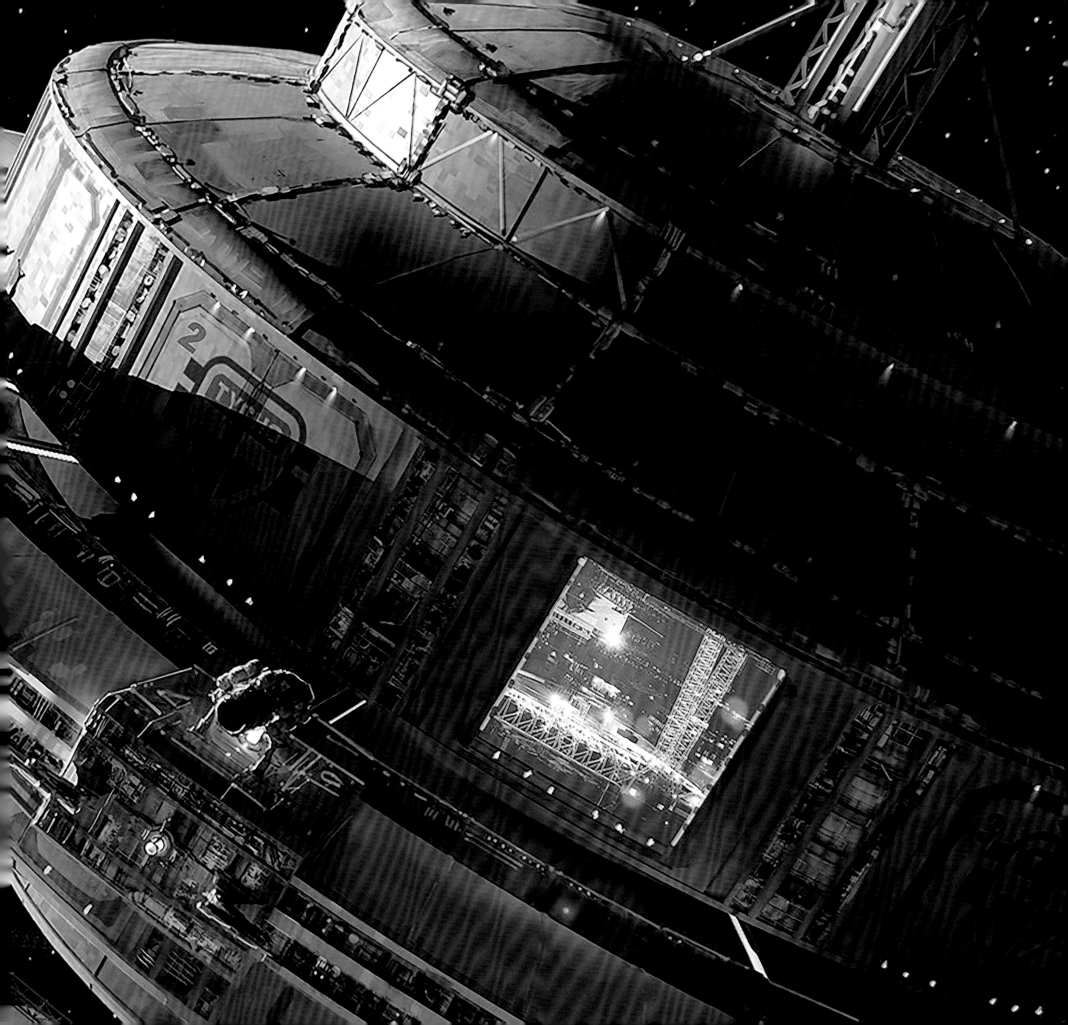

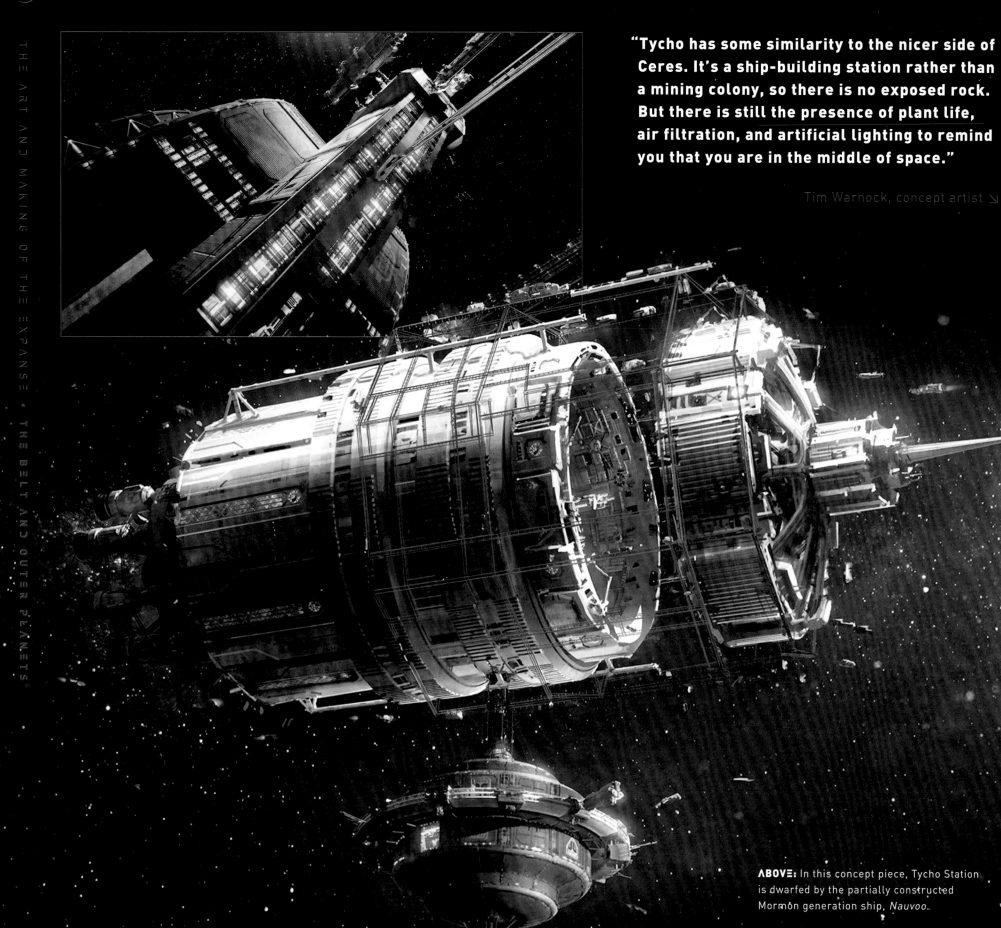

"Tycho has some similarity to the nicer side of Ceres. It's a ship-building station rather than a mining colony, so there is no exposed rock. But there is still the presence of plant life, air filtration, and artificial lighting to remind you that you are in the middle of space."

Tim Warnock, concept artist ↘

ABOVE: In this concept piece, Tycho Station is dwarfed by the partially constructed Mormon generation ship, *Nauvoo*.

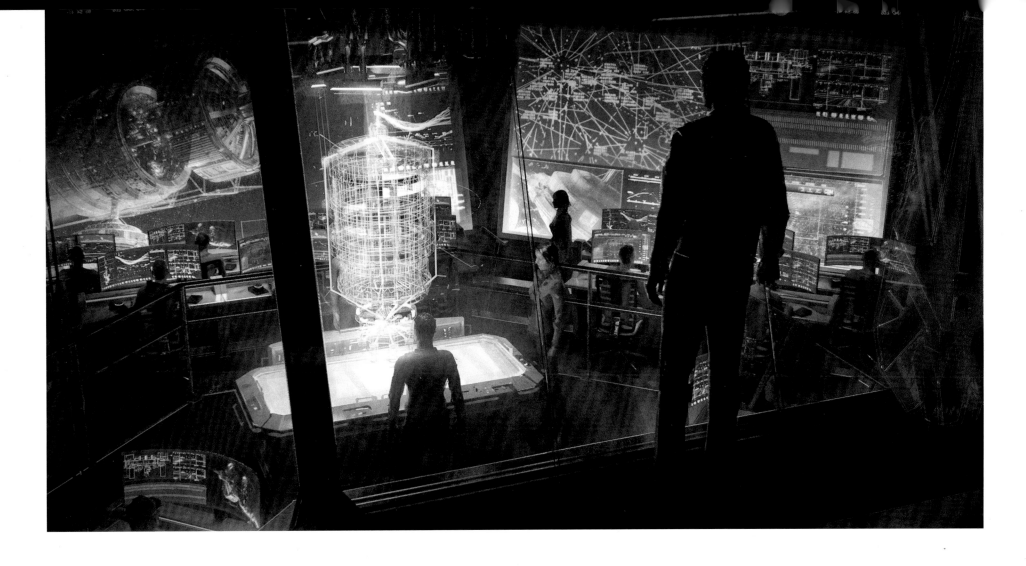

THIS PAGE: Illustrations of Fred Johnson's office overlooking the Tycho control room.

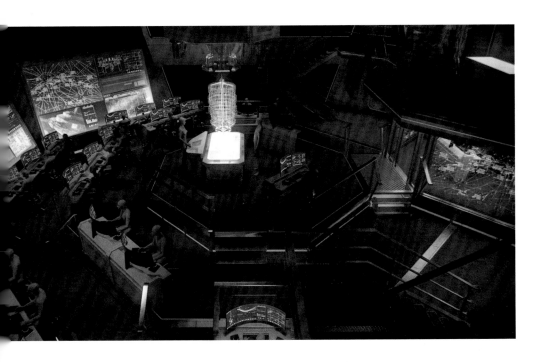

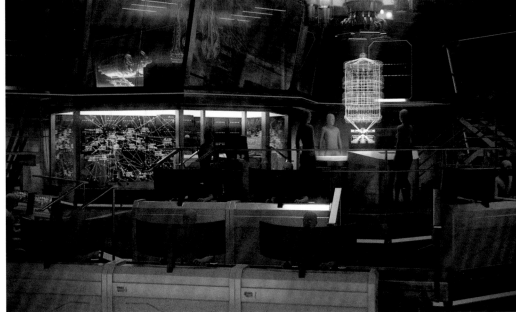

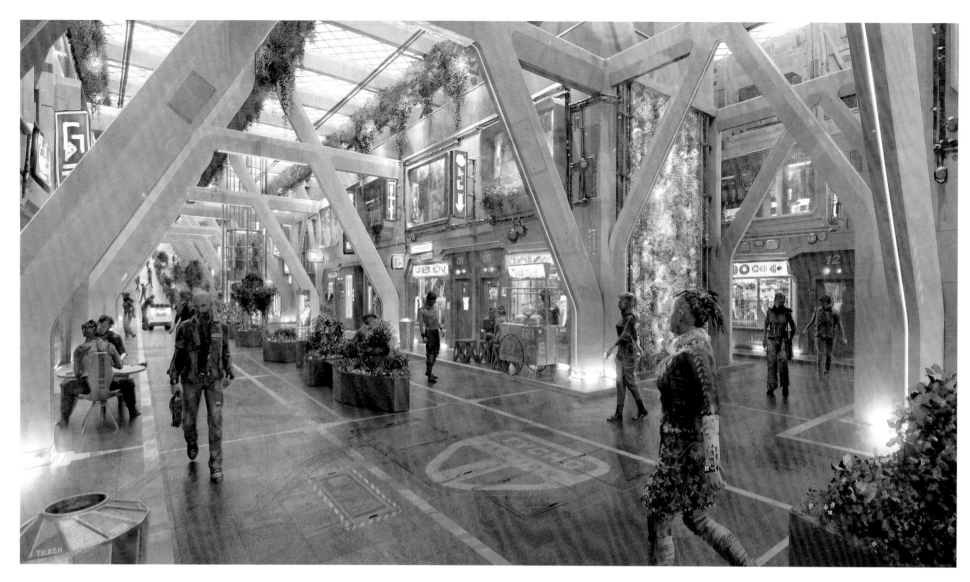

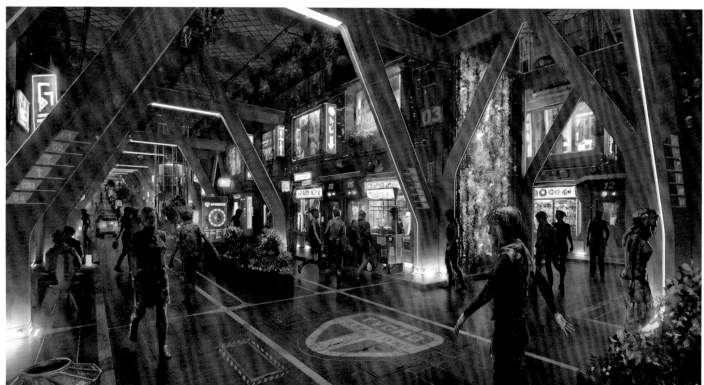

ABOVE AND RIGHT: Night and day depictions of Tycho's habitation ring.

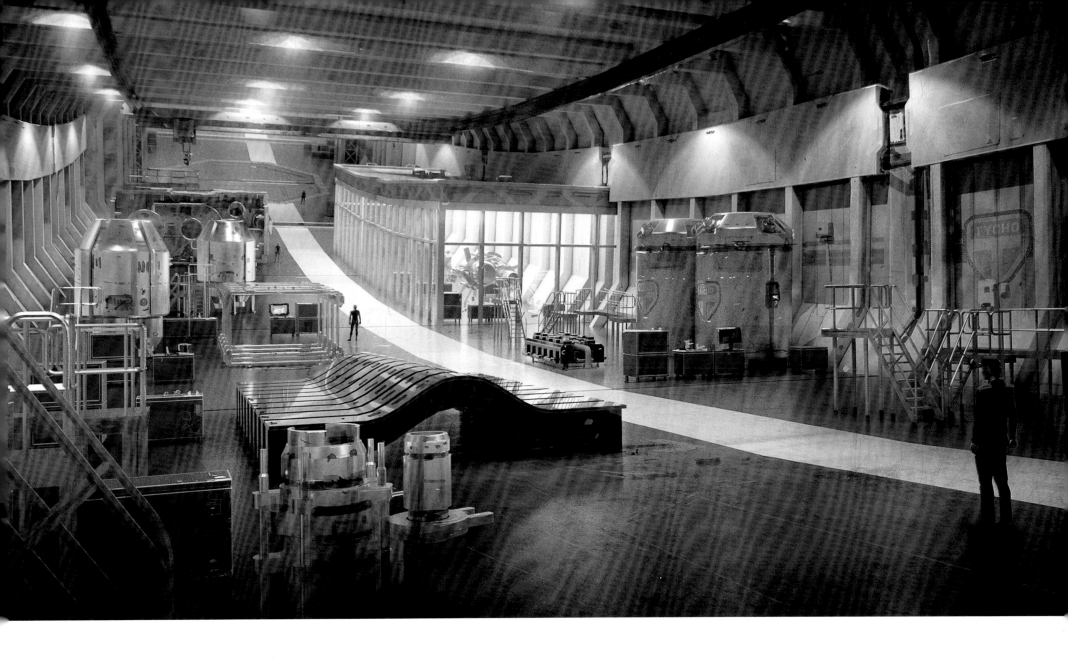

ABOVE AND BELOW: The industrial and engineering areas of Tycho are presented as neat and orderly areas in concept art (above), although the final sets are somewhat darker and less polished (below).

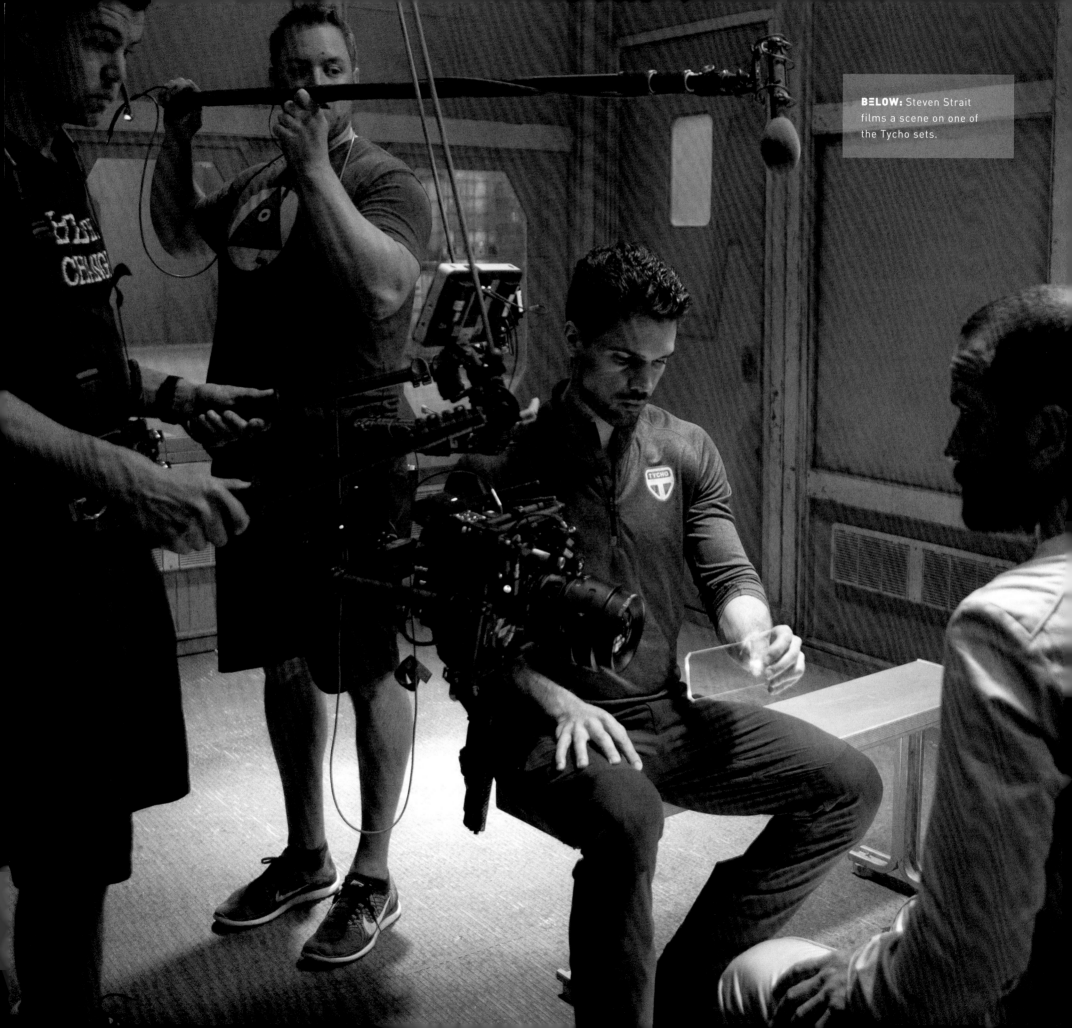

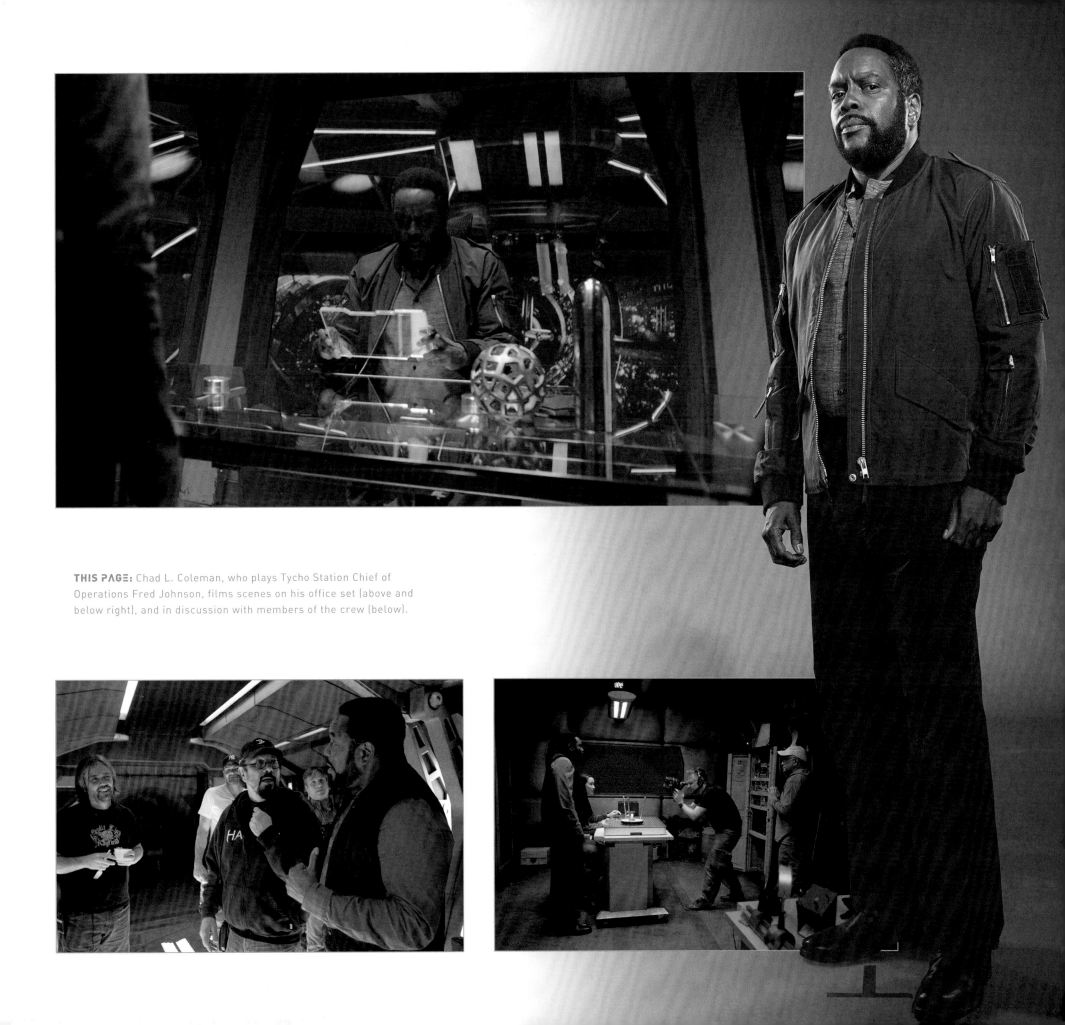

THIS PAGE: Chad L. Coleman, who plays Tycho Station Chief of Operations Fred Johnson, films scenes on his office set (above and below right), and in discussion with members of the crew (below).

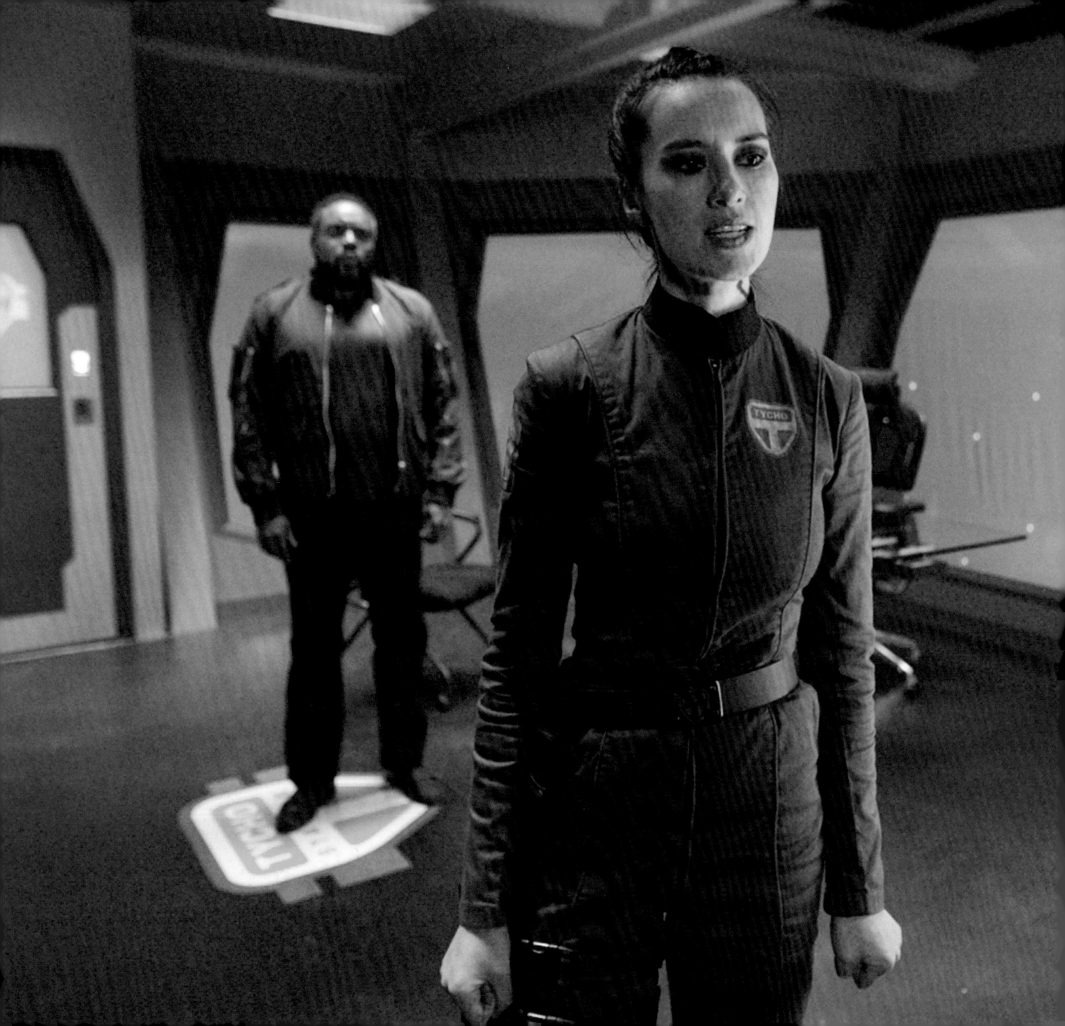

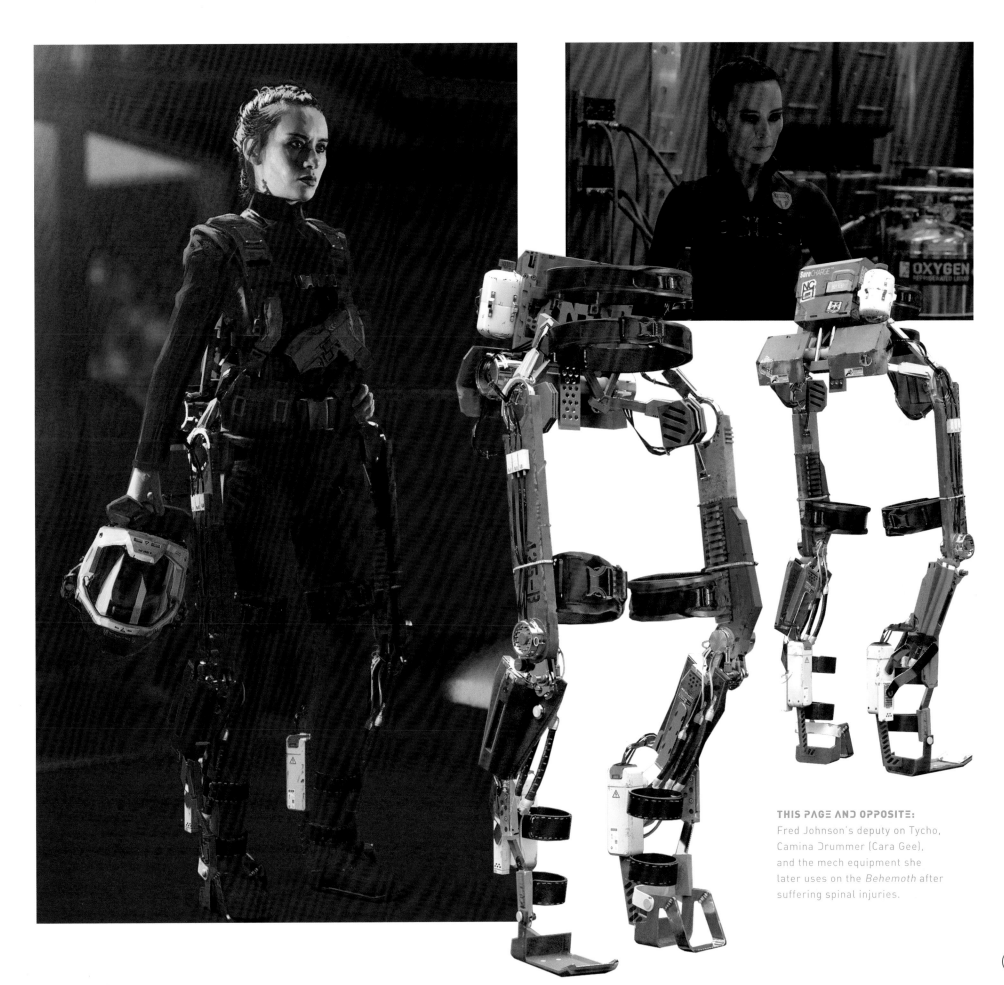

Fred Johnson's deputy on Tycho,
Camina Drummer (Cara Gee),
and the mech equipment she
later uses on the *Behemoth* after
suffering spinal injuries.

109

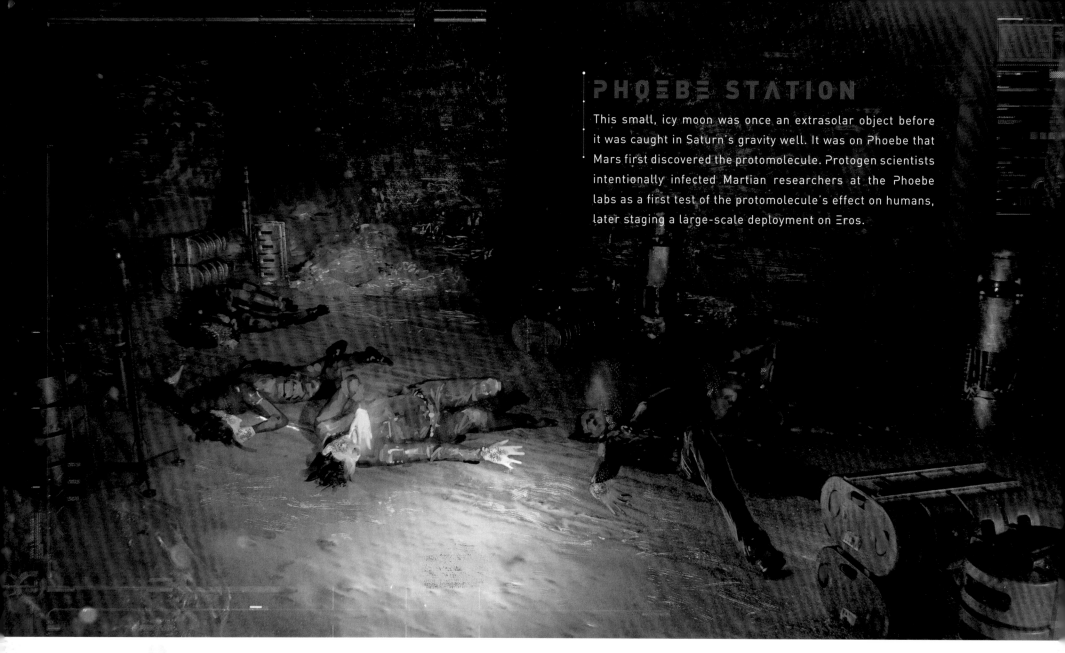

PHOEBE STATION

This small, icy moon was once an extrasolar object before it was caught in Saturn's gravity well. It was on Phoebe that Mars first discovered the protomolecule. Protogen scientists intentionally infected Martian researchers at the Phoebe labs as a first test of the protomolecule's effect on humans, later staging a large-scale deployment on Eros.

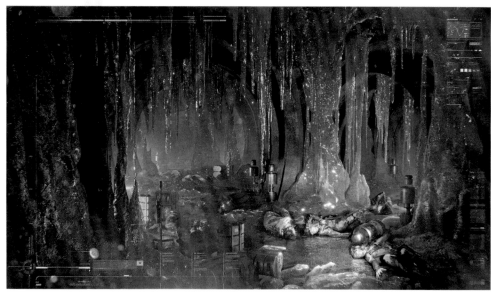

"Here we are building on the notion that something really bad is going down, but we don't know yet what it is. It's dark and jarring, for sure."

Tim Warnock, concept artist ↘

ABOVE AND LEFT: Concept drawings of the horrific scenes that greet Holden, Miller, and company at Phoebe.

THOTH STATION

After the infection of Phoebe Station, Protogen moved their labs to Thoth Station. When the *Rocinante* and *Guy Molinari* raid the station, they discover that many of the scientists have willingly undergone neurosurgery to inhibit empathy.

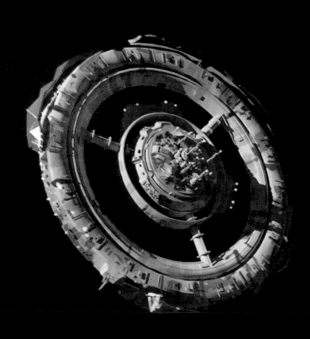

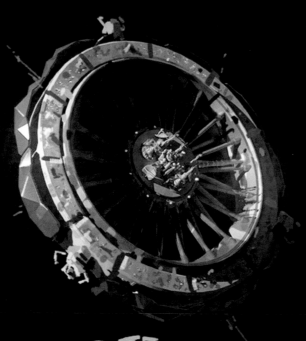

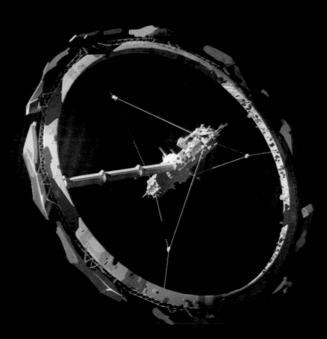

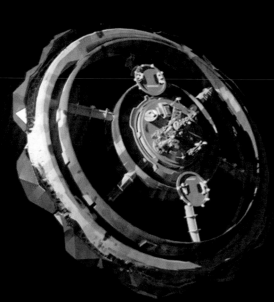

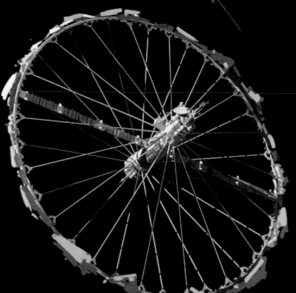

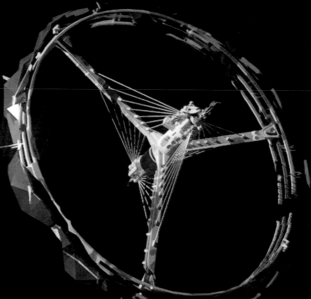

GANYMEDE

Ganymede is the largest moon of Jupiter. Because of its magnetosphere, it has become the breadbasket of the Belt, with hundreds of agricultural domes supplying food to millions of Belters. Orbital mirrors reflect sunlight down to the domes to support crop growth.

BELOW: Artwork of Ganymede's surface—one of the greenhouse domes can be seen in the background.

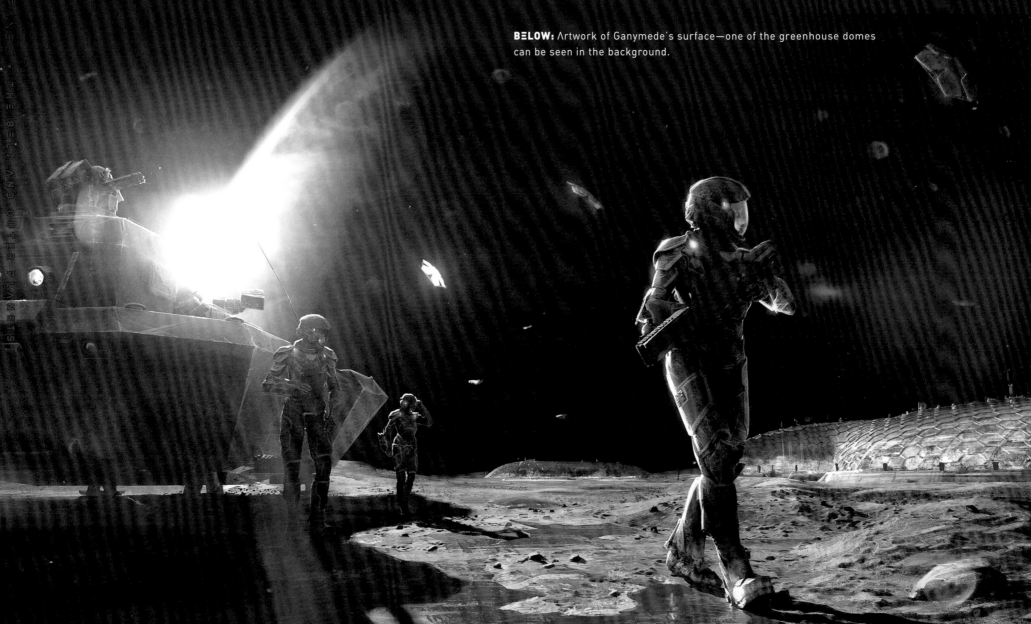

THIS PAGE: Terry Chen as botanist and Ganymede resident Praxidike Meng. "Prax is one of the few characters we have in the show that is pretty pure of heart," says showrunner Naren Shankar.

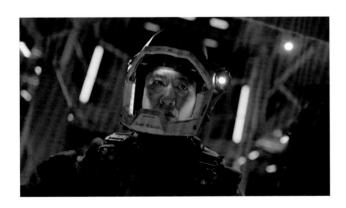
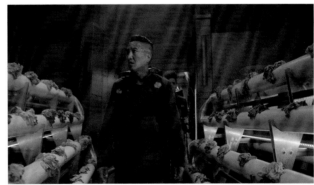

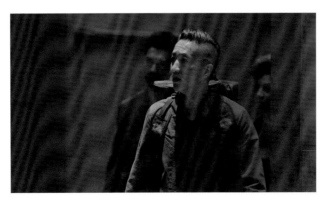

"Prax is a Belter, but he's a different kind of Belter because he's been on Ganymede most of his life. He's a botanist, he's a scientist, he's an educated guy. You can also see that he doesn't have tattoos either. He doesn't have these Belter tattoos."

Terry Chen ⬂

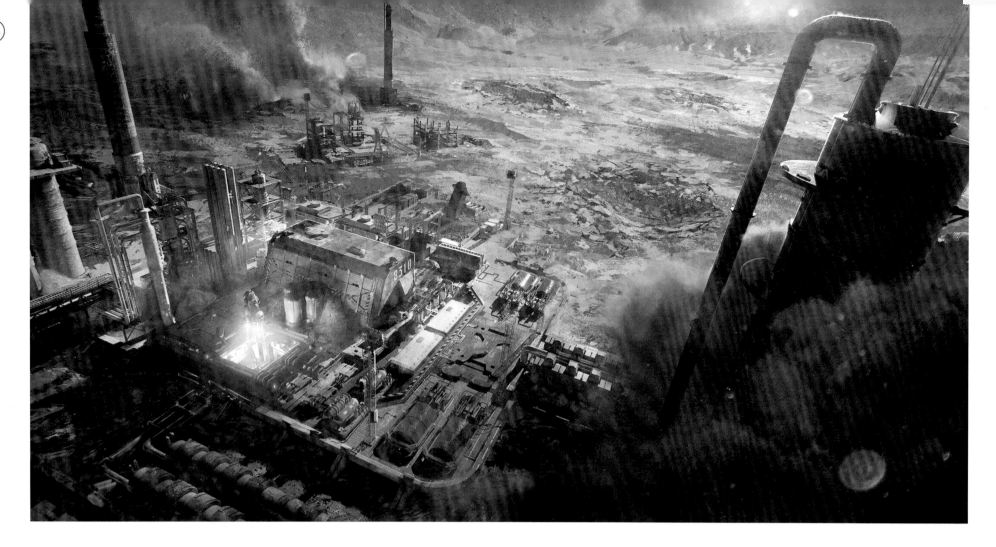

IO

Naren Shankar: "Jupiter's moon, Io, is the most volcanically active place in the solar system—the perfect spot to keep away from prying eyes and transform children into Protomolecule Hybrids. Prospero Station was designed to look like an abandoned oil refinery in the middle of a desert."

ABOVE: The Protogen facility dominates the bleak landscape on Io.

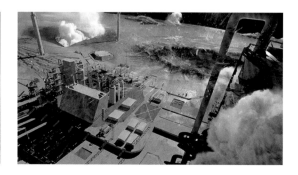
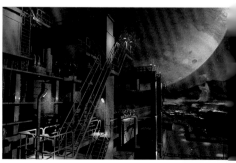

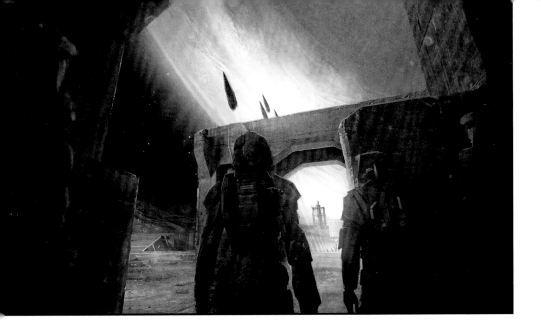
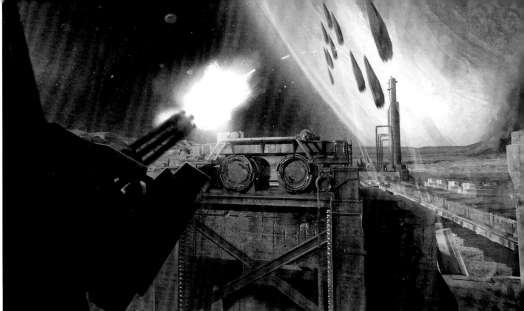

ABOVE AND BELOW: More views of the Protogen facility, showing the launch of various hybrids housed within missiles.

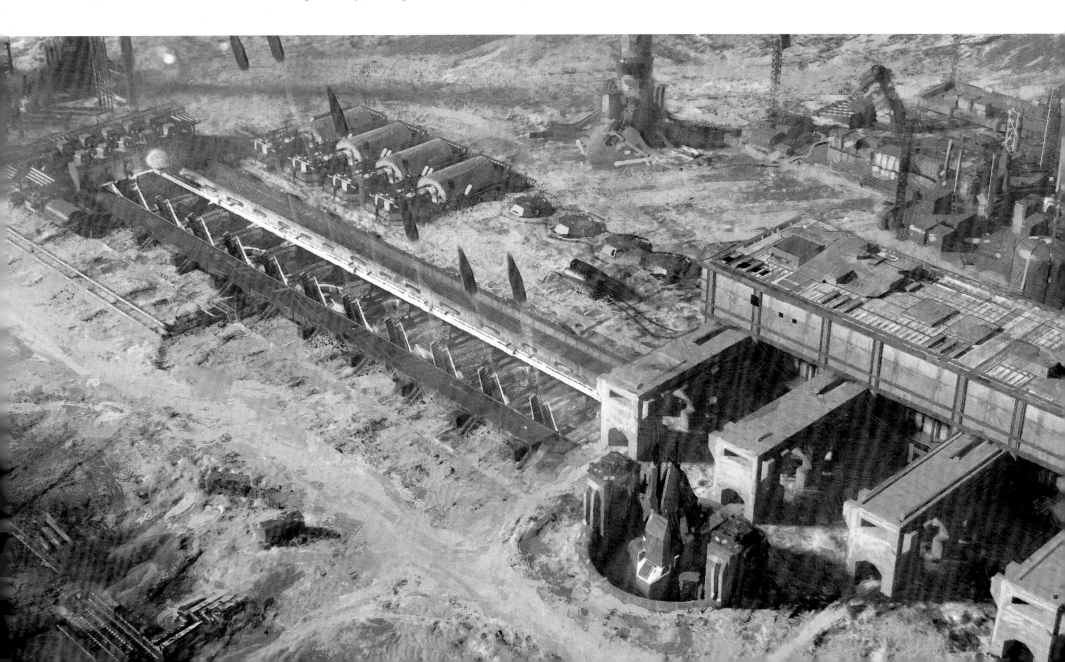

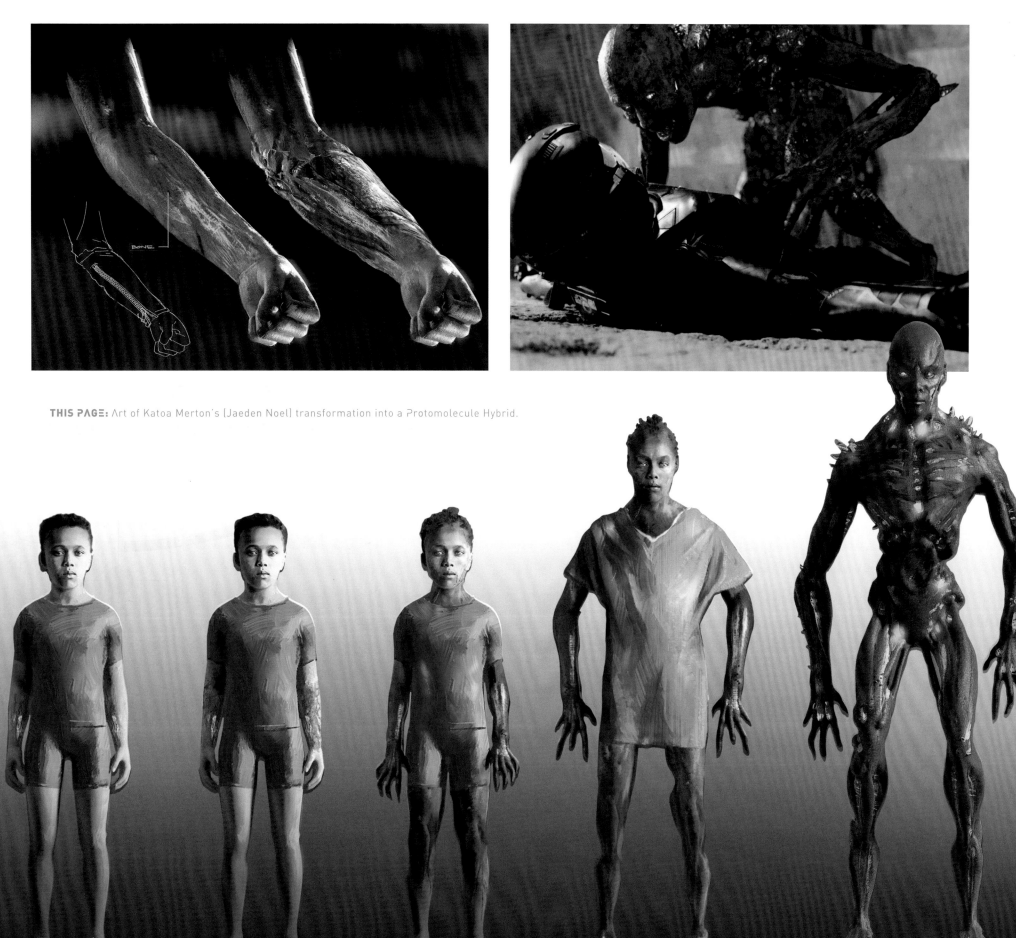

THIS PAGE: Art of Katoa Merton's (Jaeden Noel) transformation into a Protomolecule Hybrid.

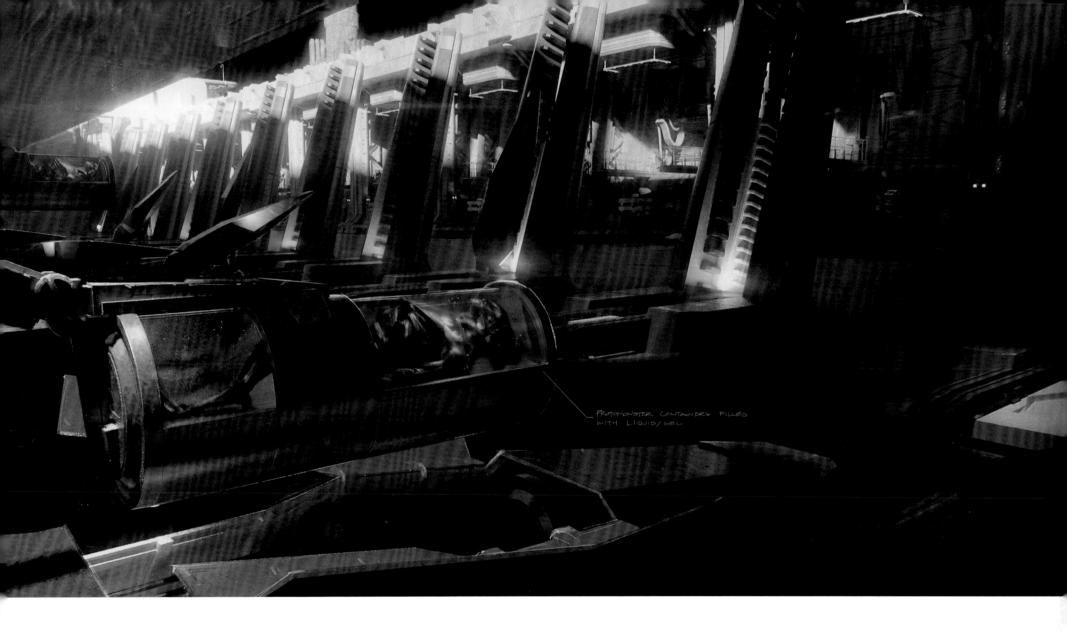

PROTOMONSTER CONTAINERS FILLED WITH LIQUID/GEL

ABOVE: Protomolecule Hybrids ready to launch from Io.
LEFT: François Chau (Jules-Pierre Mao) and Leah Jung (Mei Meng) on the Protogen facility set.

NAUVOO / BEHEMOTH

Naren Shankar: "The Mormon generation ship begins as an aspiration, is stolen to be used as a battering ram, salvaged to become the flagship of the OPΛ, and then transformed into a home for Belters. Elements of the ship's original religious iconography can be seen in every incarnation."

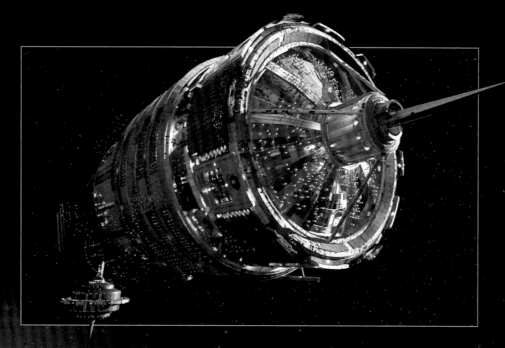

ABOVE: The *Nauvoo* leaving Tycho Station.
RIGHT: Close-up art of the *Nauvoo*'s command center and super-powerful communications laser.

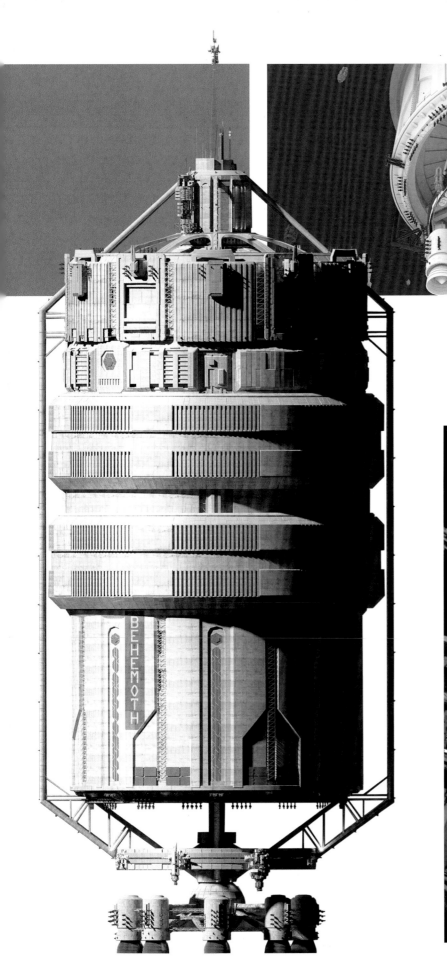

ABOVE: Computer models of the sequence where Drummer's fleet retrieves the stranded *Nauvoo*.

"When the ship is built as the *Nauvoo* the intention was that it would only be going in a straight line, it didn't need to maneuver. Once Fred Johnson claims it as a warship for the OPΛ they use hundreds of tugs positioned all over the sides of the ship to act as maneuvering thrusters, as well as multiple weapons."

Tim Warnock, concept artist ↘

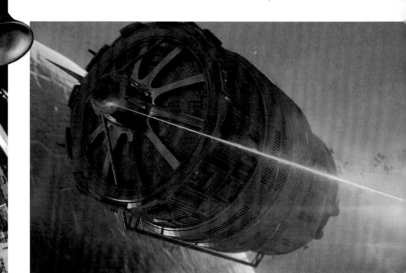

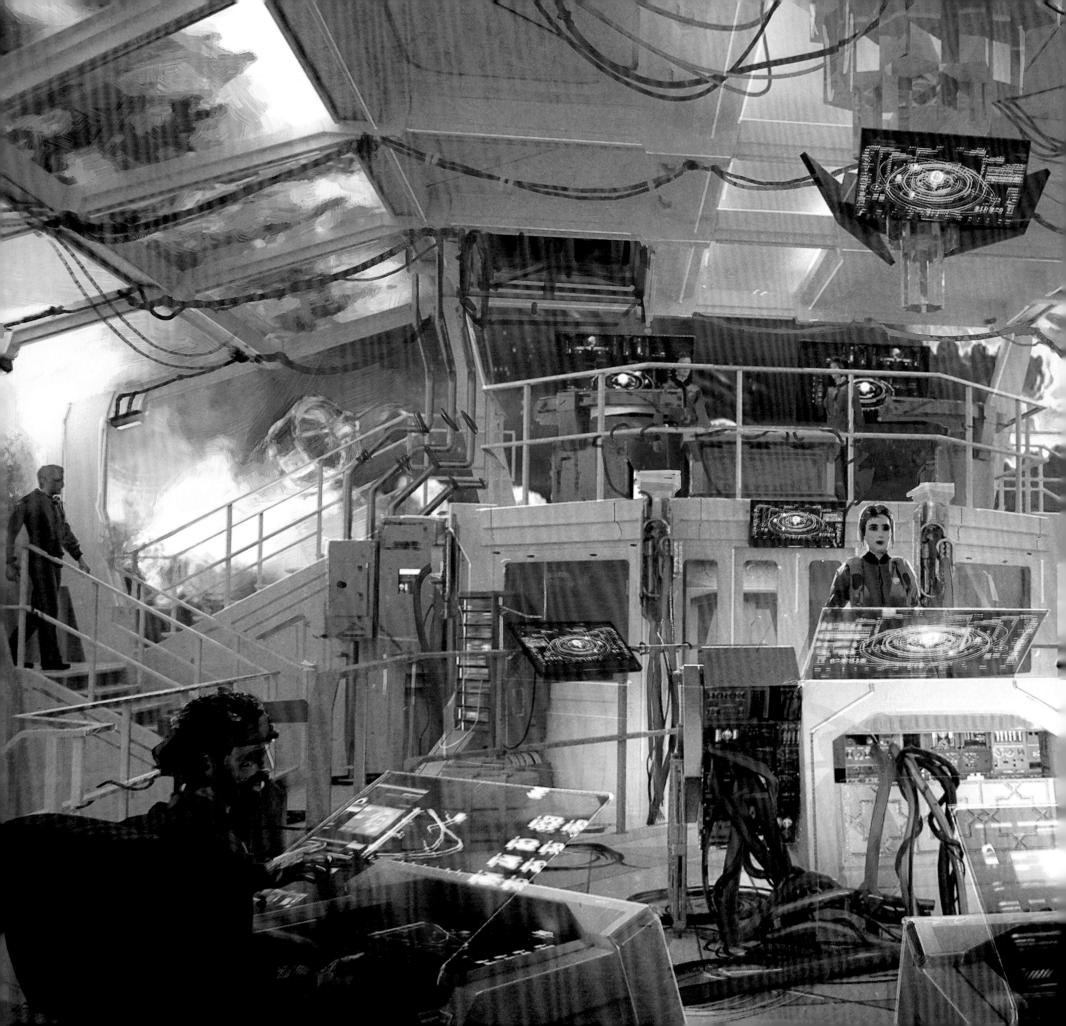

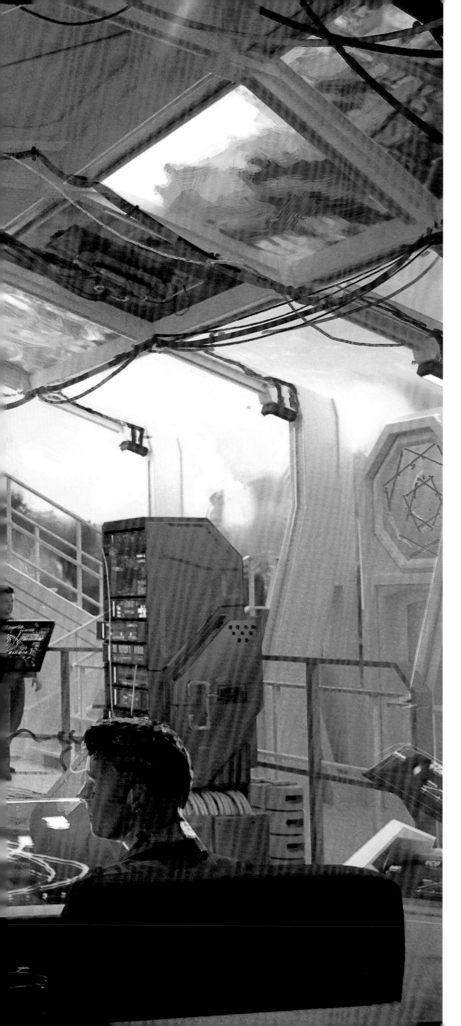

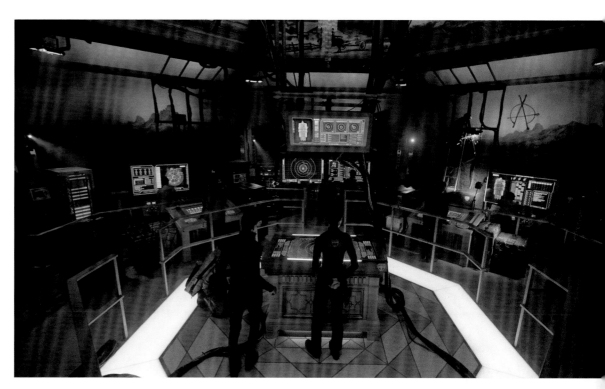

"I love the way [the *Behemoth* command room] clearly has this sense of having been a temple that is now a workroom. It's got all of the very thoughtful, very intentional, very reverential design choices that were made originally, and then they ran some cable across it."

Daniel Abraham ↘

LEFT: Concept piece of the *Behemoth*'s 'bridge,' showing a somewhat brighter color scheme than the final set (above).

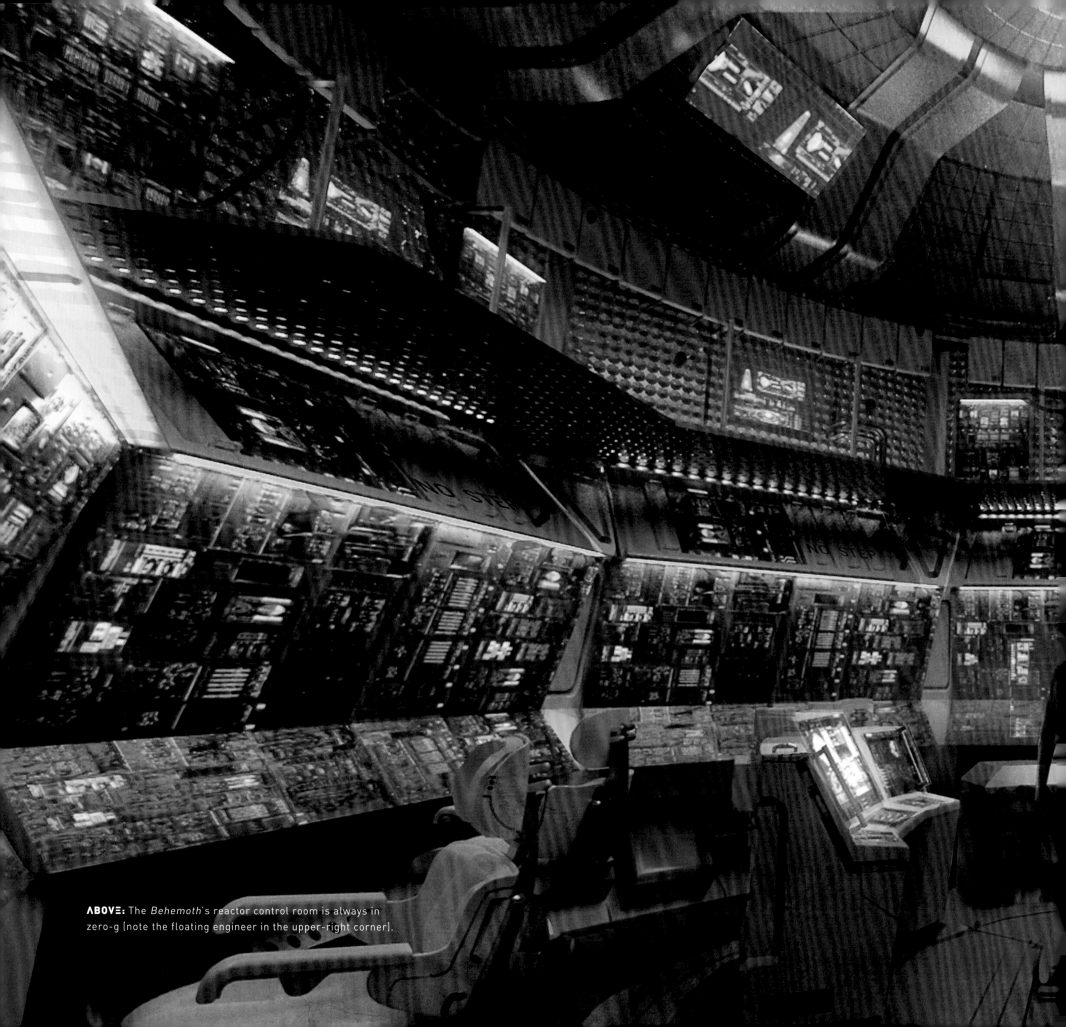

ΛBOVΞ: The *Behemoth*'s reactor control room is always in zero-g (note the floating engineer in the upper-right corner).

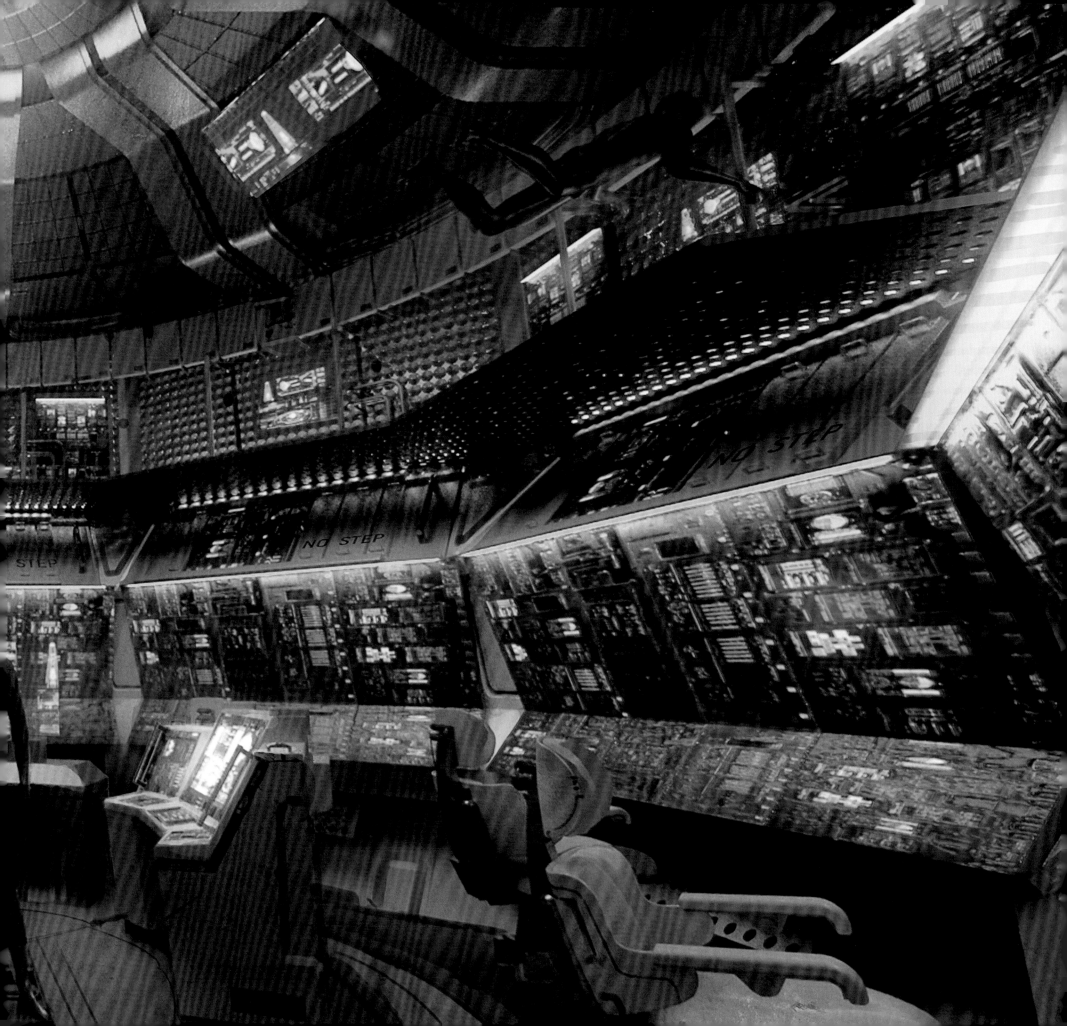

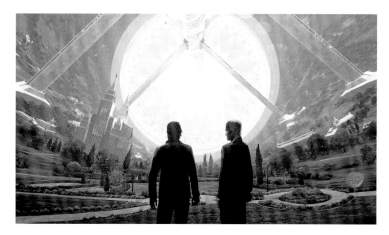
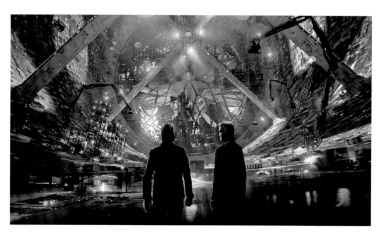

"The *Nauvoo* was definitely a very challenging environment to build. Details that only the most observant would see are deliberately esoteric. Architecture, infrastructure, even signage—all played into conveying a densely rich tableau that was never intended to be anything more than a backdrop. No detail was superfluous, everything meant something, but you'd never notice most things seeing them just once. It rewards repeated viewing."

Bob Munroe, senior VFX supervisor ↘

ABOVE: Artworks of the *Nauvoo*'s vast interior with its artificial 'sun' on (left) and off (right).
BELOW: The *Behemoth* takes on the wounded of other vessels after the activation of the 'slow zone' in this concept piece.

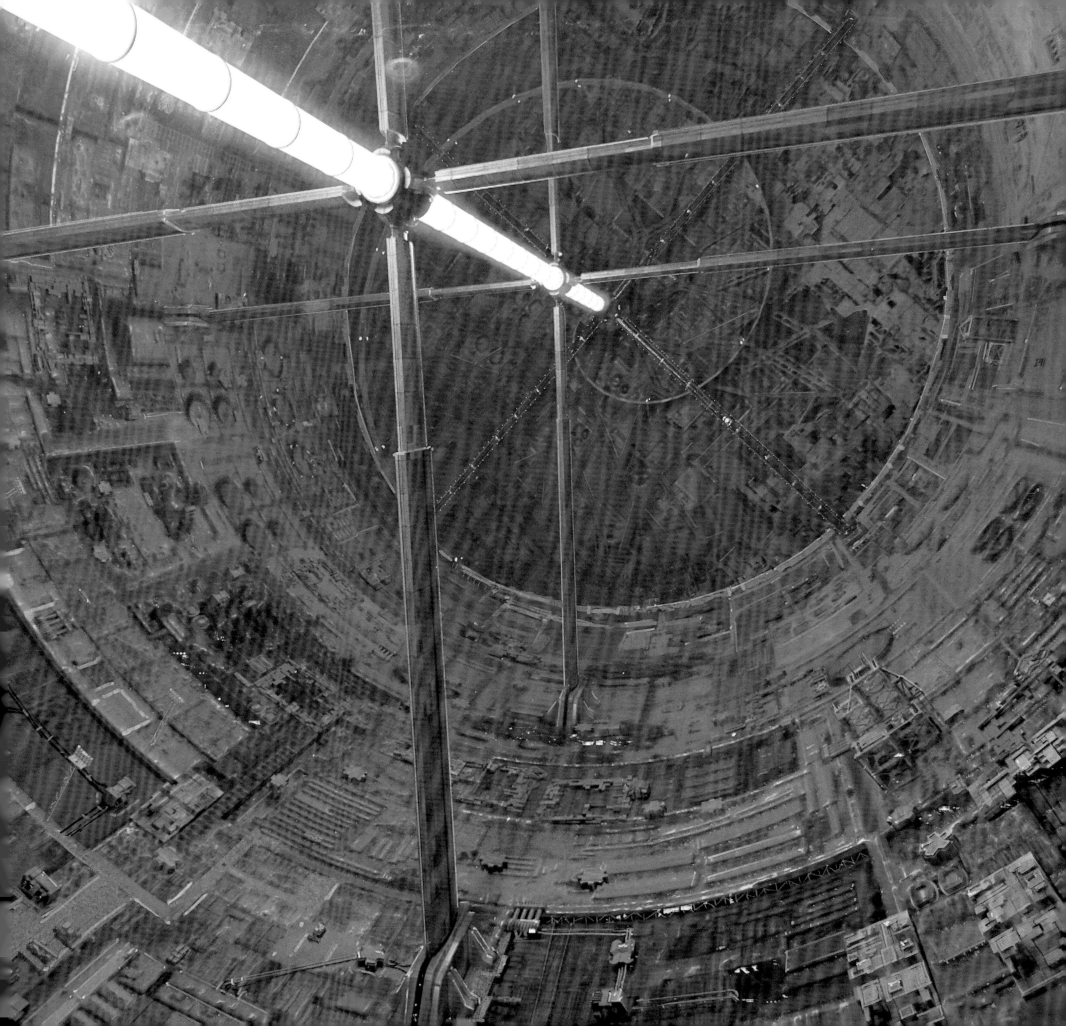

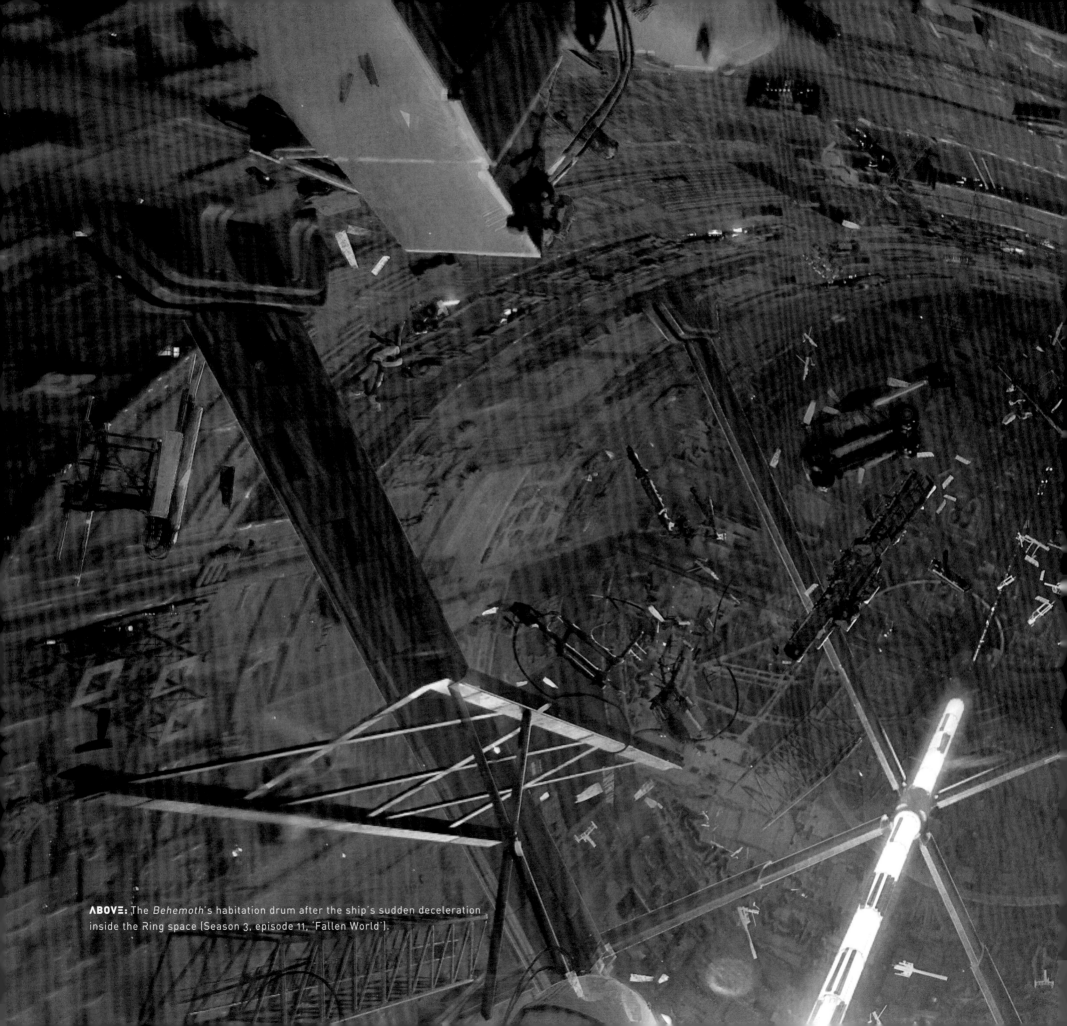

ABOVE: The *Behemoth*'s habitation drum after the ship's sudden deceleration inside the Ring space (Season 3, episode 11, 'Fallen World').

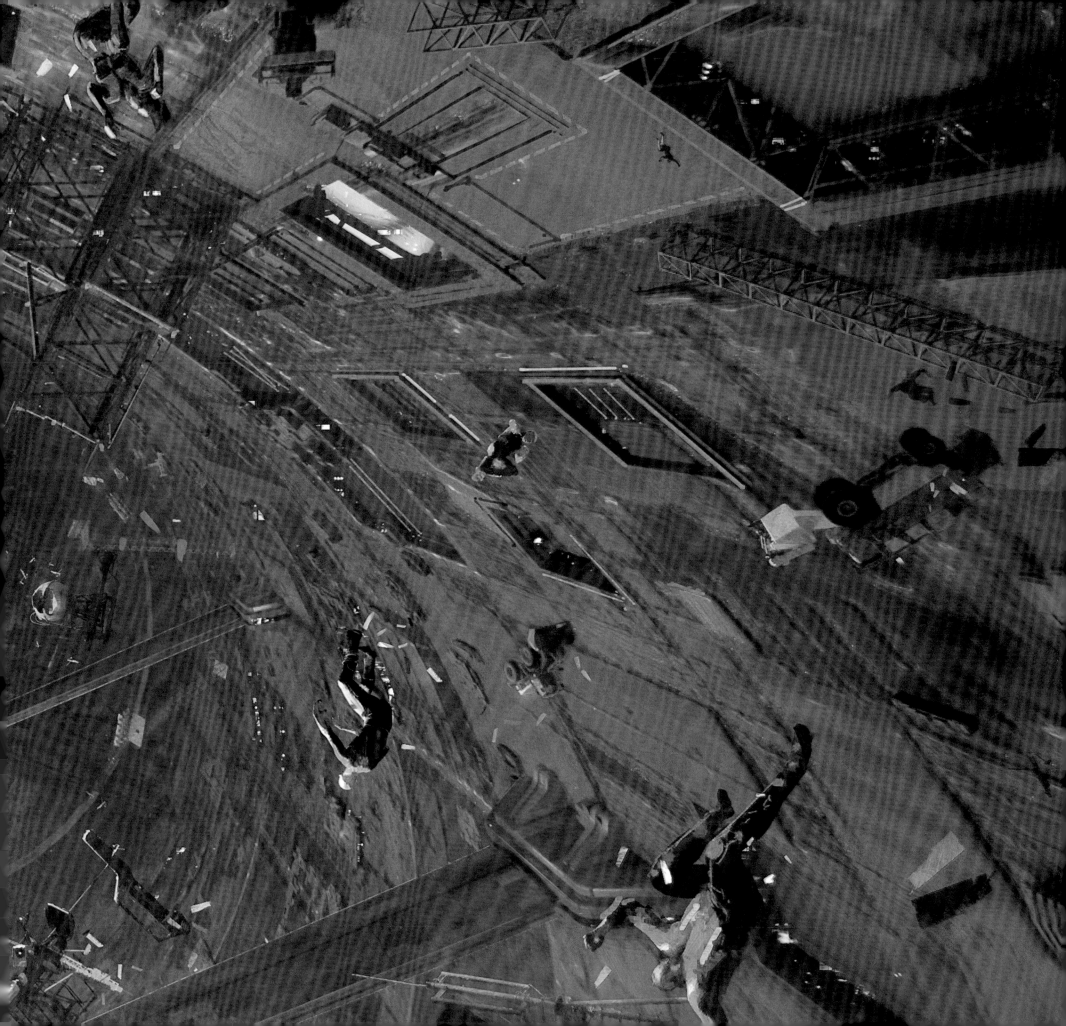

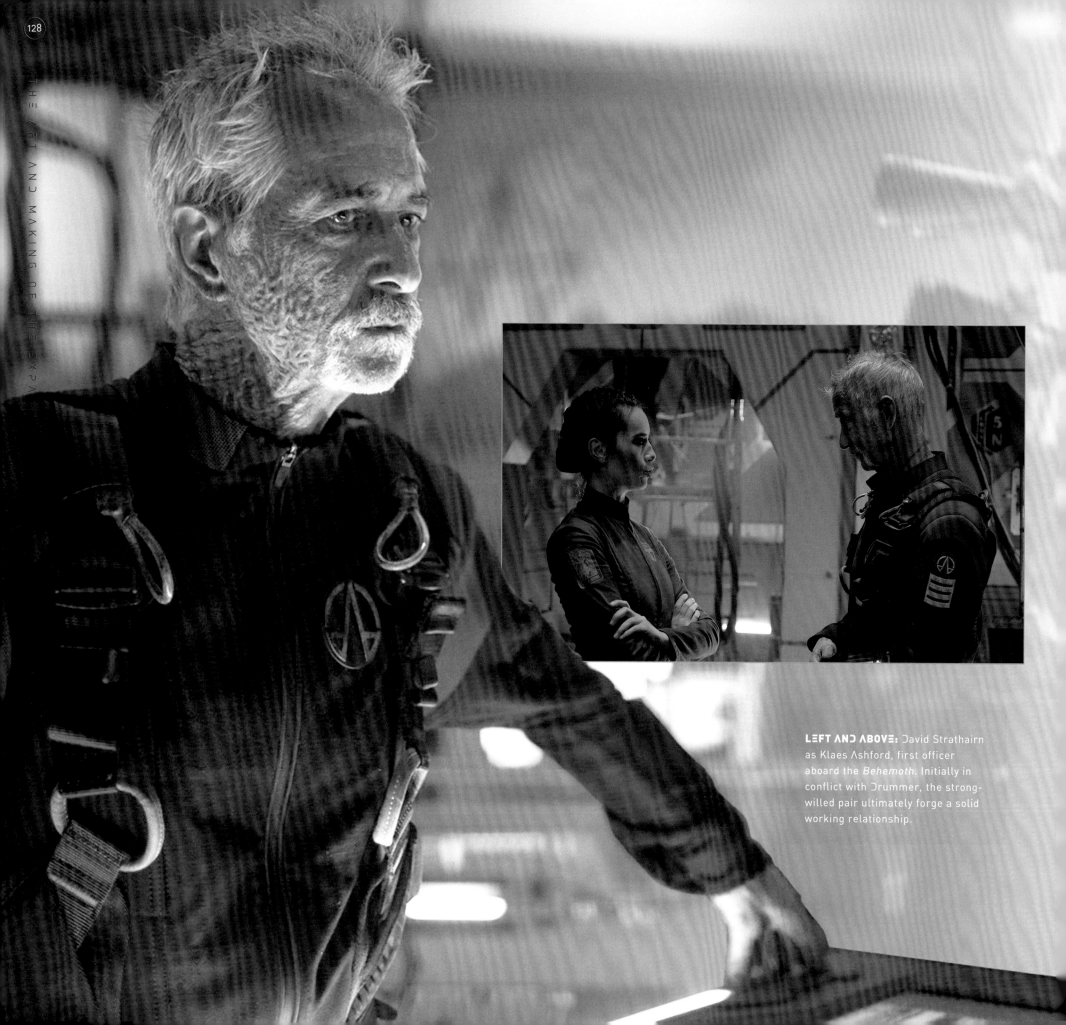

LEFT AND ABOVE: David Strathairn as Klaes Ashford, first officer aboard the *Behemoth*. Initially in conflict with Drummer, the strong-willed pair ultimately forge a solid working relationship.

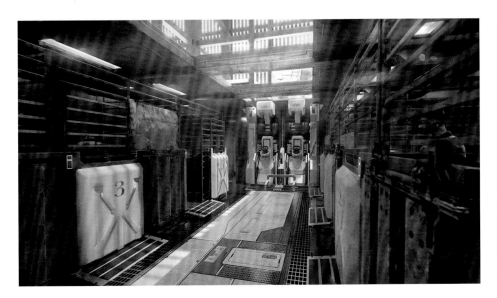
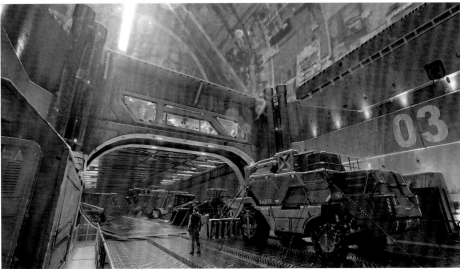

THIS PAGE: Further areas of the *Behemoth* are shown in these concept artworks: the brig (above left); the machinery elevator (above right); and an elevator shaft (below).

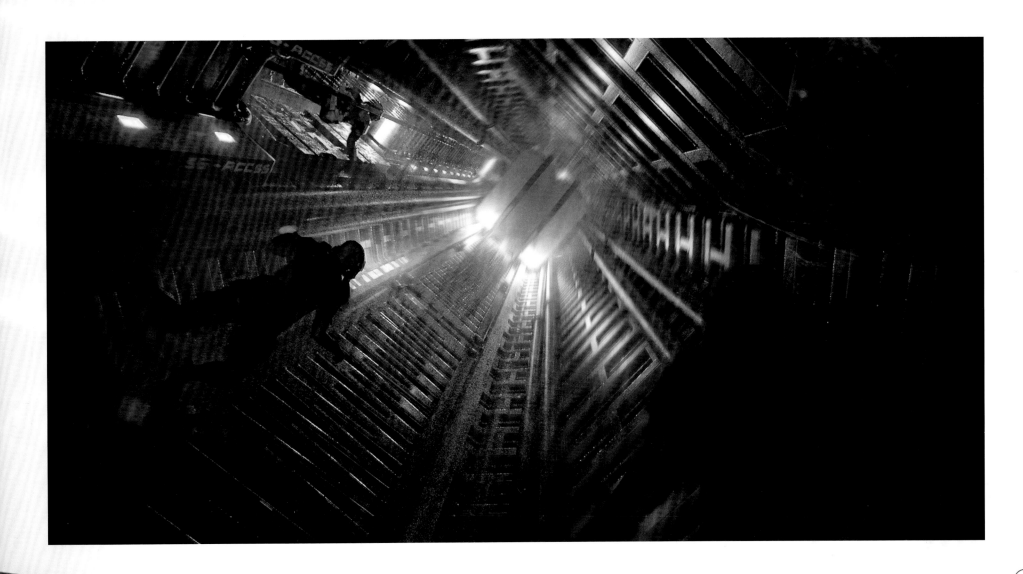

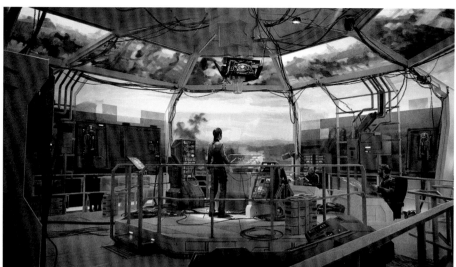

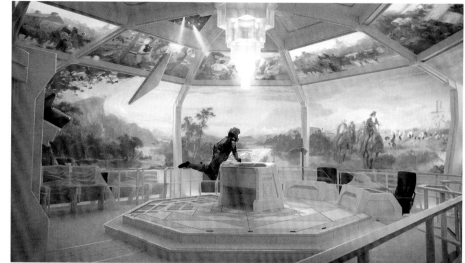

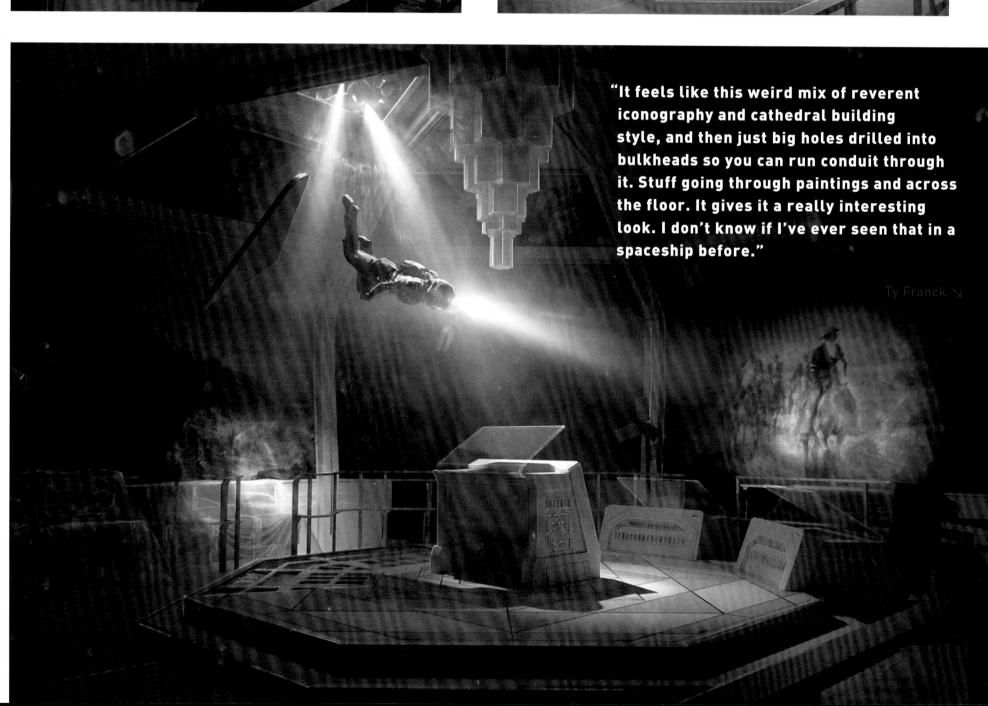

"It feels like this weird mix of reverent iconography and cathedral building style, and then just big holes drilled into bulkheads so you can run conduit through it. Stuff going through paintings and across the floor. It gives it a really interesting look. I don't know if I've ever seen that in a spaceship before."

Ty Franck ↘

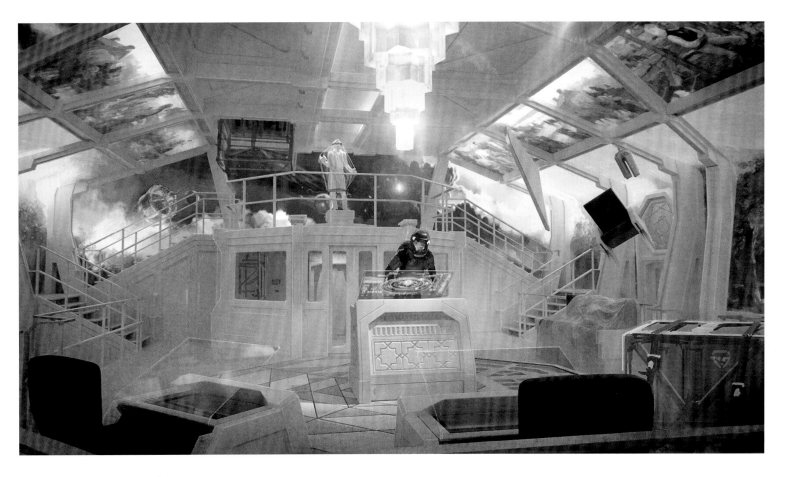

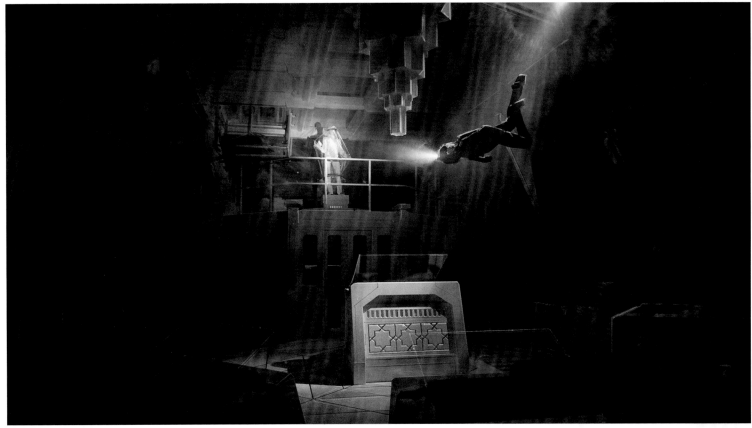

LEFT AND RIGHT:
Concepts of the moment
when Drummer's fleet
enters the *Nauvoo*'s
command room and fires
up the drives.

LEFT AND RIGHT: More
concepts of the *Nauvoo*
recovery, but with the
lights off.

THE ANUBIS

Naren Shankar: "The mystery of the stealth ships is a big storyline in Season 1. We wanted the *Anubis* to look unlike any of our other ships: unsettlingly asymmetrical, designed to scatter radar and lidar, appearing completely different from various angles. When firing its keel-mounted railgun, it looks like a dragon."

LEFT: Sketched views of the *Anubis*, and a more detailed artwork (above).

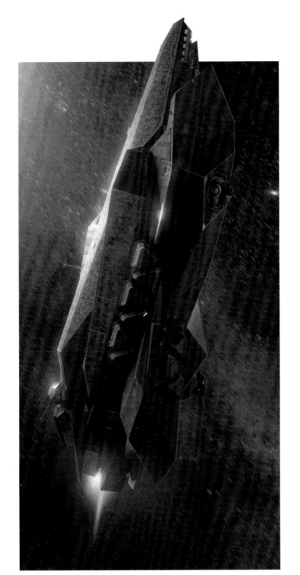

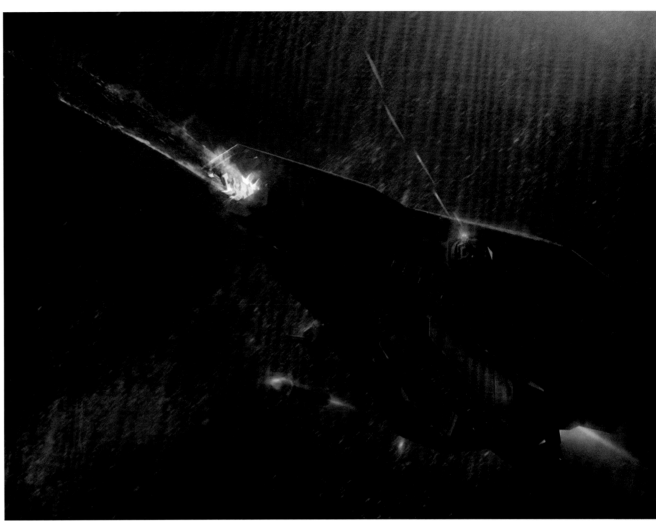

ABOVE: Art of the *Anubis* firing its weapons. BELOW: Sketches of an earlier, sharper-angled version of the *Anubis*.

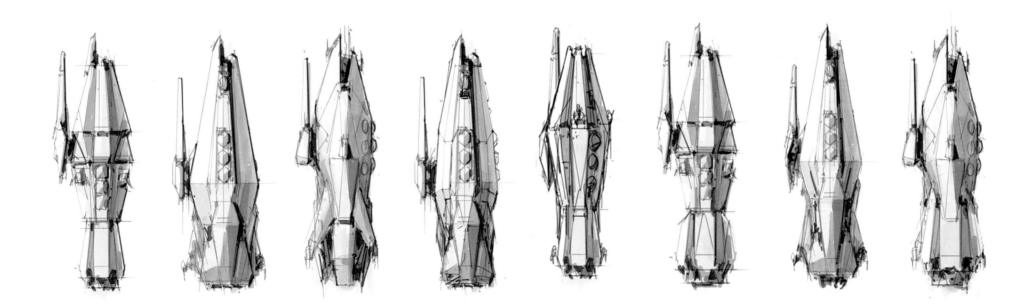

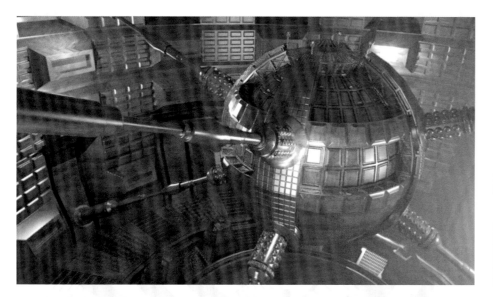

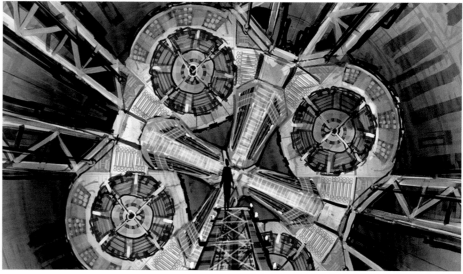

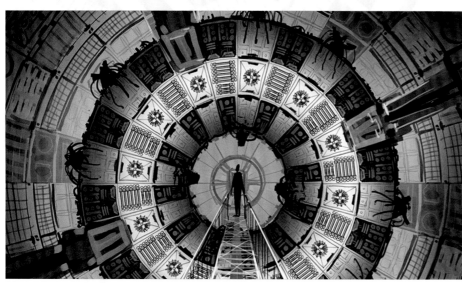

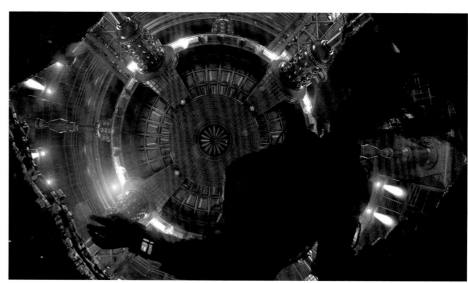

THIS PAGE: Views of the *Anubis*'s reactor core and Julie Mao's arrival there.

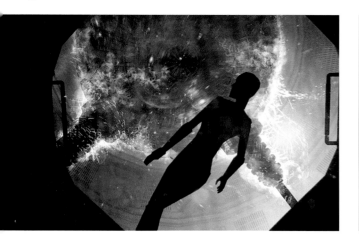

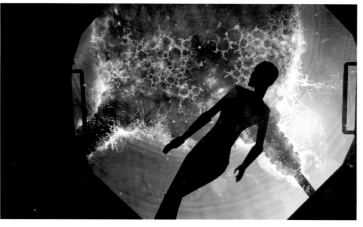

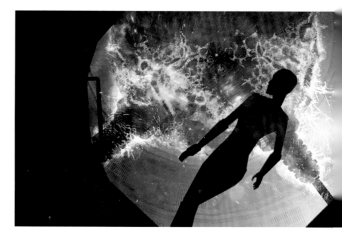

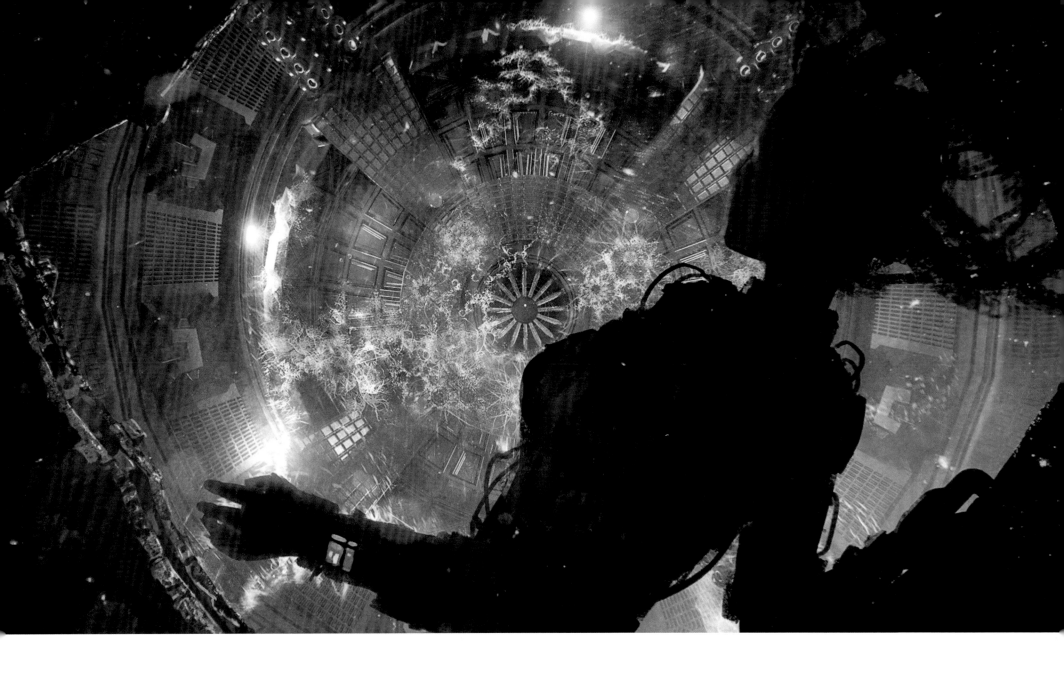

THIS PAGE: Illustrations exploring how the *Anubis*'s reactor core might look when infected with protomolecule.

"In this concept we were beginning to get our heads around the biotech look of the protomolecule. As we applied these ideas to different contexts later on and got a much closer look at the protomolecule, new ideas were introduced."

Tim Warnock, concept artist ↘

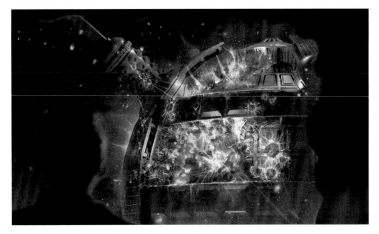

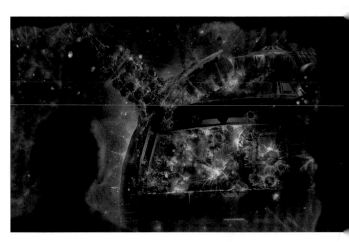

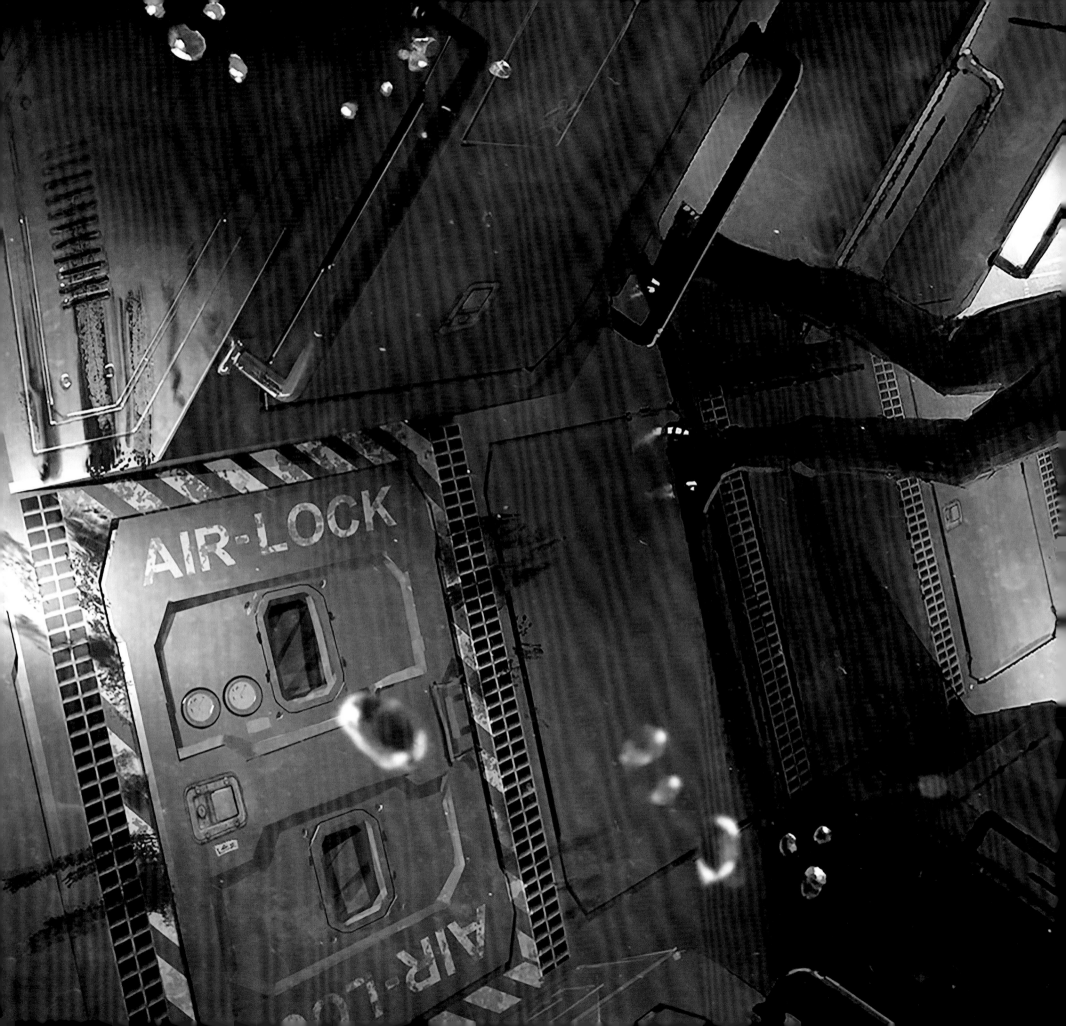

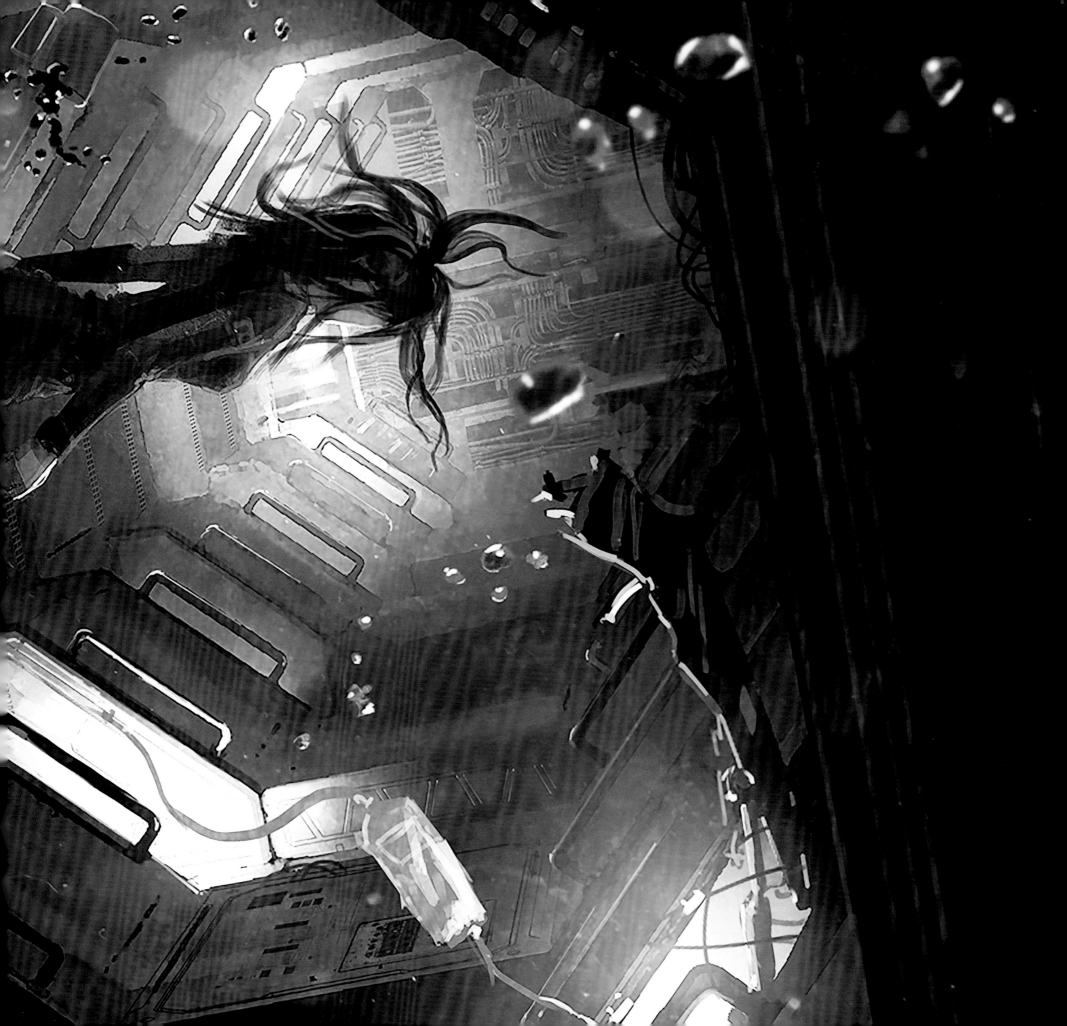

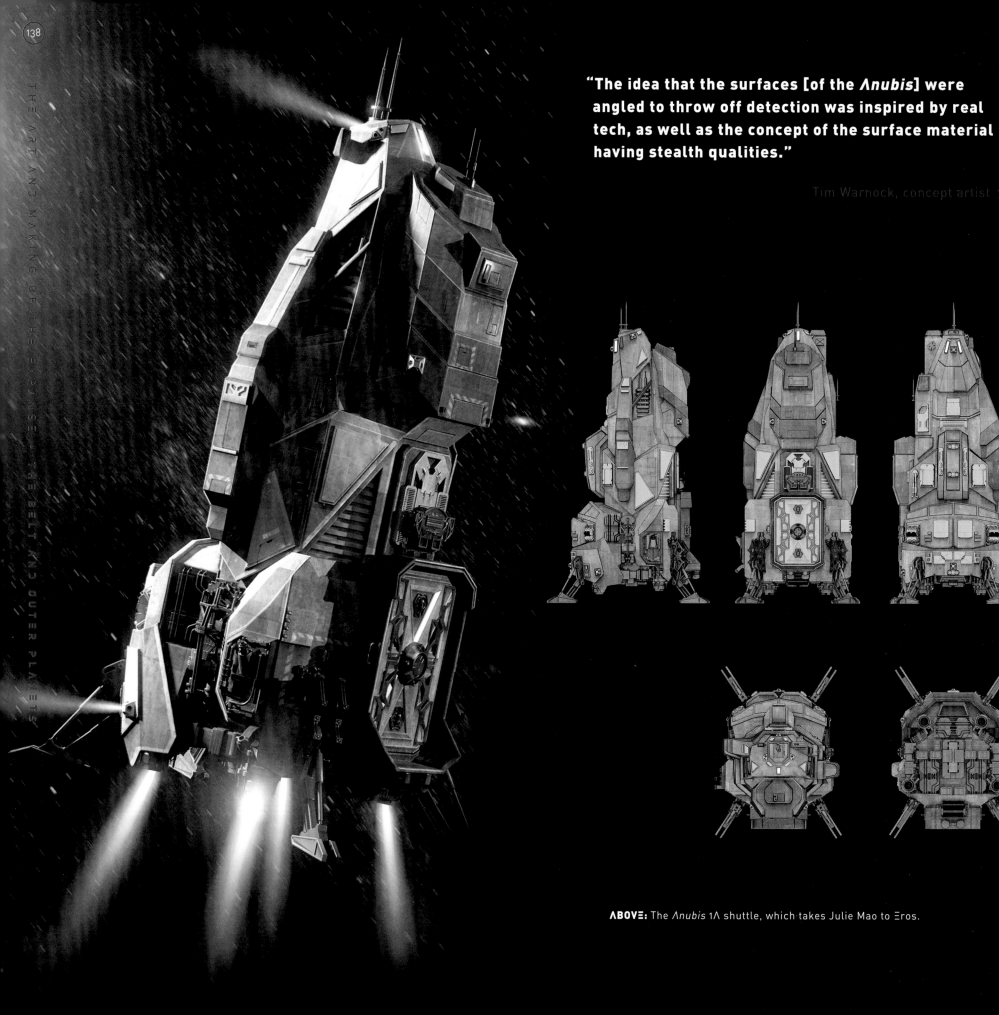

"The idea that the surfaces [of the *Anubis*] were angled to throw off detection was inspired by real tech, as well as the concept of the surface material having stealth qualities."

Tim Warnock, concept artist ↘

ΛBOVΞ: The *Anubis* 1Λ shuttle, which takes Julie Mao to Ξros.

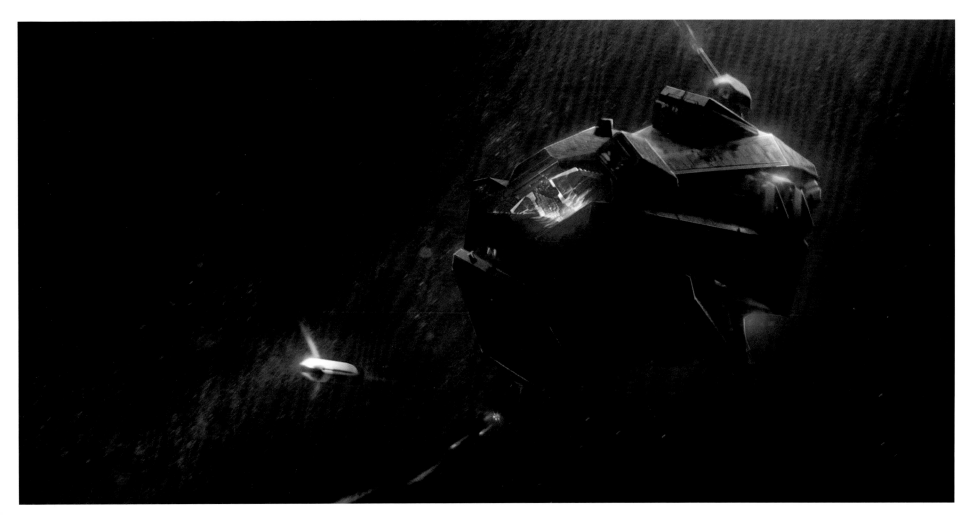

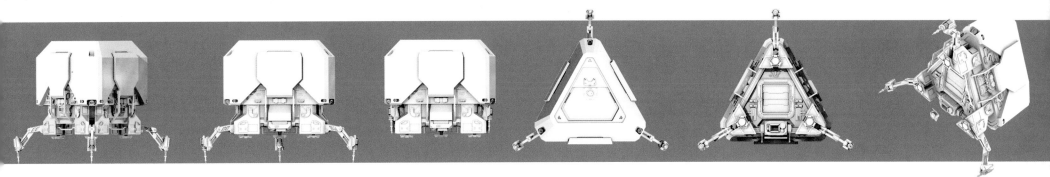

ABOVE AND BELOW: Black-and-white illustrations of one of the stealth ship's breaching pods, used to attack the hull of the MCRN vessel *Jonnager*.

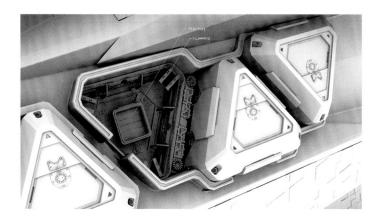

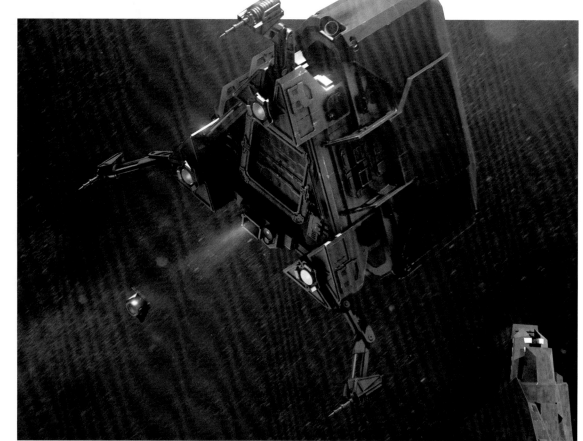

THIS PAGE: More art of one of the breaching pods, showing how they emerge from the *Anubis*.

"The goal was to make all the components of the *Anubis* feel like they have come from the same place."

Tim Warnock, concept artist ↘

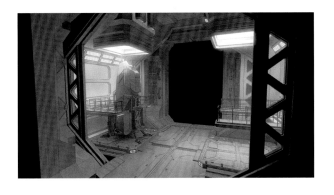 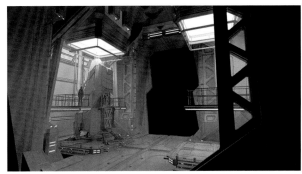 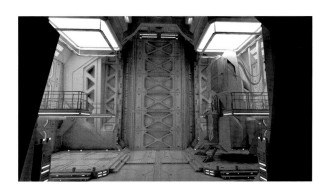

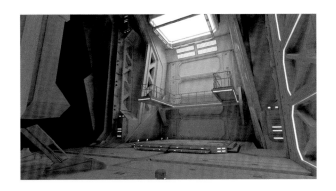 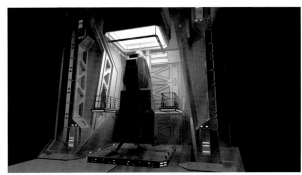 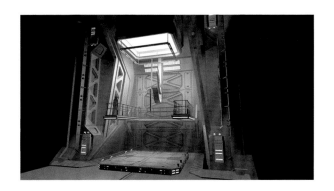

THIS PAGE: The 1Λ shuttle in the *Anubis* hangar bay.

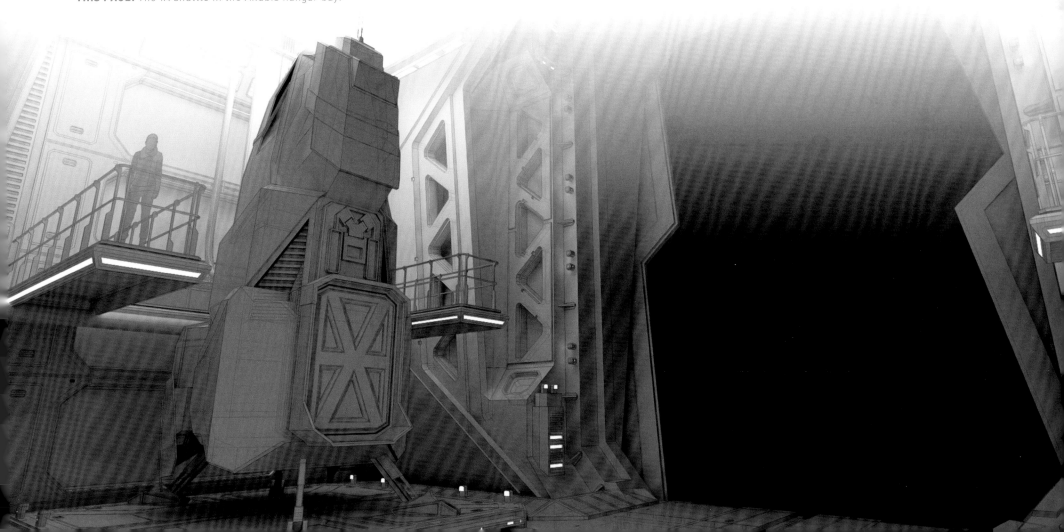

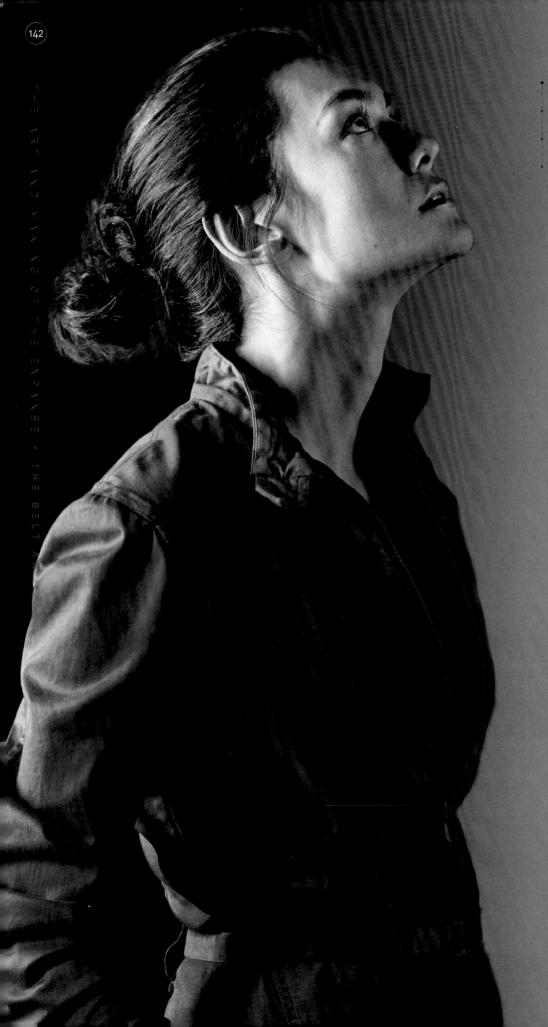

JULIΞ MAO

Rebellious daughter of ruthless billionaire Jules-Pierre Mao, Juliette Andromeda Mao (Florence Faivre) chose to reject her father's wealth in favor of the freedom of the Belt. Her infection and subsequent death by protomolecule begins the cascade of events that plunges the Sol system into war.

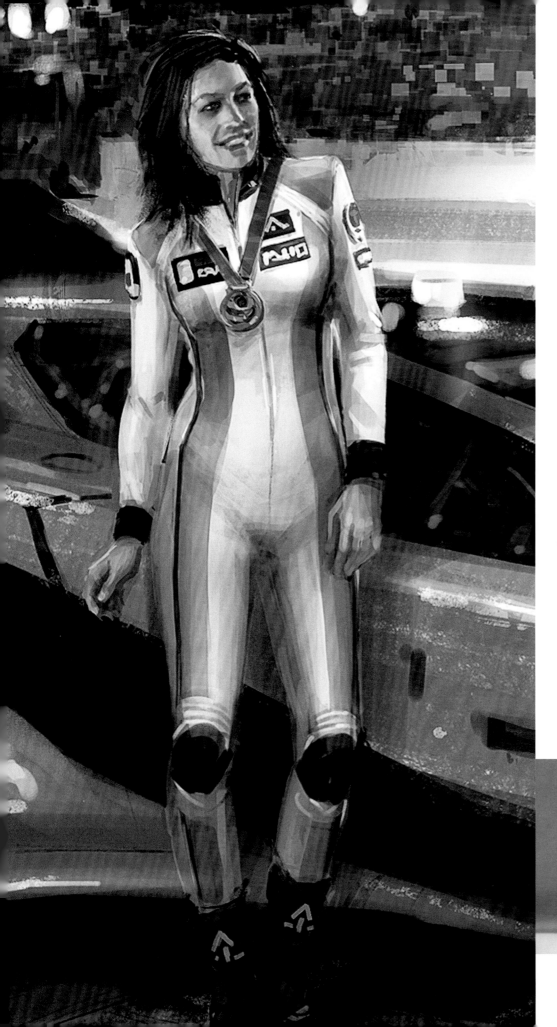

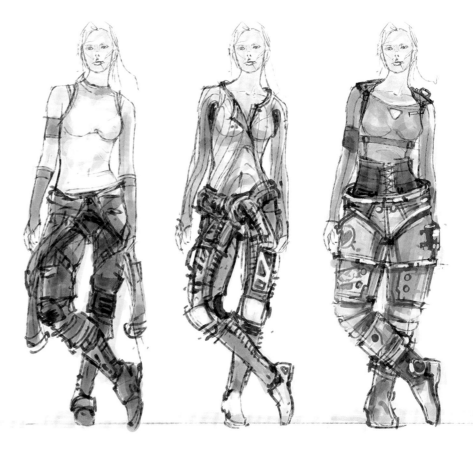

THIS PAGE: Concept art of Julie, highlighting her racing background (left); costume concepts (above and below).

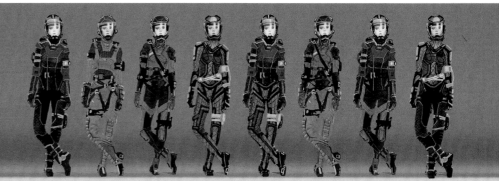

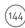

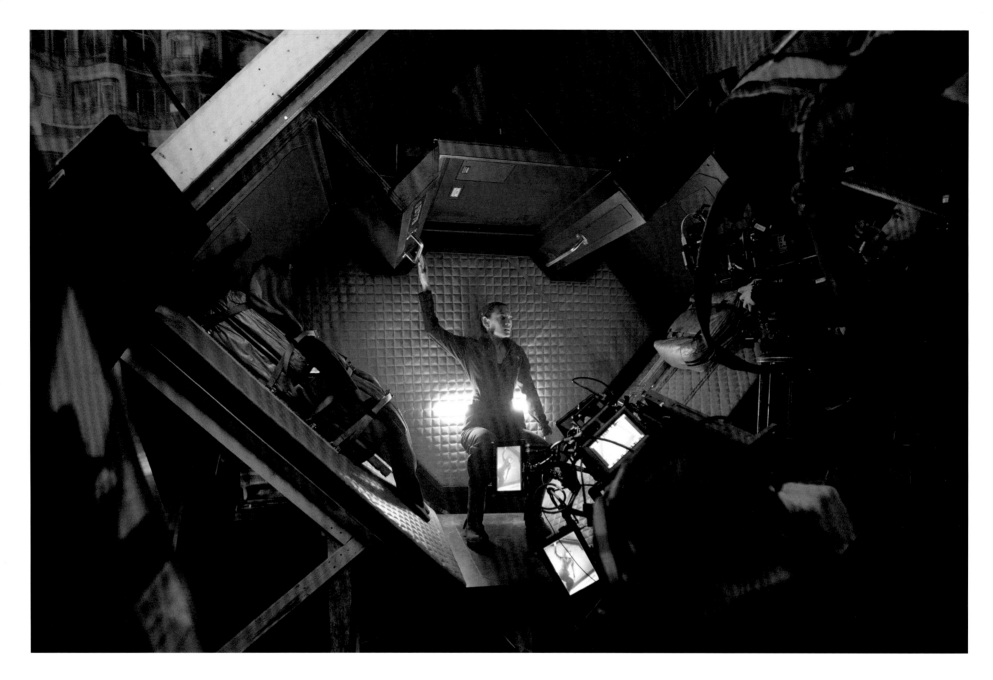

THIS PAGE, AND OPPOSITE: Filming the opening scene of *The Expanse*'s first episode, with Julie (Florence Faivre) trapped in the locker aboard the *Anubis*. The effect of Julie's floating hair was added digitally.

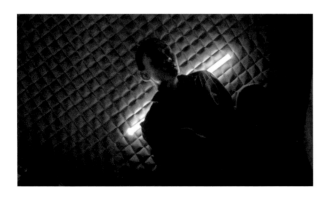
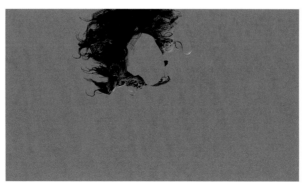
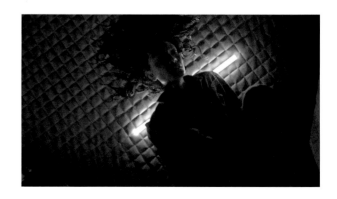

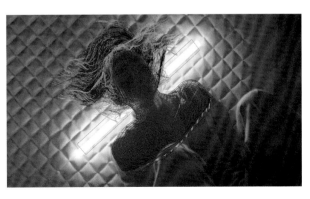
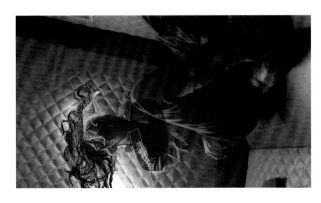

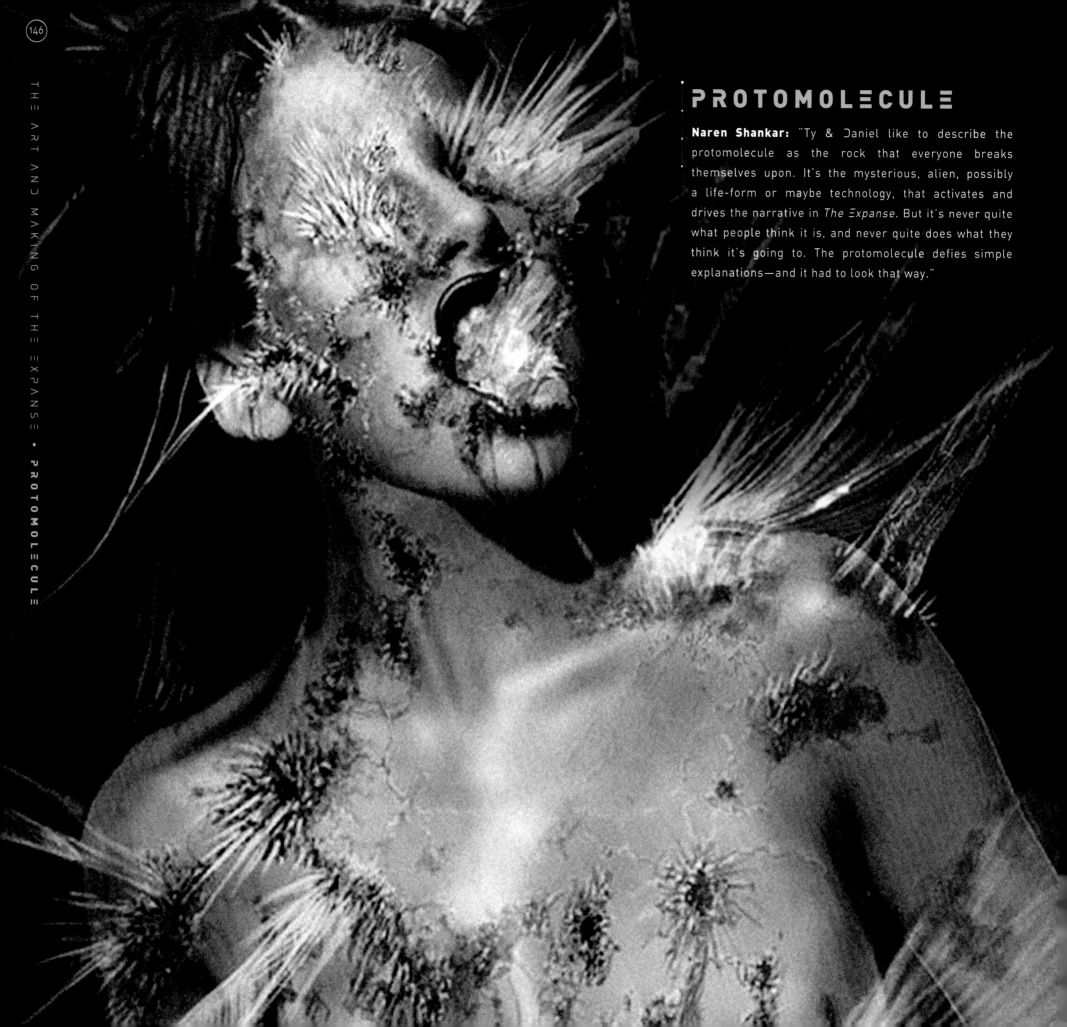

PROTOMOLECULE

Naren Shankar: "Ty & Daniel like to describe the protomolecule as the rock that everyone breaks themselves upon. It's the mysterious, alien, possibly a life-form or maybe technology, that activates and drives the narrative in *The Expanse*. But it's never quite what people think it is, and never quite does what they think it's going to. The protomolecule defies simple explanations—and it had to look that way."

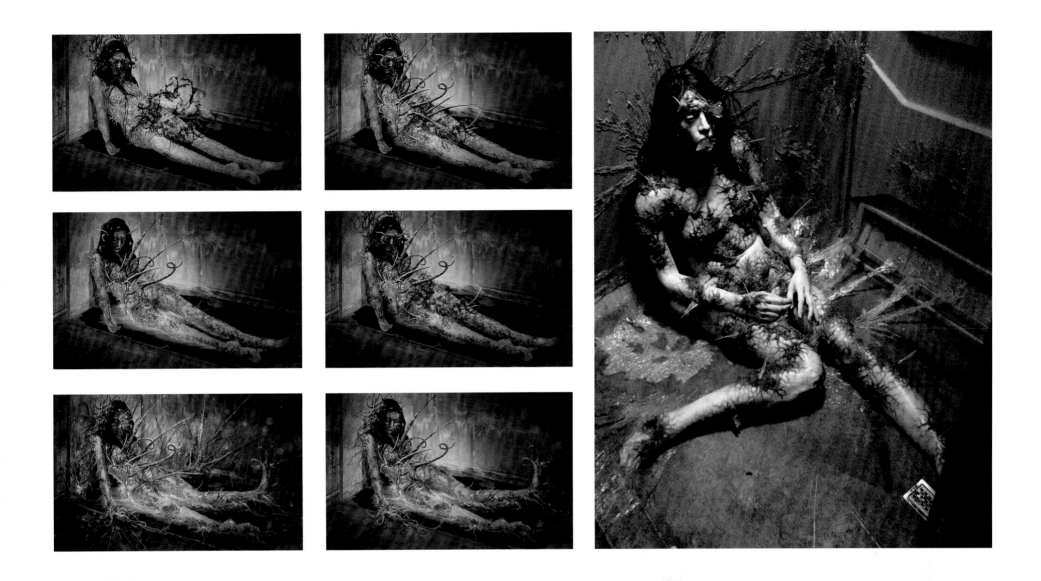

THIS PAGE, AND OPPOSITE: Early artistic exploration of the protomolecule's effect on Julie Mao (with the final look, above right).

"We looked at examples from nature of one species invading a host. One really compelling example is that of an insect-pathogenizing fungus that infects ants, turning them into 'zombie ants.' There was also the idea of a metamorphosis that we wanted to convey."

Tim Warnock, concept artist ↘

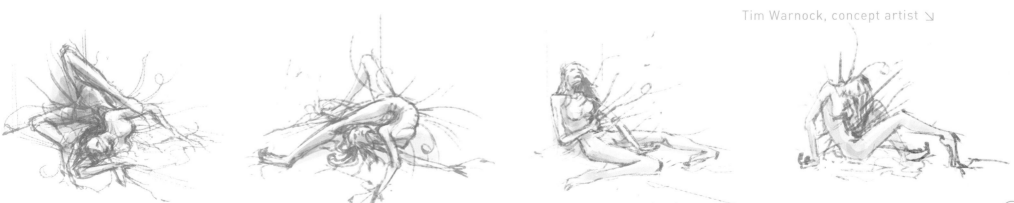

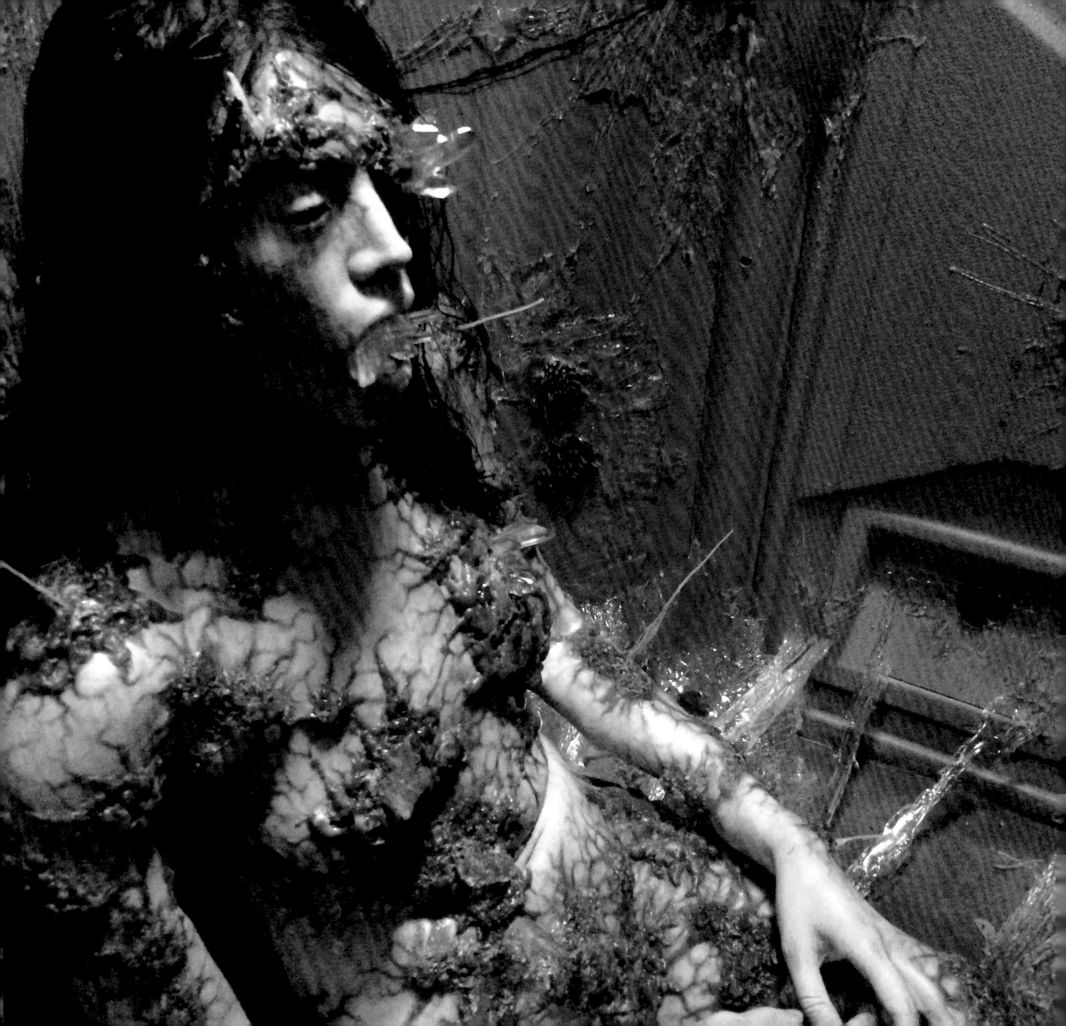

"Miller finding Julie dead near the end of Season 1 was a devastating gut punch to the character and to the audience. We used references of insects [that] lay eggs inside other insects, resulting in larvae which burst out of the host and kill it, to create the look of her protomolecule-ravaged body."

Naren Shankar, showrunner ↘

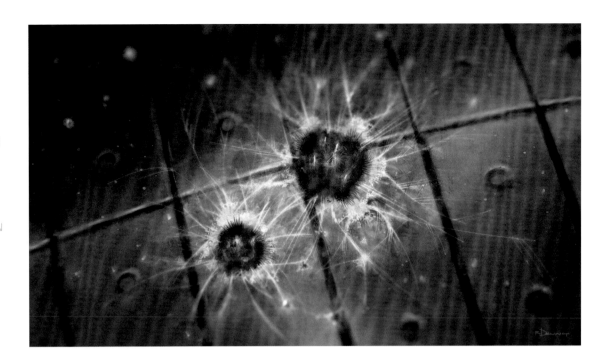

THIS PAGE, AND OPPOSITE: More exploration of infected Julie, including a close-up of the protomolecule itself (right).

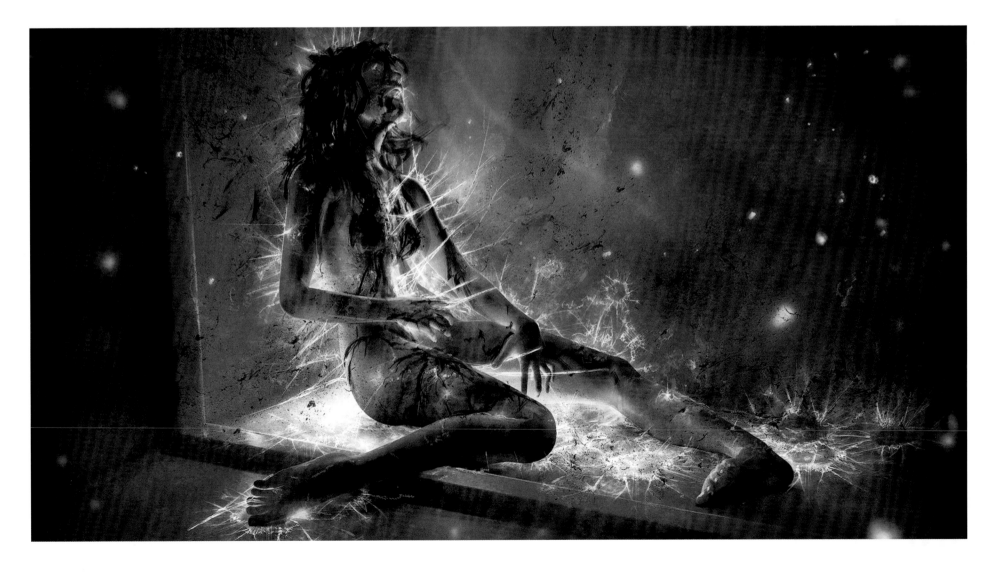

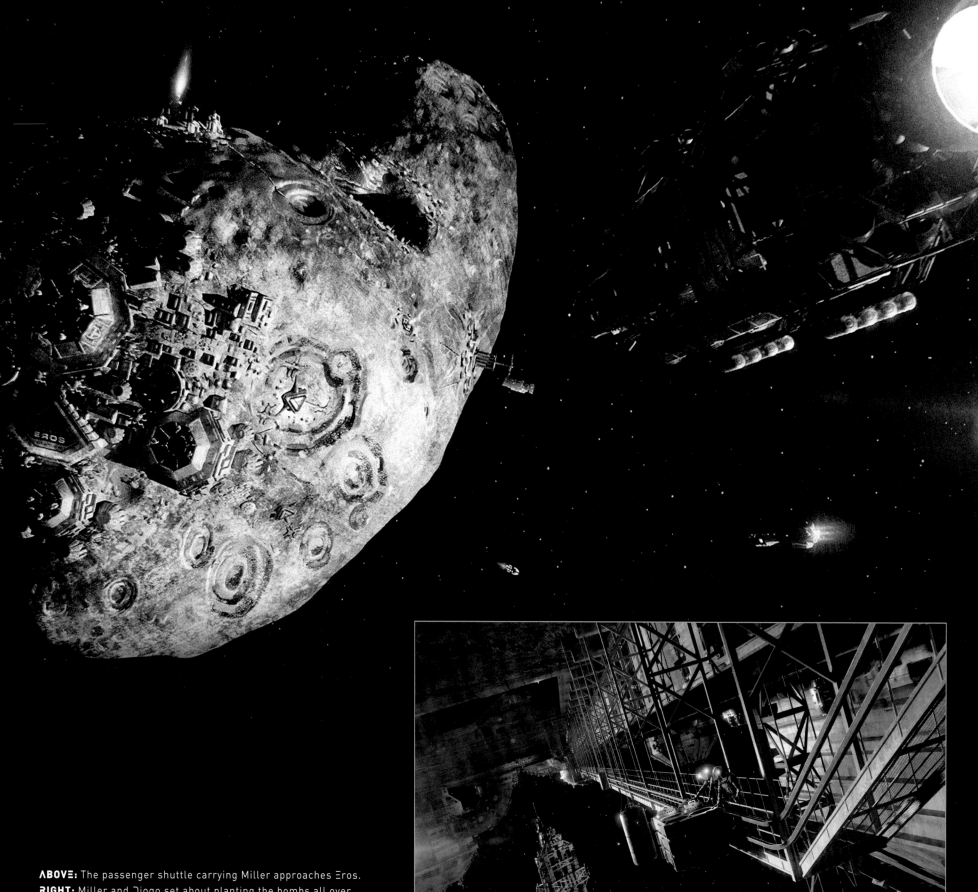

ABOVE: The passenger shuttle carrying Miller approaches Eros.
RIGHT: Miller and Diogo set about planting the bombs all over
Eros in this illustration.

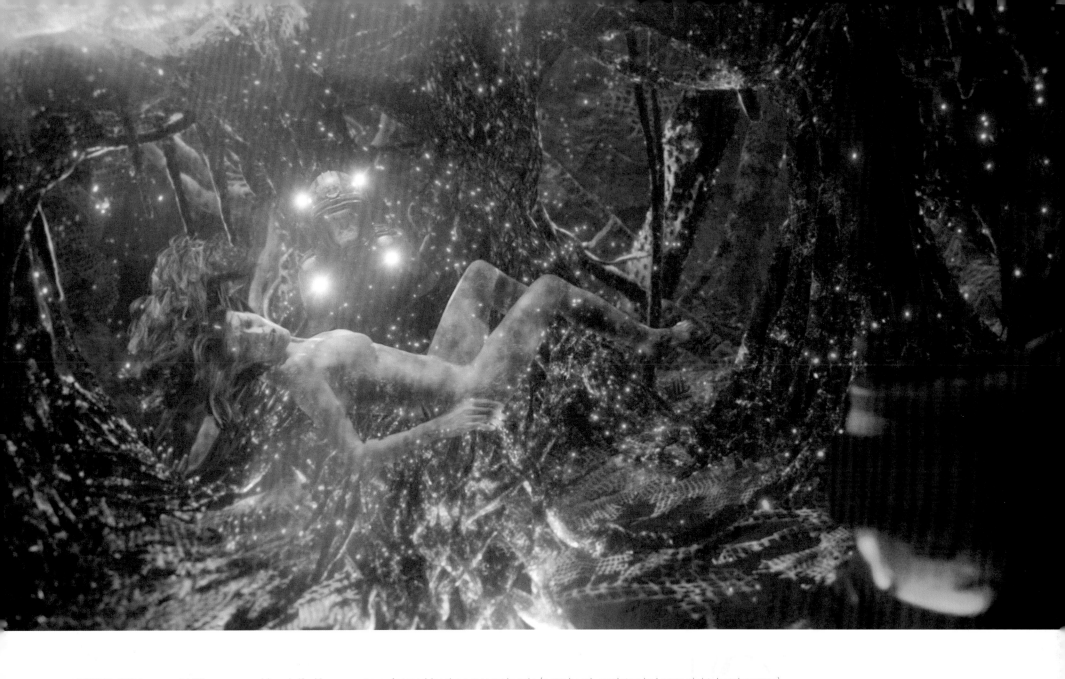

ABOVE: VFX image of Miller approaching Julie Mao, now transformed by the protomolecule (note bomb canister in lower right-hand corner).
BELOW: Concept art of proto-Julie; Miller (lower left) dragging the bomb through Eros Station.

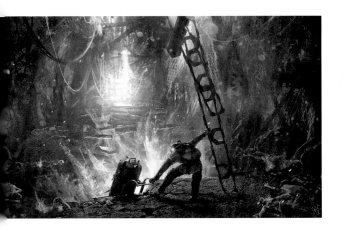

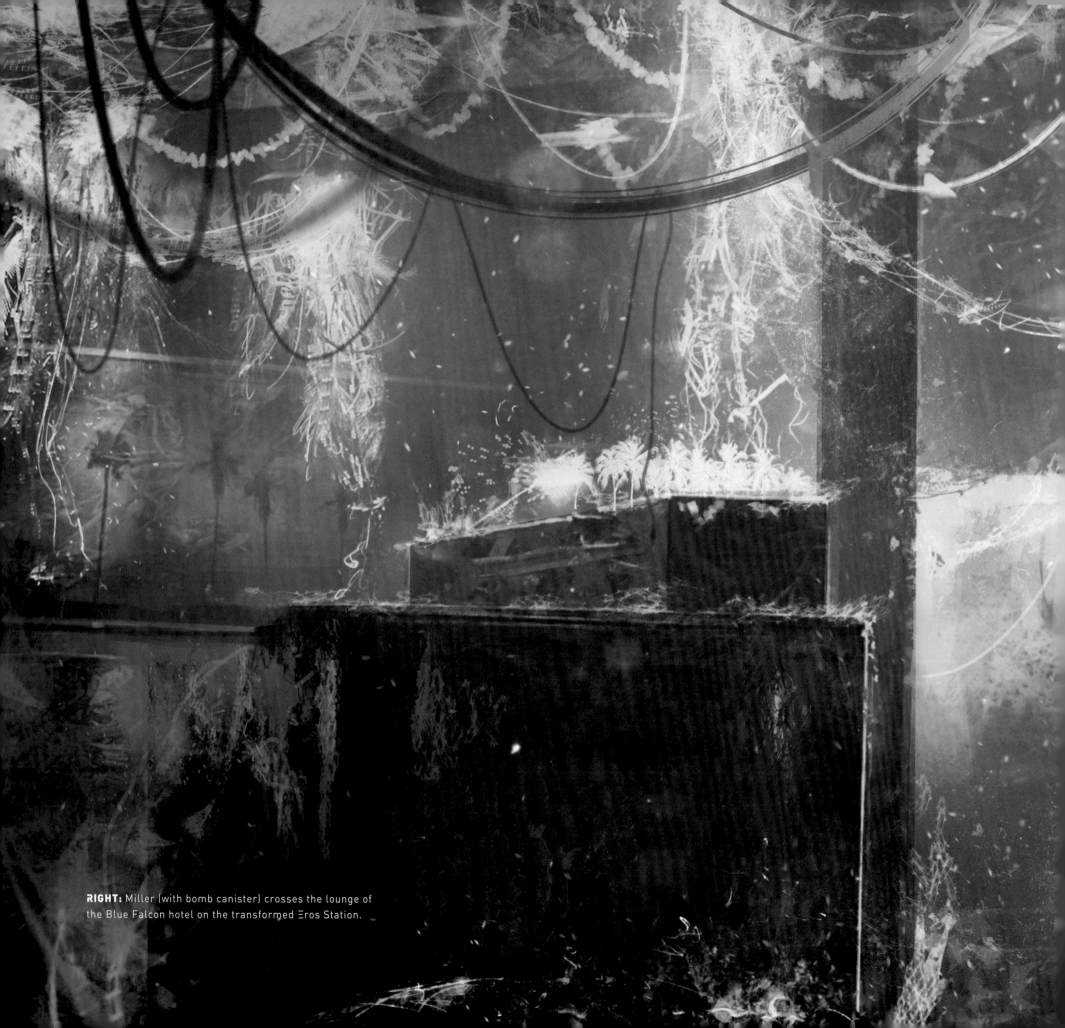

RIGHT: Miller (with bomb canister) crosses the lounge of the Blue Falcon hotel on the transformed Eros Station.

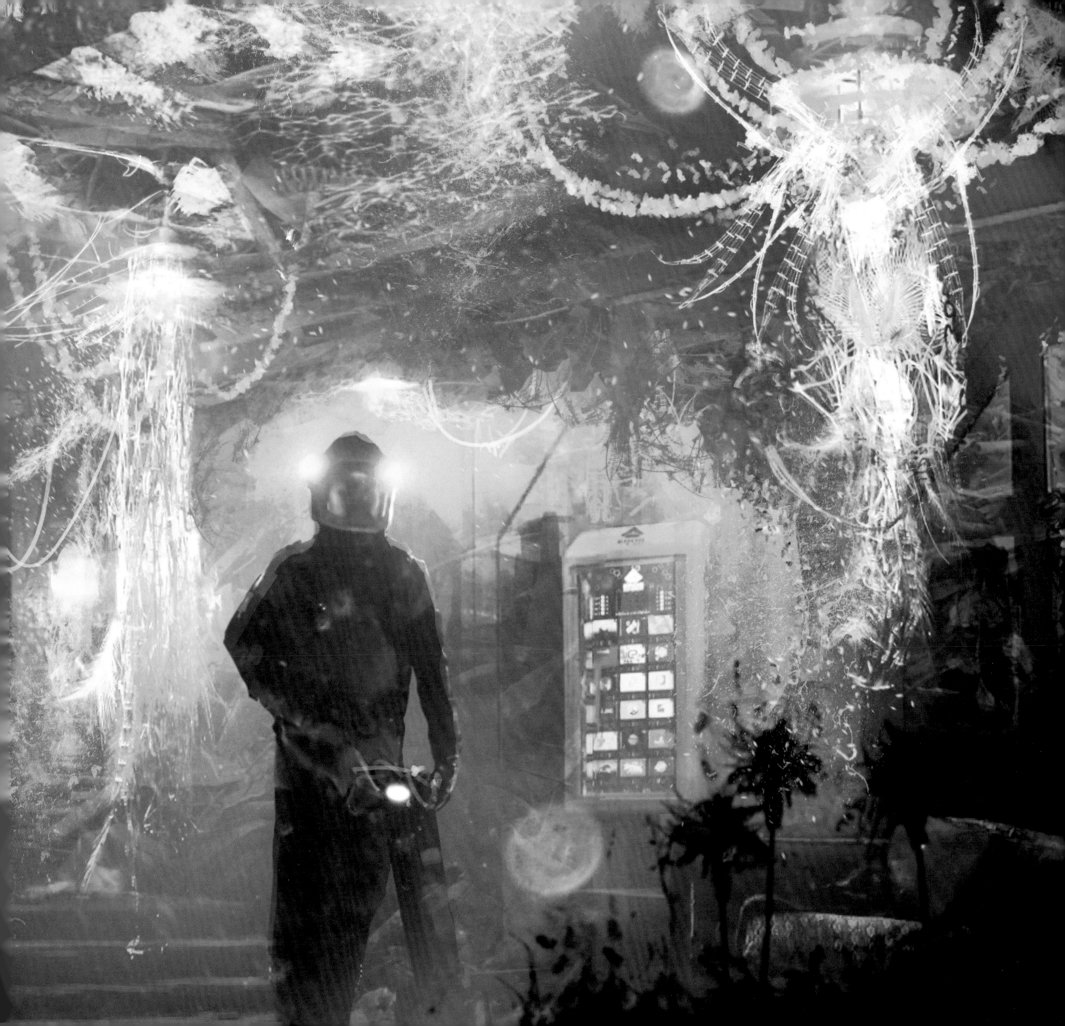

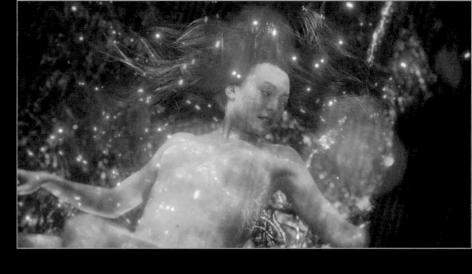
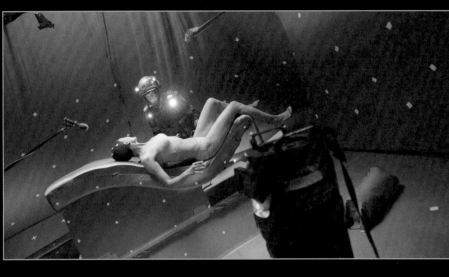
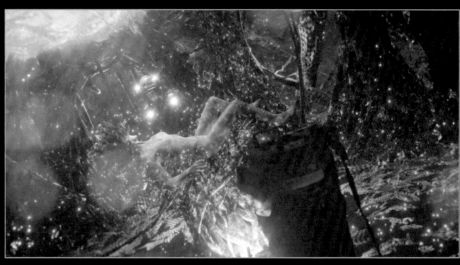
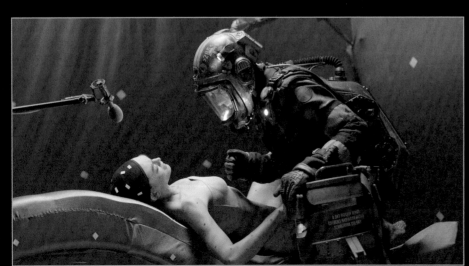
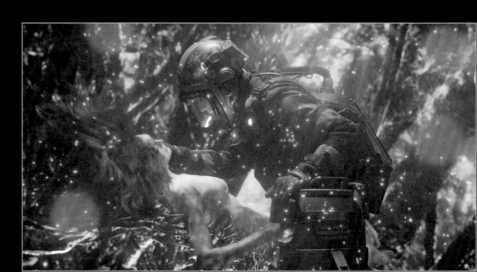

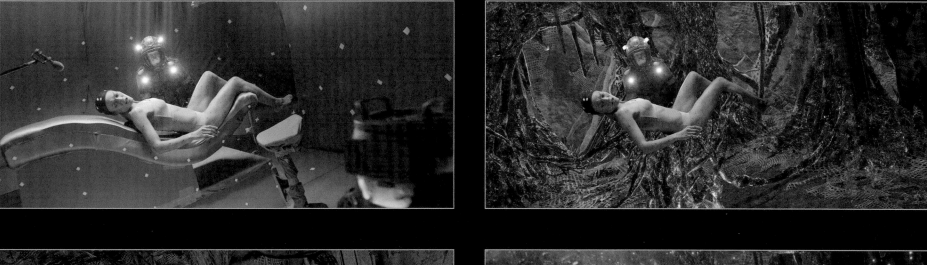

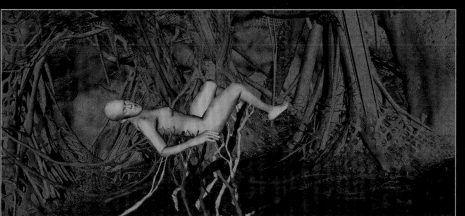
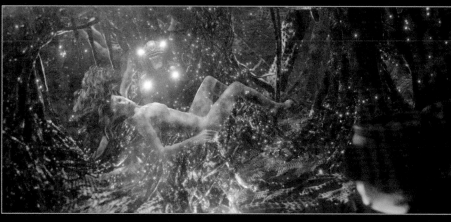

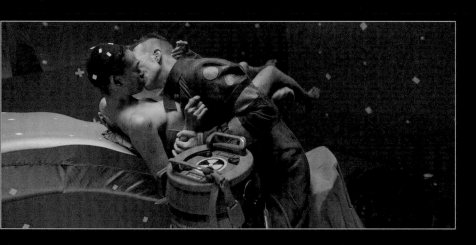
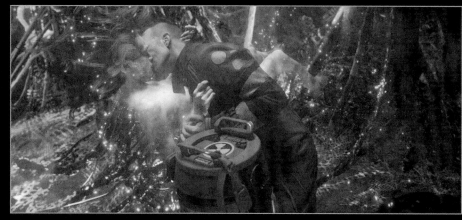

'We knew [the Julie and Miller] scene was gonna be in a blue room. I didn't know that she was gonna be on a blue mattress, which of course ended up obscuring a lot of her body because she kinda sunk into it. The original intent was to do that form-fitting back support so that we wouldn't lose her body, so we wouldn't have to paint that all back... credit to Spin VFX in Toronto, they didn't balk, they didn't run, they took that blue room with Florence and with Tom and a bomb, and made it what you saw."

Bob Munroe, senior VFX supervisor ⟍

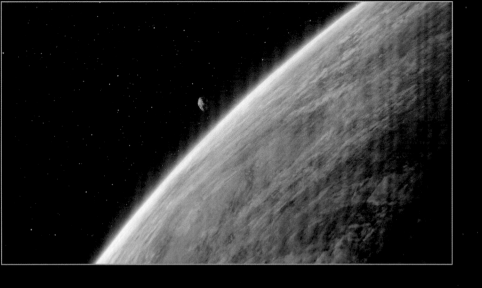

"After reading the script and having conversations with the production, we tried a few different ideas that we thought would depict the evolution of the protomolecule. Once a direction was selected, we developed the idea further and visualized it rising up out of the surface of Venus."

Tim Warnock, concept artist ↘

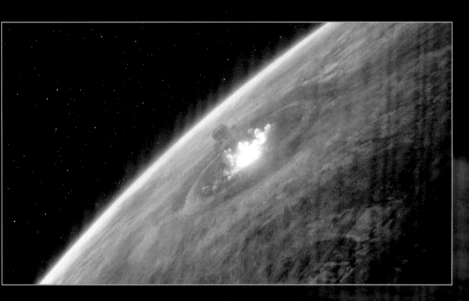

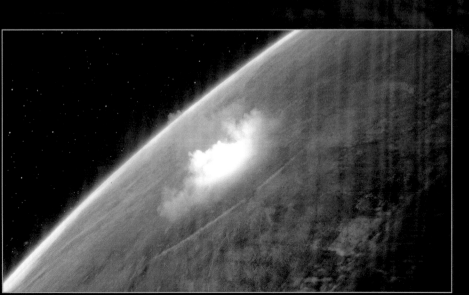

LEFT: Eros crashes into the surface of Venus.
RIGHT: Out of the depths, a new protomolecule construct appears, ready to fulfill its intended purpose.

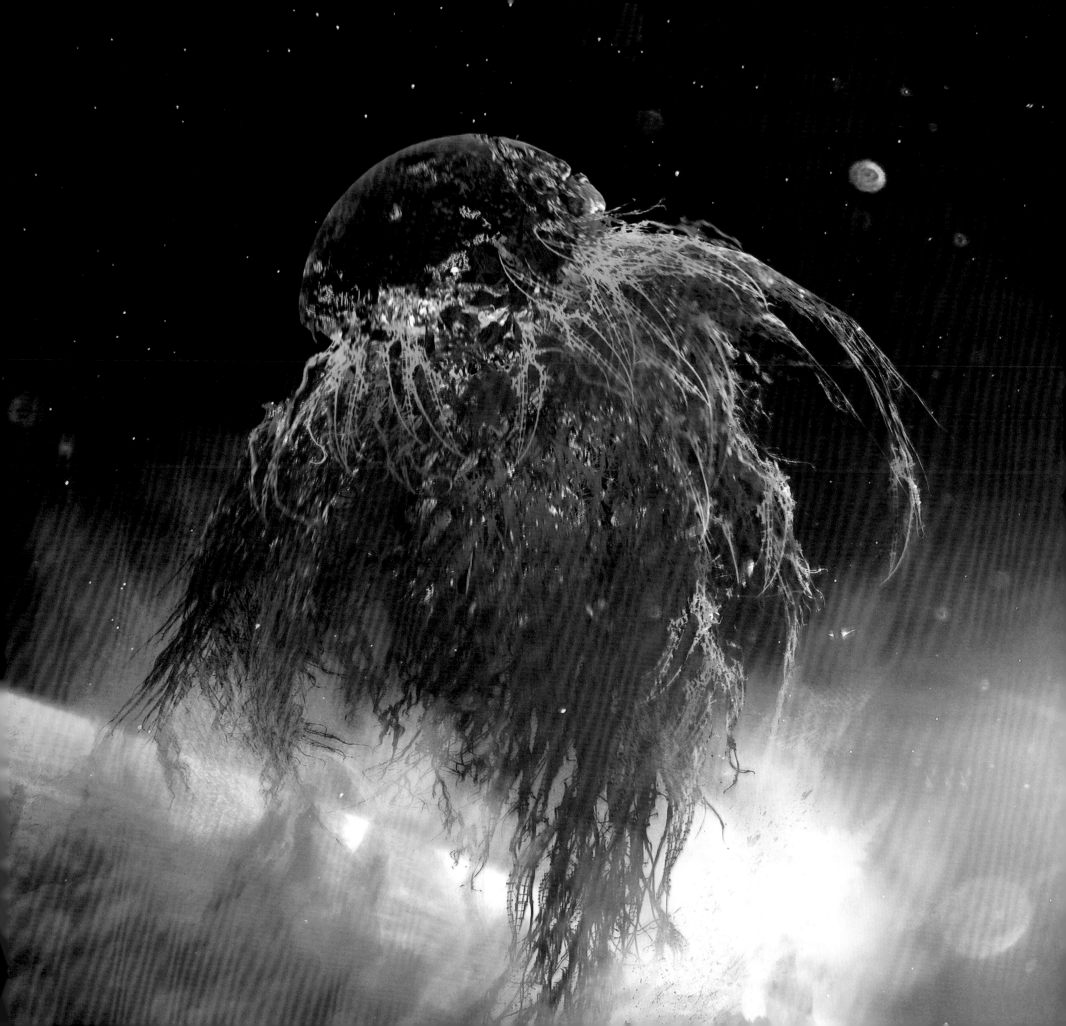

THE RING

Naren Shankar: "When the protomolecule forms the Ring in Season 3, it answers one of the big questions in the series to that point: it's not a life-form, it's a piece of (intelligent) technology designed to build the Ring. Which poses an entirely new set of questions: what does the Ring do, and how does the damn thing work…?"

RIGHT: Concept art of the slingshot racing ship *Y Que*, the first vessel to go through the Ring.

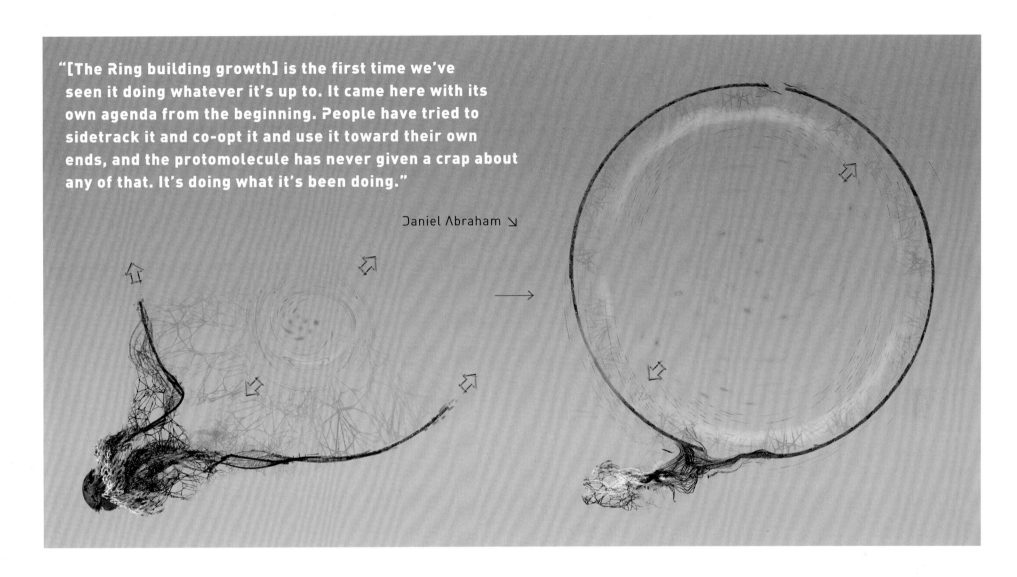

"[The Ring building growth] is the first time we've seen it doing whatever it's up to. It came here with its own agenda from the beginning. People have tried to sidetrack it and co-opt it and use it toward their own ends, and the protomolecule has never given a crap about any of that. It's doing what it's been doing."

Daniel Abraham ↘

THIS PAGE: The formation of the Ring—a new frontier for humankind.

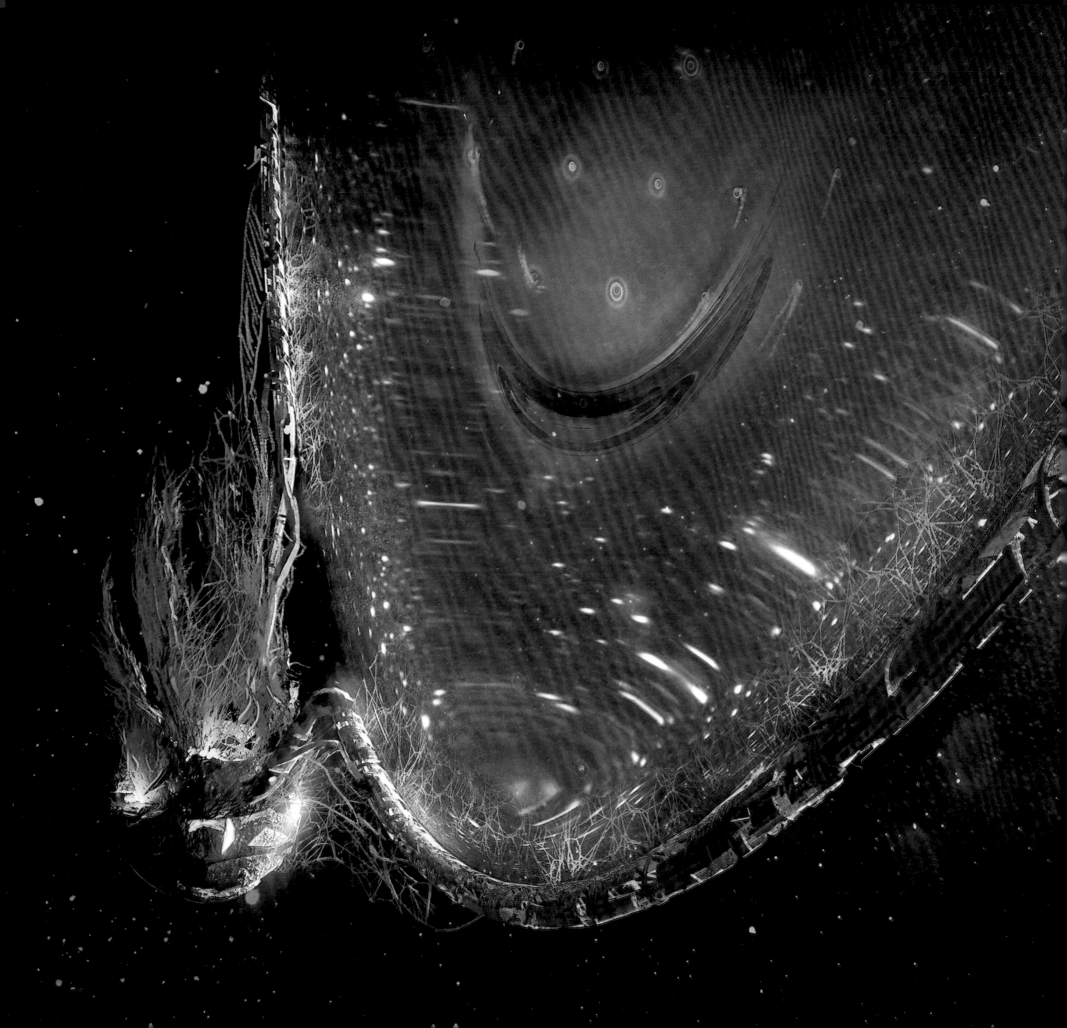

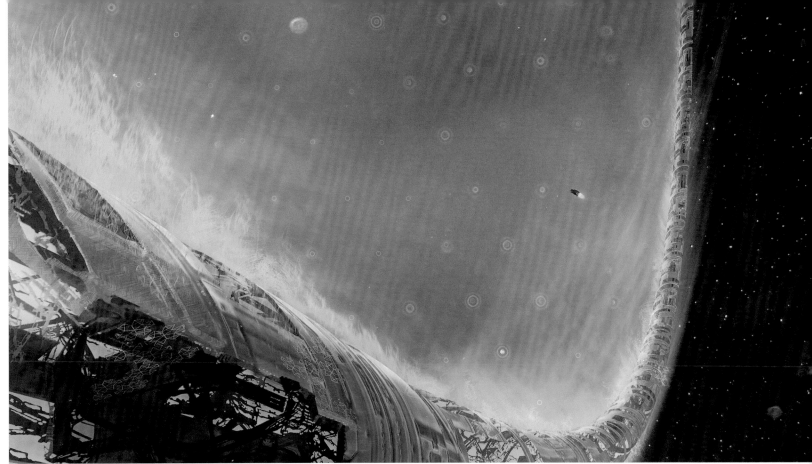

THIS PAGE, AND OPPOSITE: Detailed artwork of the Ring, maintaining the distinctive blue color of the protomolecule.

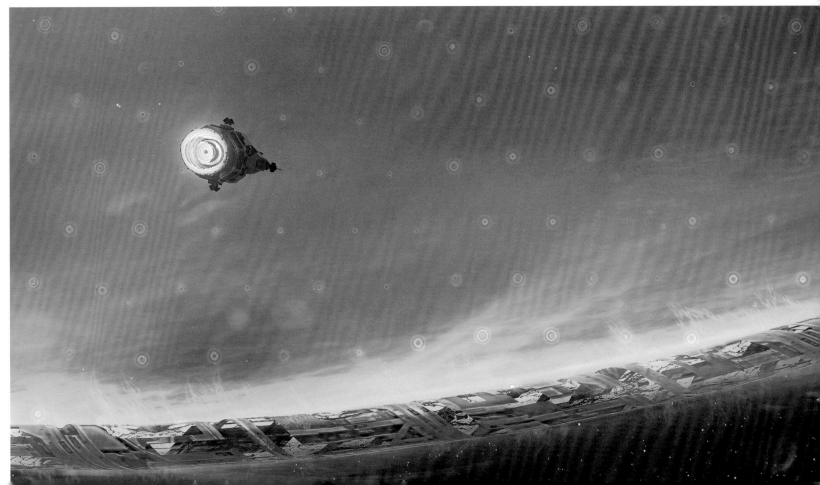

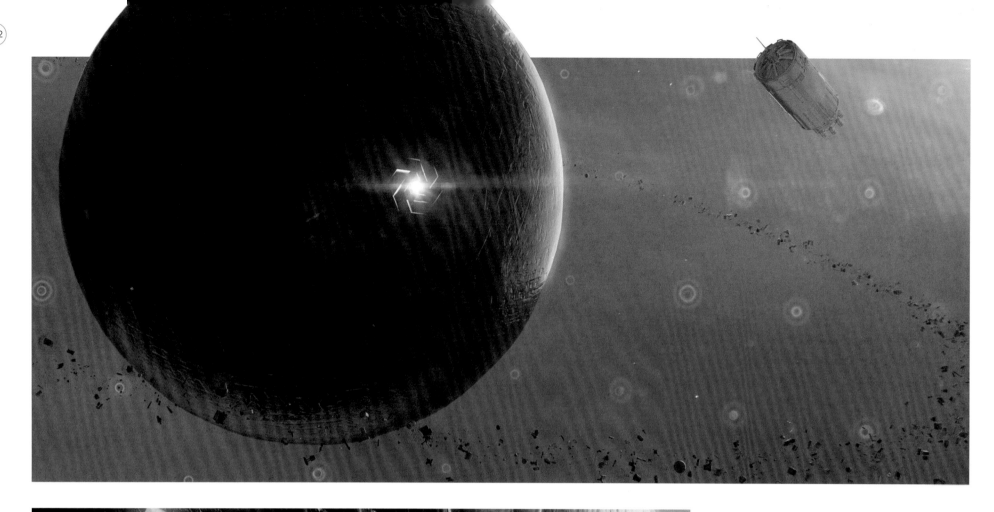

ABOVE: The Ring Station opens.
LEFT: A more detailed artwork of the Ring Station's entrance.

"We had great concept art for [the Ring Station], that we had all over the office even when we were still writing scripts, so this one didn't actually require a lot of back and forth. Bob Munroe and his crew, they knew what they needed to do right from the start and just made that, they made the thing we'd been writing and talking about for months at that point, and it's gorgeous."

Ty Franck ↘

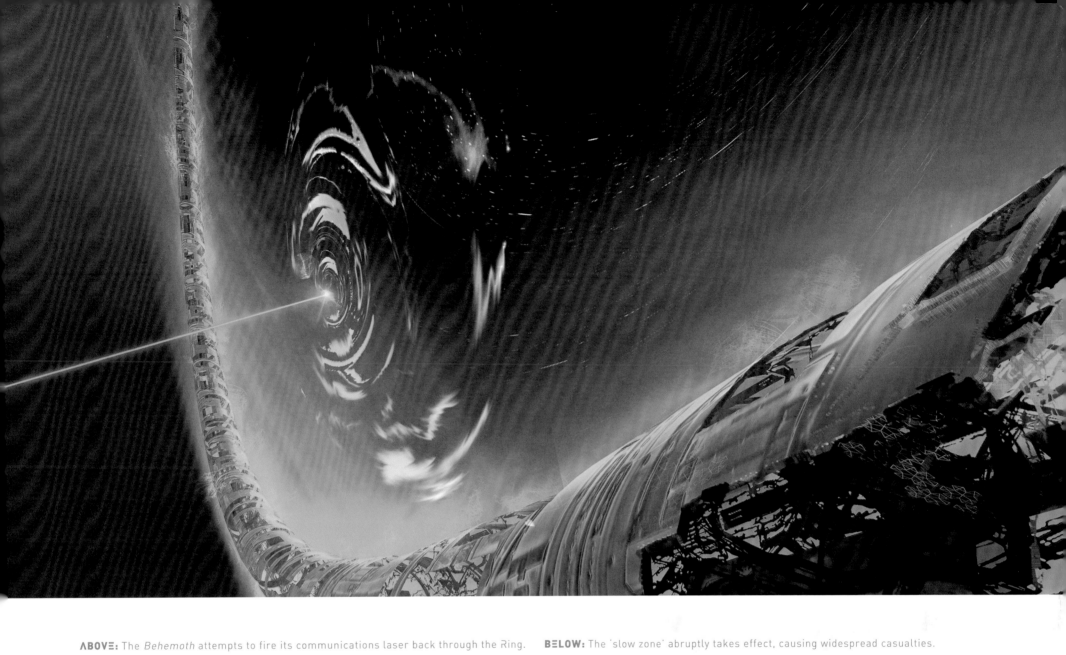

ΛBOVƎ: The *Behemoth* attempts to fire its communications laser back through the Ring.　　**BƎLOW:** The 'slow zone' abruptly takes effect, causing widespread casualties.

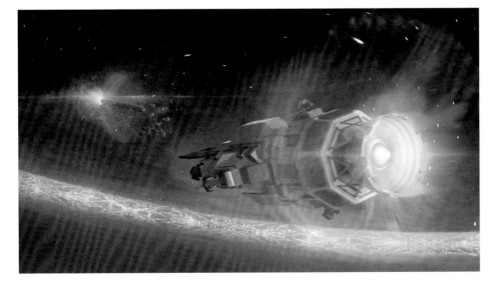

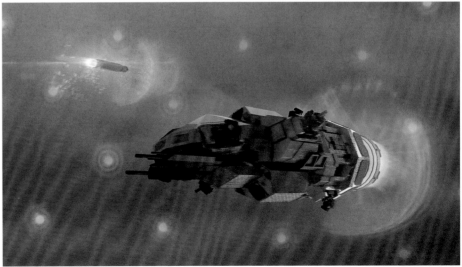

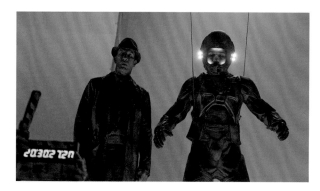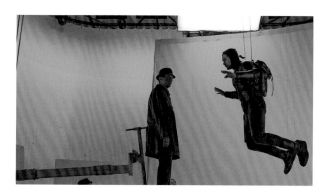

ABOVE: Filming Holden's descent to the Ring Station.

BELOW: Holden entering the Ring Station as captured in concept art.

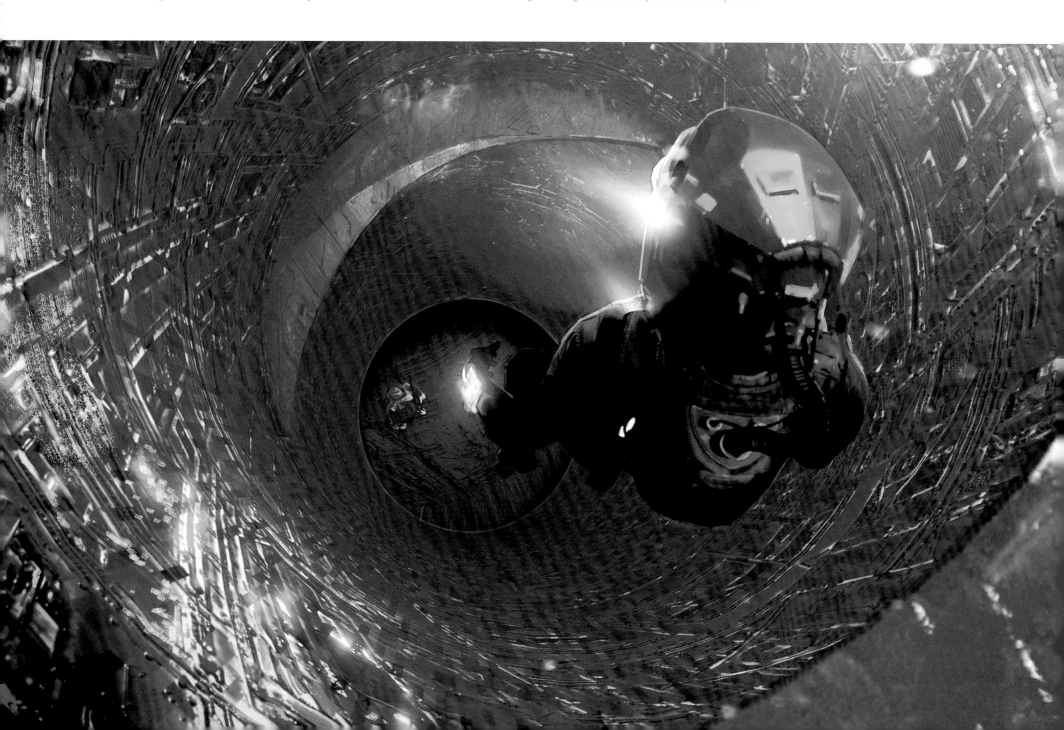

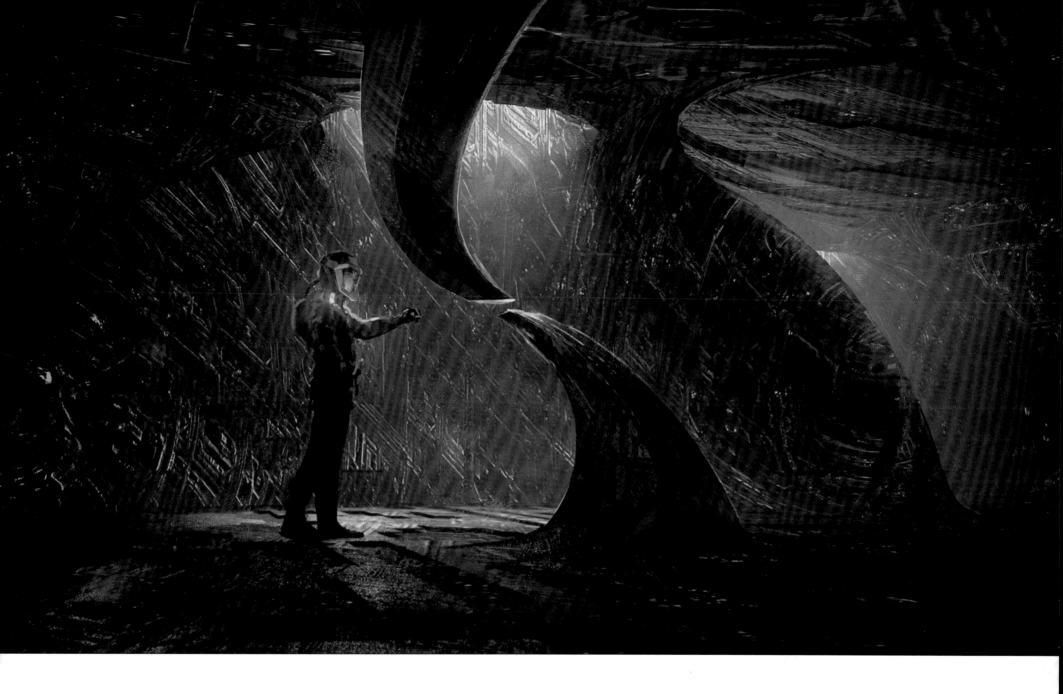

ABOVE: Holden prepares to complete the 'circuit' aboard the Ring Station.

"[The Ring Station] is a combination of effects and the practical set, which was rather dizzying to walk along—we had a long track going along a tunnel there. It was not much real estate to film on, but it looks vast now in the final product."

Mark Fergus, executive producer ↘

BEYOND THE RING

Naren Shankar: "The opening of the Ring gates has put thousands of Earth-like planets within easy reach of human beings for the first time in the history of the species. Throughout the solar system, Earthers, Martians, and Belters are champing at the bit at the prospect of new worlds to colonize, new resources to exploit, and vast new fortunes to be made. Humanity is on the verge of a new Gold Rush. But not everyone will share equally. Season 4 of *The Expanse* is about what happens when new technologies render people obsolete, and how those people often respond in the only way they can—with *violence*..."

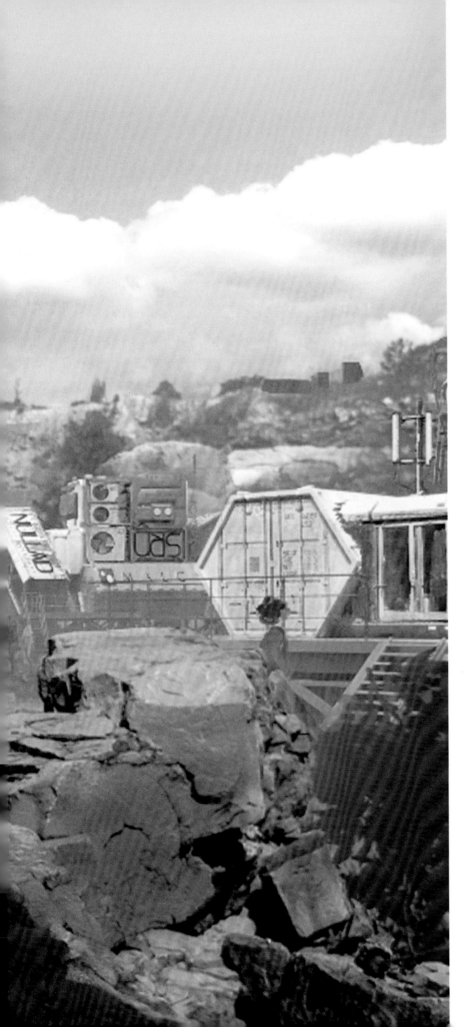

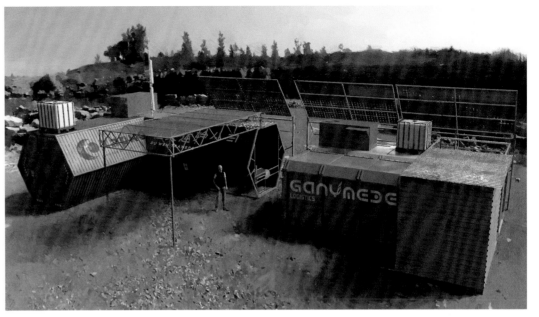

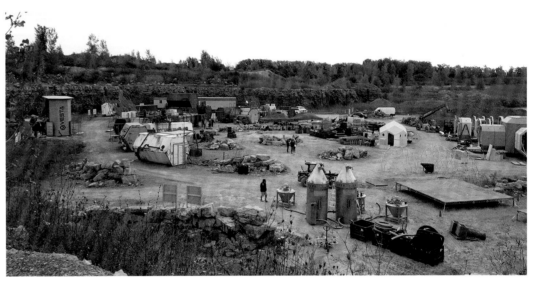

ΛBOVΞ: The exterior First Landing set takes shape.
LΞFT: Concept art establishing the general look and mood of First Landing.

"One of the first things that was talked about was the need to have a strong visual distinction between the Belter colony and the RCΞ camp. All of the Belter structures look like they have been repurposed from cargo containers and parts of the ship, while the RCΞ camp is high-tech and looks like a futuristic research outpost. The Belter side feels retrofit and disorderly, the RCΞ side is purpose built and orderly."

Tim Warnock, concept artist ↘

RIGHT: Illustration showing the immediate aftermath of the explosion at the landing pad just outside First Landing.

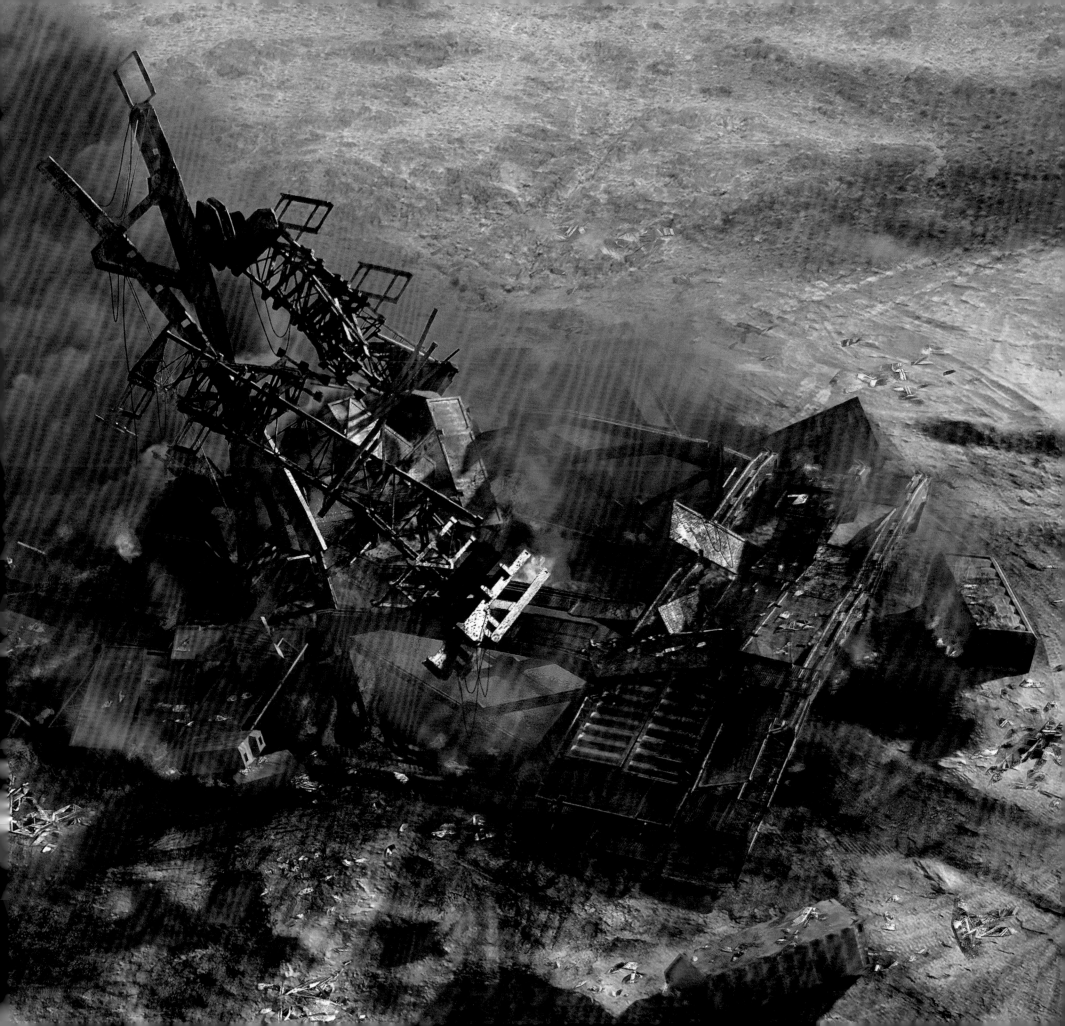

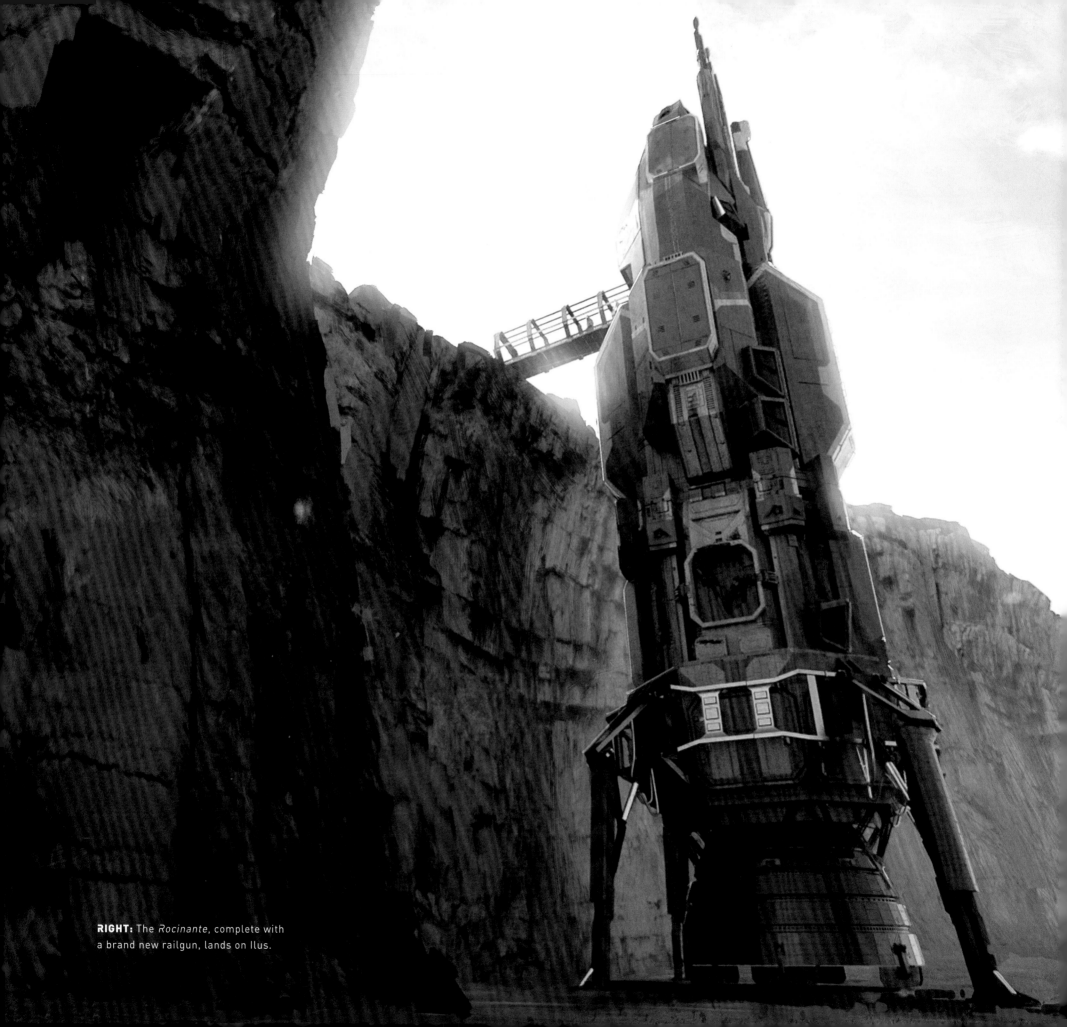

RIGHT: The *Rocinante*, complete with
a brand new railgun, lands on Ilus.

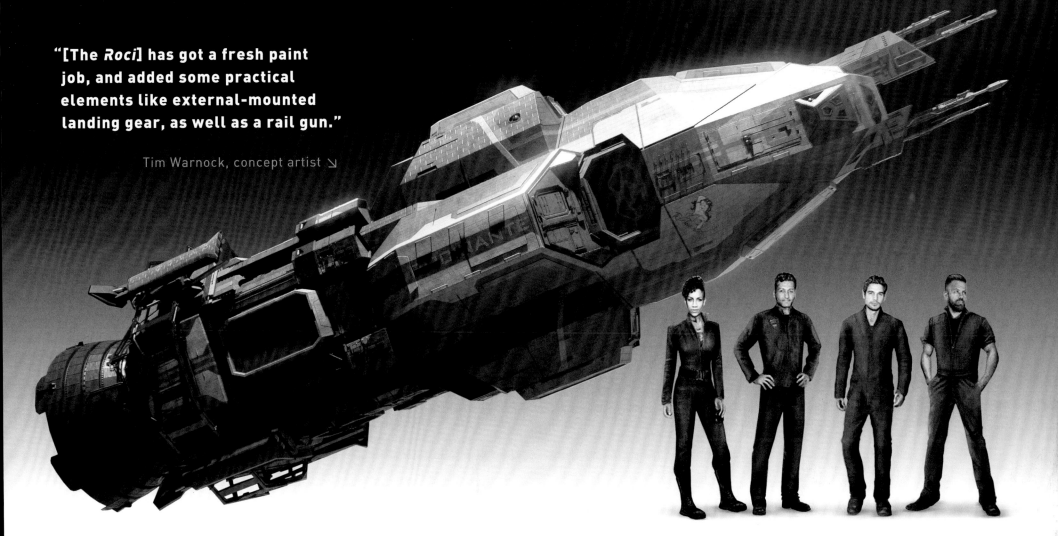

"[The *Roci*] has got a fresh paint job, and added some practical elements like external-mounted landing gear, as well as a rail gun."

Tim Warnock, concept artist ↘

ABOVE: The *Roci* as it looks at the start of Season 4.

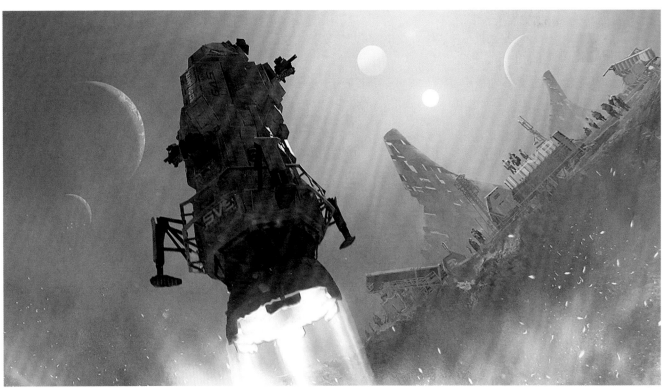

RIGHT: Artwork of the *Roci* blasting off from the Ilus surface.

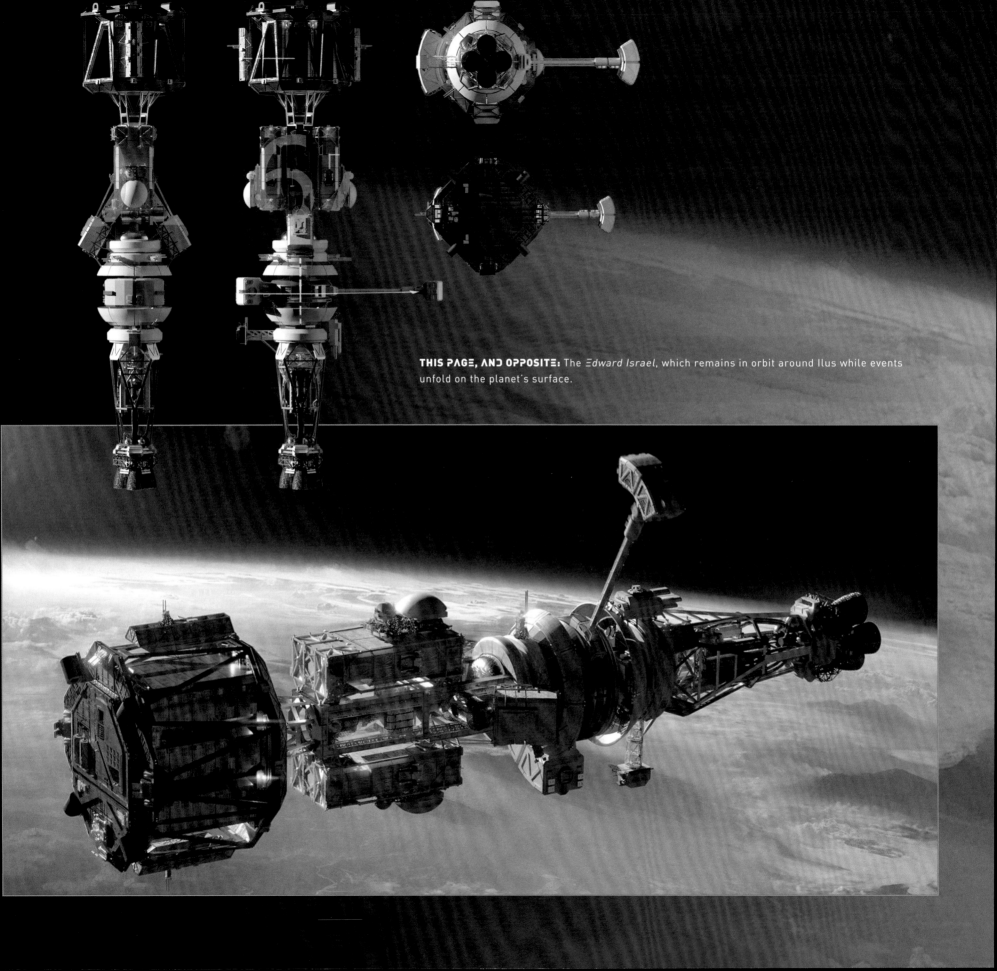

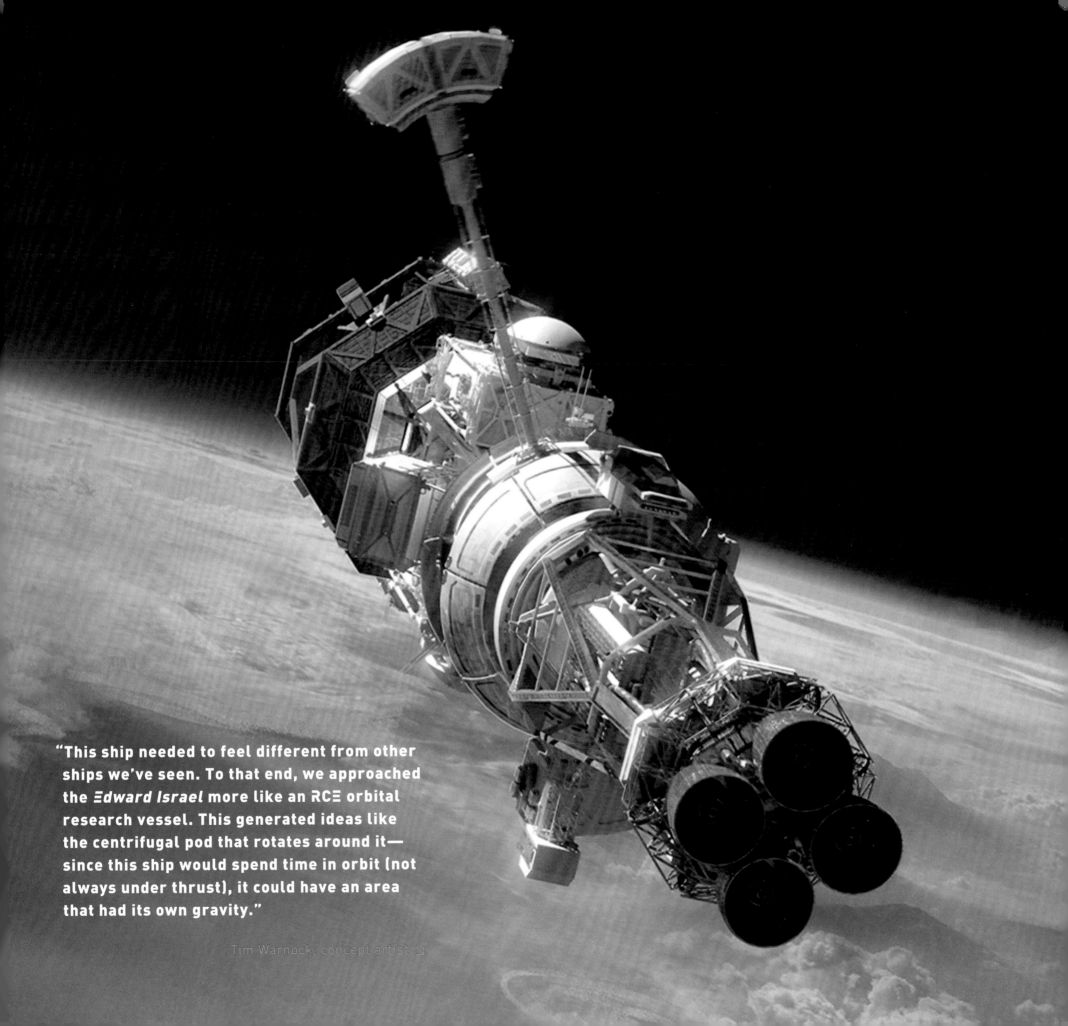

"This ship needed to feel different from other ships we've seen. To that end, we approached the *Edward Israel* more like an RCΞ orbital research vessel. This generated ideas like the centrifugal pod that rotates around it— since this ship would spend time in orbit (not always under thrust), it could have an area that had its own gravity."

Tim Warnock, concept artist ↘

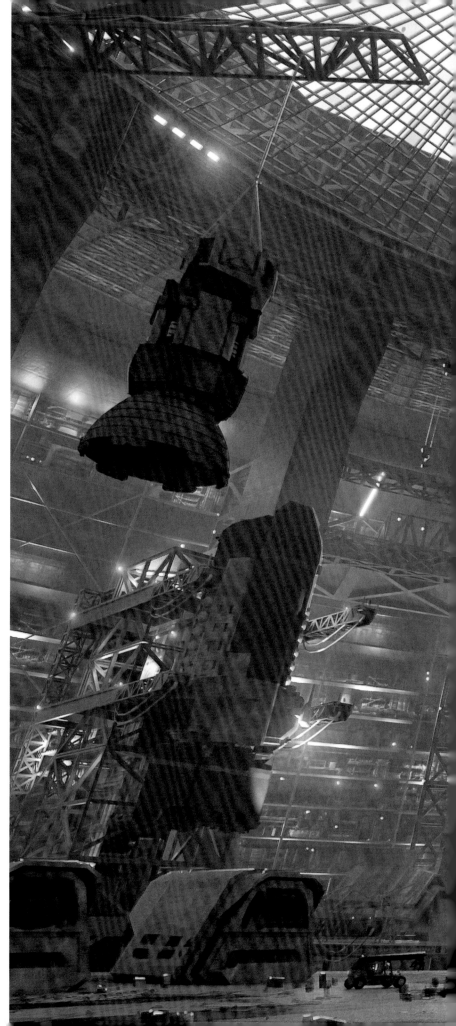

TOP: The UN shuttle 'UN One' leaves dock on Mars.
ABOVE: Illustration of Mariner Valley on Mars.
RIGHT: One of Mars's massive shipyards.

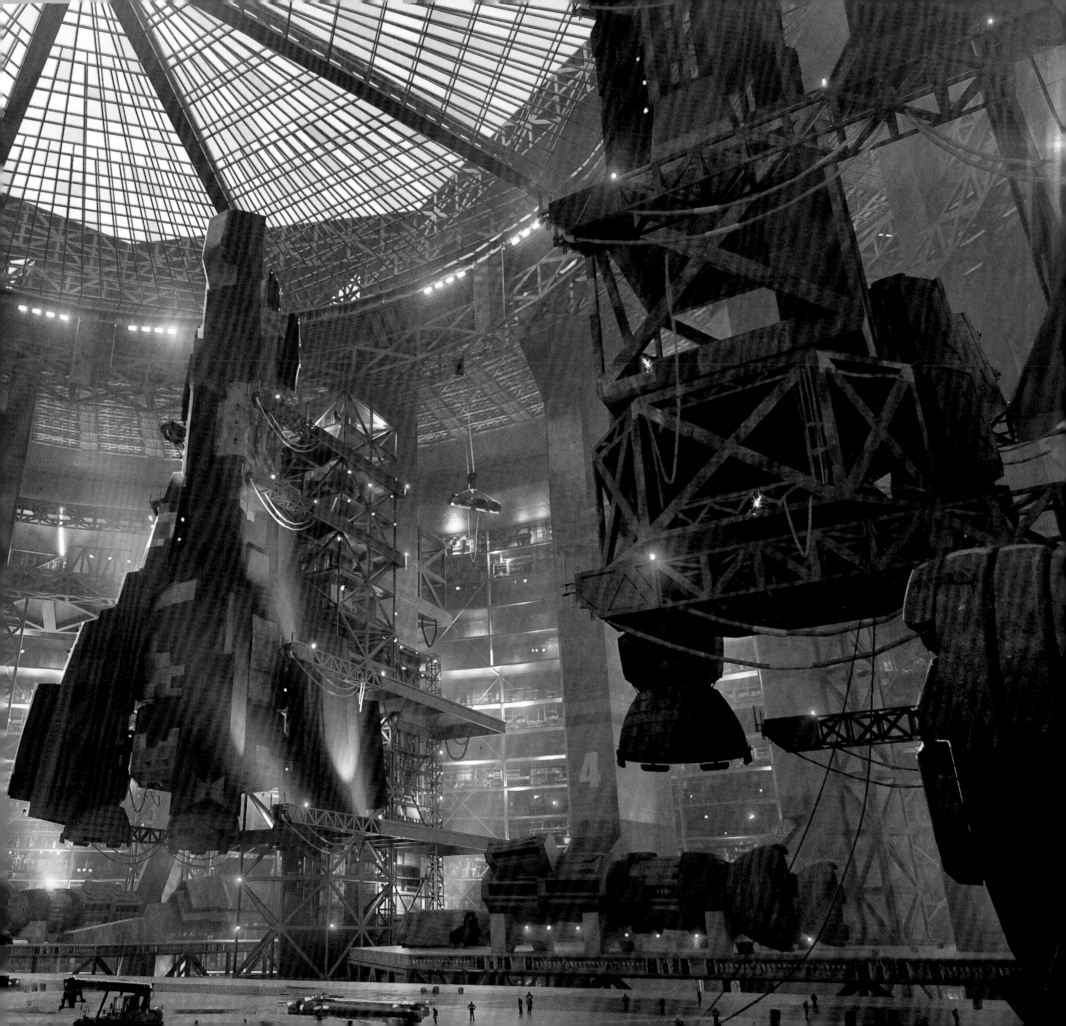

ART DEPARTMENT

Production Designers
Tony Ianni
Seth Reed

Art Directors
Peter Emmink
Kim Karon
Kim McQuiston
Sandra Nieuwenhuijsen
James Oswald

Art Dept Coordinators
Jamie Frith
Zazu Myers

Set Designers
Barbara Agbaje
Sylvain Bombardier
Rudy Braun
Chris Bretecher
Karl Crosby
Eric Deros
Tucker Doherty
Robert Emery
J. Ryan Halpenny
Alexandra Juzkiw
Stefany Koutroumpis
Diette MacDonald
Matt Middleton
Russell Moore
Ahn Mur
Monica Navarrete
Sorin Popescu
Corinna Porsia
Liane Prevost
Khanh Quach
Andrew Redekop
Doug Slater
Mike Stanek
Shelby Lynn Taylor
Jessica Terry
James Usas

Graphic Designers
Andra Fay Butler
Kelly Diamond
Marika Gal
Jeremy Gillespie
Jon Hunter
Kim Sison
Bruce Wrighte

Motion Graphics Designers
Melanie Ellis
Walter H. May
Olivia Makish
Victor Mare
Chris Ouimet
Tim Peel
Hiep Pham
Sumeet Vats
Rhys Yorke

NORTH FRONT
Concept Illustrators
Ryan Dening
Tim Warnock

Illustrators
Amro Attila
Sanford Kong

Virtual Reality/3D Modeler
Christopher Danelon

Set Decorators
Justin Craig
Peter Nicolakakos

Props Master
Jim Murray

Construction Coordinator
Rob Valeriote

Key Scenic
Brian Mullin

Storyboard Artist
Alex Row

CAMERA DEPARTMENT

Directors of Photography
Jeremy Benning
Ray Dumas
Michael Galbraith
Kevin Jewison

On Set Stills Photographers
Rafy
Jan Thijs

POST DEPARTMENT

Co-Producer
Gary Mueller

Colorist
Joanne Rourke

VFX

Production VFX Supervisor
Bret Culp

Production VFX Producer
Bob Munroe

ROCKET SCIENCE
VFX Supervisor
Chris Nokes
Tom Turnbull
CG Supervisor
John Cordrick

SPINVFX
VFX Supervisor
Kyle Menzies
Animation Director
Peter Giliberti
FX Director
Tim Sibley
Lighting Lead
Inna Itkin
Compositing Lead
Andrew Scott

OBLIQUE
VFX Supervisor
Pierre-Simon Lebrun-Chaput
Comp Supervisor
Michael Beaulac
CG Supervisor
Louis-Philippe Clavet
Asset Lead
Sylvain Lesaint
Shot Lead
Christopher Gonnord

JOHN MARIELLA VFX
VFX Supervisor
John Mariella

COSTUME DEPARTMENT

Costume Designer
Joanne Hansen

ALCON TELEVISION GROUP, LLC

Co-CEOs & Co-Founders
Andrew Kosove & Broderick Johnson
President
Laura Lancaster
COO/CFO
Scott Parish
SVP, Development
Ben Roberts
SVP, Business Affairs
Grace Del Val

The producers would like to thank Naren Shankar, Mark Fergus & Hawk Ostby, Daniel Abraham & Ty Franck, Steven Strait, Dan Nowak, Sharon Hall, Sean Daniel, Jason Brown, Alan DiFiore, Robin Veith, Georgia Lee, Hallie Lambert, Laura Marks, Jason Ning, Denise Harkavy, Matthew Rasmussen, Lynn Raynor, Glenton Richards, Julianna Damewood, Ben Cook, Manny Danelon, Lewin Webb, Kenn Fisher, Robin Griffin, Robert Crowther, Krista Allain, Sarah Wormsbecher, Cailin Munroe, and all of the amazing members of the cast and crew who work so tirelessly on this show.

SEASON 3 SHIP SCALES

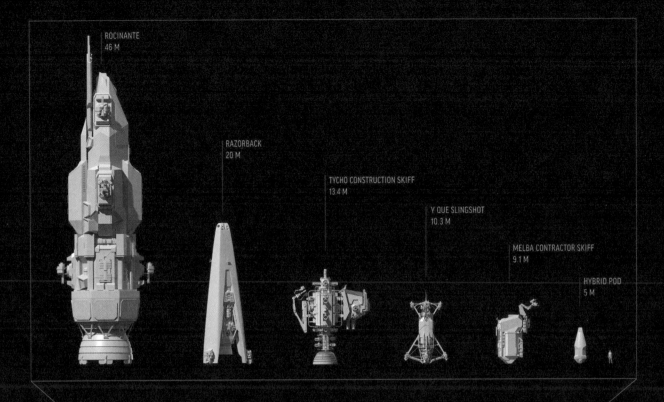

ROCINANTE
46 M

RAZORBACK
20 M

TYCHO CONSTRUCTION SKIFF
13.4 M

Y QUE SLINGSHOT
10.3 M

MELBA CONTRACTOR SKIFF
9.1 M

HYBRID POD
5 M

ROCINANTE
46 M

RAZORBACK
20 M

TYCHO CONSTRUCTION SKIFF
13.4 M

Y QUE SLINGSHOT
10.3 M

MELBA CONTRACTOR SKIFF
9.1 M

HYBRID POD
5 M

UNN DEFENCE SATELLITE
27 M (DIAMETER)

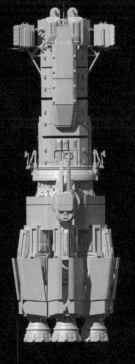
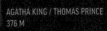

AGATHA KING / THOMAS PRINCE
376 M

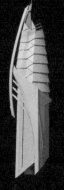

GUANSHIYIN
205 M

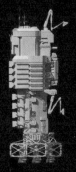

TYCHO SALVAGE SHIP
174 M

ESCORT SHIP
104 M

MCRN STEALTH SHIP
83 M

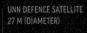

UNN RAILGUN PLATFORM
81 M

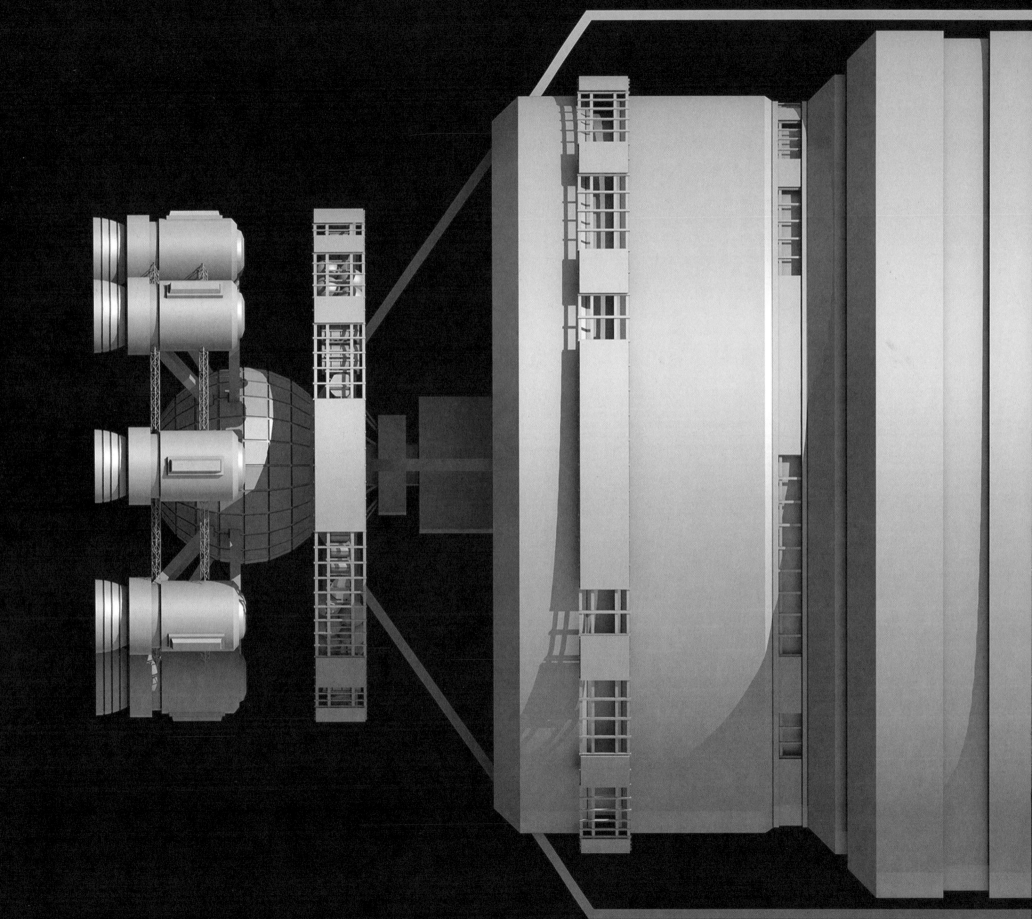